SOFA
NEW YORK
SCULPTURE OBJECTS
& FUNCTIONAL ART

The 11th Annual Sculpture Objects & Functional Art Fair

May 29 – June 1, 2008

Park Avenue Armory
Park Avenue & 67th Street

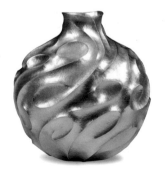

SOFA NEW YORK is produced by
dmg Art & Antiques Fairs

dmg world media

Hiroshi Suzuki
M-Fire VI, Aqua-Posey VII, M-Fire VII,
hammer-raised Fine silver 999
Clare Beck at Adrian Sassoon

All dimensions in the catalog are in inches (h x w x d) unless otherwise noted

Library of Congress – in Publication Data

SOFA NEW YORK 2008
Sculpture Objects & Functional Art Fair

ISBN 978-0-9789206-0-9
2008903046

Published in 2008 by dmg Art & Antiques Fairs, Chicago, Illinois

Graphic Design by Design-360° Incorporated, Chicago, Illinois
Printed by Pressroom Printer & Designer, Hong Kong

SOFA
NEW YORK
SCULPTURE OBJECTS
& FUNCTIONAL ART

SOFA NEW YORK 2008

Produced by dmg Art & Antiques Fairs

4401 North Ravenswood, Suite 301

Chicago, IL 60640

voice 773.506.8860

fax 773.345.0774

www.sofaexpo.com

Management

Mark Lyman, Vice President, dmg Art & Antiques

Anne Meszko

Julie Oimoen

Kate Jordan

Greg Worthington

Barbara Smythe-Jones

Patrick Seda

Bridget Trost

Michael Macigewski

Aaron Anderson

Ginger Piotter

Conte

SOFA
NEW YORK
SCULPTURE OBJECTS
& FUNCTIONAL ART

Welcome to the 11th annual SOFA NEW YORK!

As many of you know, the SOFA fairs in New York and Chicago are part of dmg world media and its holding company, Daily Mail and General Trust (DMGT)—one of the London Stock Exchange's top 100 companies. A key attribute of successful fair organization is financial stability and long-term commitment which dmg world media ensures.

Early this year, dmg announced that it would bring together its high level art and antique fairs. As Vice-President of dmg, I am directing this elite group that includes Palm Beach | America's International Fine Art & Antique Fair; palmbeach3 | contemporary art fair; and SOFA NEW YORK and CHICAGO. By bringing these fairs together we'll provide even better customer service, and maximize our marketing and public relations strengths. We can all look forward to dmg's continued financial stability and long-term commitment to these strong fair organizations, stronger now for their combined creative and operational skills.

I am also pleased to announce that SOFA NEW YORK 2009 will partner with ICFF, the International Contemporary Furniture Fair, dmg's highly successful professional design show celebrating its 20th anniversary this year in New York City. Held annually the third week of May for four days at the Jacob K. Javits Center and featuring more than 600 top designers presenting in 145,000 net square feet, the ICFF bustles with more than 25,000 visiting interior designers, architects, retailers, designers, manufacturers, representatives, distributors, and developers. Contingents making the annual quest to this celebrated design hub include Austrian Trade Commission, BEDG (British European Design Group), Designed in Brussels (Belgium), FNY (Furniture New York), The Furniture Society (U.S.), i Saloni WorldWide (Italy), ICEX (Spanish Institute for Foreign Trade), IDSA (Industrial Designers Society of America), Innovation Norway, New Design Canada, Pure Austrian Design and Royal Danish Consulate General (Denmark). To be held concurrently with ICFF, SOFA NEW YORK 2009 will benefit from cross-marketing and programming with this cutting-edge design showcase. We all look forward to an earlier start date for SOFA NEW YORK away from Memorial Day—stay tuned for a possible venue move!

Along these lines, special thanks to Jack Lenor Larsen and Cowtan & Tout for sponsoring SOFA NEW YORK's 2nd annual Designer Breakfast; and to SOFA's new National Design Commitee for their assitance in making SOFA a destination for top designers and their clients.

This year's SOFA NEW YORK Opening Night Preview Gala is Collector's Choice! Following the enormous success of recent SOFA CHICAGO's Opening Night events which brought in an excellent, qualified crowd and demonstrated tremendous sales, we have fine-tuned the New York Opening to attract leading collectors invited by SOFA participating dealers, as well as key leaders drawn from collecting groups and the financial and art worlds who will attend at our invitation. An affordable admission ticket is designed to attract new collectors, especially a younger crowd. Many thanks to our dealers for their strong partnership in making Opening Night a success!

Anne and I would also like to congratulate the Museum of Arts & Design, New York, on the opening of its new facility at 2 Columbus Circle this fall—which promises to be a vibrant and engaging cultural center like no other institution in the city. As long-time partners in the promotion of one-of-a-kind masterworks bridging design, decorative and fine arts, we are delighted that MAD will again host a fund-raising dinner in the Tiffany Room on Opening Night. We look forward to continuing to work together to support the dealers and artists whose hard work and creativity gives us all so much joy and thoughtful pause.

Enjoy!

Mark Lyman, *Vice-President, dmg Art & Antiques Fairs and Founder/Director of SOFA*

Anne Meszko, *Advertising and Programming*

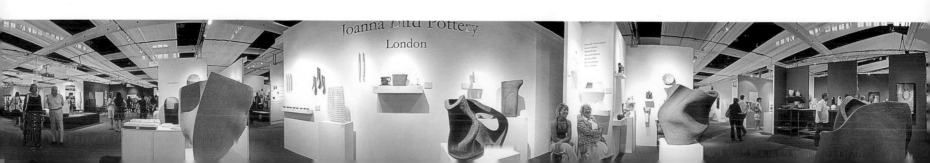

Ioanna Bird Pottery
London

Expressions of Culture, Inc. would like to thank
the following individuals and organizations:

Participating galleries, artists, speakers and organizations

Active Graphics

Jane Adlin

Art Jewelry Forum

Asia Society

Thomas Samuel Bailey

Bard Graduate Center for Studies in the Decorative Arts, Design & Culture

John Barman

David Barnes

Kathryn Baron

Rosanna Bellusci

Jonas Breneman

Bronfman Corporation

Desiree Bucks

Julian Chu

Sara Clark

Collectify

Cooper Hewitt, National Design Museum

Keith Couser

Cowtan & Tout

Erinn Cox

Susan Cummins

Design 360

Dietl International

Floyd Dillman

Kevin Donovan

Annie Dowhie

Lenny Dowhie

Elle Decor

Empire Safe Company

D. Scott Evans

Jane Evans

Gregory Feehan

Sean Fermoyle

Amanda Fielding

Michael Franks

Peter Gee

Greenwich House Pottery

Lou Grotta

Sandy Grotta

Key Hall

John Hamilton

Lauren Hartman

Stephanie Hatzivassiliou

Hispanic Society of America

Scott Hodes

Holly Hotchner

JP Morgan

Scott Jacobson

Howard Jones

Patrick Keefe

Stefani Kochanski

Stephanie Lang

Jack Lenor Larsen

Amy Lau

Lauren Levato

Levin & Associates

Richard Lewis

David Ling

LongHouse Reserve

Suzanne Lovell

Ellie Lyman

Nate Lyman

Sue Magnuson

Jeanne Malkin

Kevin McCormack

David McFadden

Metropolitan Museum of Art

Kay Mitchell

Moët Hennessy

Desmond Moneypenny

Marjorie Mortensen

Museum of Arts & Design

Ann Nathan

Morgan Oaks

Tom Oimoen

John Olson

Miry Park

Pressroom Printer & Designer

Emily Reynolds

Bruce Robbins

Miroslava Sedova

Select Contracting

The Seventh Regiment Armory Conservancy

Franklin Silverstone

Society of North American Goldsmiths

Alison Spear

Jennifer Stark

Joe Striefsky

TASTE Caterers

Barbara Tober

Matko Tomicic

Marilyn White

Robert Zale

photo: David Barnes

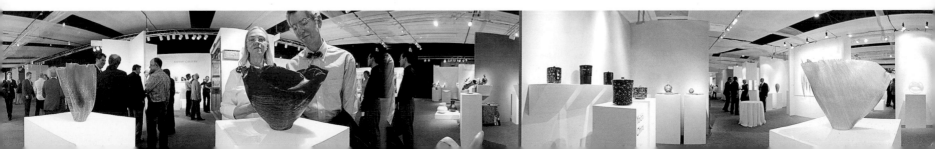

On behalf of the entire Board of Trustees and staff of the Museum of Arts & Design (MAD), welcome to the Eleventh Annual Sculpture Objects & Functional Art Fair: SOFA NEW YORK 2008. This year also marks the eleventh anniversary of MAD's partnership with Mark Lyman and SOFA. Their dedicated support of our field has encouraged tens of thousands of people to become collectors of arts and design—and to become patrons of our Museum, which celebrates the creative process through which materials are crafted into works that enhance contemporary life.

As many of you know, MAD will soon move from its current home at 40 West 53rd Street to 2 Columbus Circle, the very center of one of Manhattan's most significant public spaces. Architect Brad Cloepfil of Allied Works Architecture, has changed a building that for many years lay shrouded in mystery into a contemporary, approachable, dynamic cultural center that will transform the traditional museum experience for the casual visitor and the experienced scholar alike. Mark your calendars! MAD opens this September—just four short months from now.

The 2 Columbus Circle visit starts in a unique, light-filled education center on the 6th floor—the heart of the Museum—which provides MAD's audience with an immediate context for the works on display. Open studios allow museum-goers to observe and interact with artists and designers creating objects that directly reference those shown at MAD and on our collections website. Classrooms on the same floor will welcome more than 10,000 New York City school children each year to a world of creativity they can inhabit as active participants. Other highlights of 2 Columbus Circle are the first galleries dedicated to our permanent collection; the new Tiffany & Co. Foundation Jewelry Gallery, the nation's first resource center and gallery for contemporary jewelry; a restaurant with panoramic views of Central Park; an expanded retail space; and a 155-seat auditorium which will serve as a programming gallery for MAD and its strategic partners, allowing our visitors access to a host of New York City cultural institutions—all in one place!

Of course, the core of MAD's mission will always be its groundbreaking approach to looking at art, craft and design. Our last two major exhibitions on 53rd Street—*Radical Lace and Subversive Knitting* and *Pricked/Extreme Embroidery*—showcased our mission to reflect trends and issues in arts and design as they develop. Our opening exhibition at 2 Columbus Circle—*Second Lives: Remixing the Ordinary*, a special exhibition co-curated by Chief Curator David Revere McFadden and Curator Lowery Stokes Sims—continues this trend, featuring

40 artists from across the globe who repurpose and transform existing objects into works of art. *Second Lives* will be joined opening week by a host of activities inside and outside the Museum—a truly spectacular event, and the highlight of New York's fall cultural season. Museum members will receive priority admission to the new MAD; if you're not yet a MAD member, we urge you to join today. Don't miss the party!

Holly Hotchner
Director

A.
Chairman Emeritus Jerome A. Chazen holding a shovel by artist Tommy Simpson, Director Holly Hotchner, Chairman Barbara Tober, former Manhattan Borough President C. Virginia Fields, and President Nanette Laitman at the 2CC Ceremonial Wall Cutting on September 29, 2006.

B.
The new Museum façade features 22,000 ceramic tiles, with a specially-designed nacreous glaze, designed to reflect different shades of purple and gold depending on the point of view, position of the sun, and city lights. This material paired with fritted glass represents the Museum focus on design materials and process, and brings a distinctly visual arts presence to the Upper West Side.

C.
The Museum's unique façade of fritted glass and ceramic tiles opens the interior educational and gallery spaces to natural light and sweeping views of Central Park and the neighboring Columbus Circle community. Image courtesy of Allied Works Architecture.

D.
The Museum of Arts & Design's new home at 2 Columbus Circle, opening September 2008. Image courtesy of Mark Watanabe.

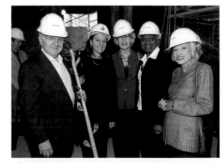

A.

B.

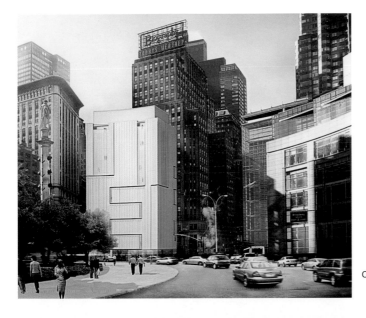

C.

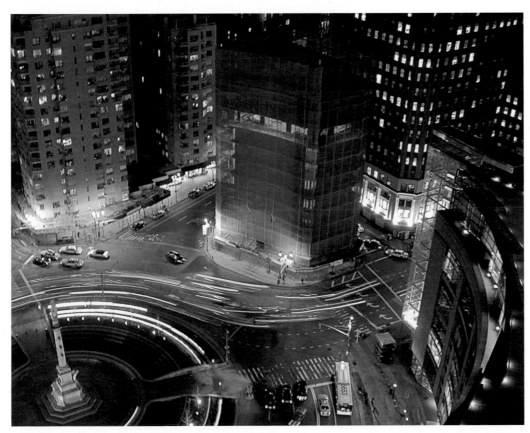

D.

SOFA National Designer Committee

Co-Chairs

John Barman
Holly Hunt
Amy Lau
Suzanne Lovell
Alison Spear

Committee

Frank de Biasi and Gene Meyer
Bruce Bierman
Lars Bolander
Christopher B. Boshears
Geoffrey Bradfield
Mario Buatta
Sherrill Canet
Joanne De Palma
Jamie Drake
Arthur Dunnam
Patrick Gallagher
Jennifer Garrigues
Alexander Gorlin
David Ling
Timothy Macdonald
Brian McCarthy

Juan Montoya
Brian Murphy
Sandra Nunnerley
Dennis Rolland
H. Parkin Saunders
Steven Sclaroff
Michael Simon
Marjorie Shushan
Stephen Miller Siegel
Matthew Patrick Smyth
Stephanie Stokes
Alan Wanzenberg
Jennifer Watty
Ilene Wetson
White Webb
Rod Winterrowd

committee in formation

THE CITY OF NEW YORK
OFFICE OF THE MAYOR
NEW YORK, N.Y. 10007

Dear Friends:

It is a pleasure to welcome everyone to the 11th annual Sculpture Objects and Functional Art Fair, SOFA NEW YORK.

The five boroughs are home to everything from towering metal-and-glass skyscrapers to the iconic wooden Coney Island boardwalk — so what better place to celebrate artists who, like the builders of our City, have crafted striking, purposeful works in ceramics, glass, metal, wood and fiber? This week, art aficionados will gather here in the world's artistic capital to enjoy creations by both established and emerging artists. And with galleries featuring pieces from Japan, France, Korea, Turkey, and far beyond, SOFA reflects not only our City's material variety, but also its boundless cultural diversity.

On behalf of the City of New York, please accept my best wishes for an enjoyable event and continued success.

Sincerely,

Michael R. Bloomberg
Mayor

Salon

Salon SOFA:
Lectures & Conversations

Salon SOFA:
Exploring the Culture of Contemporary Decorative Arts & Design

Lectures

Lectures take place Thursday, May 29 in the Armory's Tiffany Room and are included with daily admission.

10:00 – 11:00 AM
Jewelry by Artists: The Daphne Farago Collection at the Museum of Fine Arts, Boston
A survey of the Daphne Farago Collection of studio jewelry recently given to the Museum of Fine Arts, Boston; with an accompanying discussion of its historic and artistic significance. **Kelly L'Ecuyer**, Ellyn McColgan Assistant Curator of Decorative Arts and Sculpture, Art of the Americas, Museum of Fine Arts, Boston. *Presented by Art Jewelry Forum.*

11:15 AM – 12:15 PM
Weaving Tapestries into Buildings
Helena Hernmarck's tapestry designs are derived from the local environment, often encapsulating the great outdoors on a monumental scale. Her commissions include four seasonally rotating tapestries in the lobby of the Time Warner Center apartments in New York. Hernmarck is represented by browngrotta arts, CT.

12:30 – 1:30 PM
People of Clay
Akio Takamori talks about the development of his figurative clay sculpture from 1996 to the present, revisiting projects, exhibitions and tracing his inspiration. Takamori is represented by Barry Friedman, Ltd., NY.

1:45 – 2:45 PM
'anima'...animations, syntheses and mimicries
Adam Paxon discusses the development of colour and form in his recent acrylic pieces, journeying through the surface into the interior of the material of dreams. Paxon is the UK's Jerwood Applied Arts: Jewellery prize-winner of 2007 and is represented by Clare Beck at Adrian Sassoon, London.

3:00 – 4:00 PM
Second Lives: Remixing the Ordinary
Preview the Museum of Art & Design's inaugural show at their new museum; works and installations by 40 established and emerging artists from five continents, created from everyday manufactured objects originally made for another functional purpose. The exhibition will illuminate issues of materials and process, global consumerism, cultural and personal identity, and current value systems. **David Revere McFadden**, Chief Curator of the Museum of Arts & Design, New York.

4:15 – 5:15 PM
Karen Pontoppidan: Why I Do What I Do
"My jewellery speaks in a quiet voice about everyday life, connecting small moments of beauty and sadness, invisible to history, with the immortality of the metal." **Pontoppidan** trained at the Akademie der Bildenden Künste in Munich. She is currently a professor at Ädellab (metal department) KONSTFACK in Stockholm, Sweden, and is represented at SOFA by Jewelers' Werk Galerie, Washington DC.

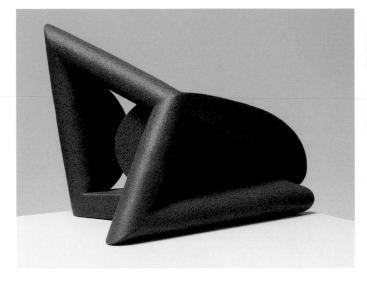

Anne Currier
Lacoste Gallery

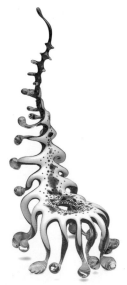

Adam Paxon
Clare Beck at Adrian Sassoon

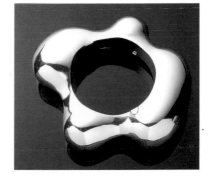

Helena Hernmarck
browngrotta arts

Conversations

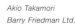

Alma Eikerman
Daphne Farago Collection, Museum of Fine Arts
Photograph © Museum of Fine Arts, Boston

Akio Takamori
Barry Friedman Ltd.

Essays

Neil Brownsword: New Work

Amanda Fielding

A.

Coinciding with his first solo exhibition with Galerie Besson in the United Kingdom, Neil Brownsword gave a riveting presentation to a packed audience at the Royal College of Art during Ceramic Art London 2008. It was a fascinating, intensely personal and moving account of his shifting relationships with the now declining ceramic industry of his native North Staffordshire, and the industry's pivotal influence on the evolution of his artistic practice.

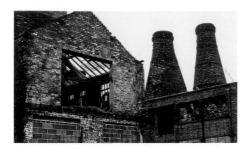

He began with a grainy black and white photograph of his grandmother who worked at the Carlton Ware factory in the 1940s, followed by images of an iron-rich clay seam close to his childhood home, and the people he worked with as a trainee modeller (aged sixteen) at the Wedgwood factory. Fast forward a decade or so and the pictures change, the mood darkens:

scenes of deserted factory floors and an enormous pile of rubble where a pottery once stood. A shot of factory waste he unearthed in his own back garden – locally known as 'shraff' and used to line house foundations in Stoke – brought into sharp focus a time past when the city's specialist ceramics skills and vigorous production put it on a par with China as a world centre.

As a professional ceramist, Brownsword has always drawn heavily on his intimate knowledge and authentic experience of the Potteries. Observation of the youthful behaviour and banter at Wedgwood led to a series of grotesque collaged figures, often engaged in narratives that explore themes of insecurity, self-doubt, and "the hedonistic pursuits of my male peers alienated by the routine of the factory floor." It was these oddly humorous, richly textured works that first brought his work to serious critical attention in the mid-1990s.

But his shock and anger at the collapse of Stoke's ceramics industry, loss of expertise and factory demolition demanded a different artistic response. Given free rein to experiment with material and process during a residency at the European Ceramic Work Centre in Holland, he abandoned the figure in favour of abstract assemblage – a kind of fictive industrial archaeology – to communicate his feelings. Titles are brief yet potent with meaning: *Loss, Trace, Remnant, Salvage Series* and *Flux*. There are parallels with the collages of found materials by Gillian Lowndes, a ceramist whose open approach to clay he has long admired.

Brownsword's most recent body of work expands on earlier themes of destruction, irrevocable loss, absence and memory. Cast and handmade components are juxtaposed with clay detritus salvaged from the production line and other manufacturing paraphernalia that, in Brownsword's words, "are preserved and aestheticised through firing." Again, titles are short yet evocative, on this occasion referring to specific aspects of ceramic process: *Buller, Raft, Crank*. There are single objects and groups of elements that frequently occupy both horizontal and vertical space. He takes a painterly approach to composition, placing individual parts with deliberation and giving special attention to colour relationships; for instance, milky turquoise is complemented by deep red, olive-green energised by bright orange.

Neil Brownsword's use of fragmentary installation and exploitation of the mutability of his chosen materials to explore abstract ideas, arguably positions him at the forefront of current experimental and conceptual approaches to clay in Europe and Scandinavia.

Amanda Fielding is the Camberwell/V&A Fellow in Craft. Current research interests focus on curation and contemporary ceramic practice. She is curating an exhibition of new work by Richard Slee at the Victoria & Albert Museum in 2010 and is joint coordinator of a new research partnership between Camberwell College of Arts and Bergen National Academy of the Arts.

Published in conjunction with Galerie Besson's exhibition at SOFA NEW YORK 2008.

A.
Neal Brownsword
Crank, 2007
ceramic and salvaged factory detritus
two elements, largest 17.75 x 6.75

B.
Derelict Enson Pottery Works,
Langton, Stoke-on-Trent

C.
Buller, 2007
ceramic and salvaged factory detritus
three elements, largest 12.5 x 3.5

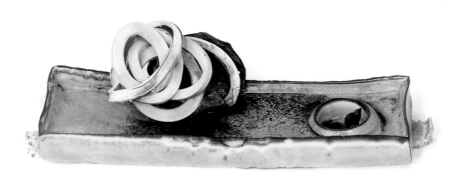

C.

A.

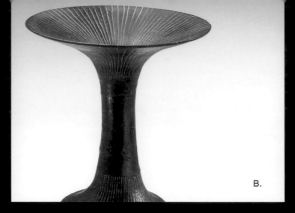

B.

C.

D.

"I really hadn't thought about it before, but the vessel form is the common denominator of our collections – in many mediums, cultures, and eras (particularly my own.)"

Jack Lenor Larsen

100 VESSELS at LongHouse

Curated by Jack Lenor Larsen

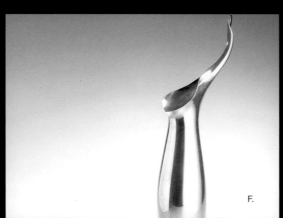

F.

G.

H.

I.

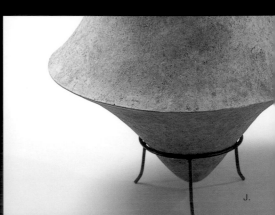

J.

Even more pervasive than LongHouse textiles, our fifty-year collecting focus has been on vessels. Small, large, or shoulder high – millennia old or born yesterday – they are here at LongHouse in galaxies like hundreds of stars.

Not surprisingly, ceramic vessels dominate the exhibition *100 VESSELS* in number and variety. From thick slabs to eggshell translucency and from tiny thimbles to Toshiko Takaezu's ten foot *Tree Form*. A group titled *Asian Clay: 5000 Years* is in itself a major holding but there are also pre-Columbian and ethnic pots plus a strong showing by several contemporary potters.

Alongside glass and metal vessels, including Chunghi Choo's suave silver forms, are strong examples of turned and carved wood. Basketry comes second in number of vessels on view – as bowl shapes, fish traps and haversacks – both ethnic and studio crafted. Glass is dominated by four decades of pieces by my maverick friend, Dale Chihuly.

Most of these vessels exhibited inside the Pavilion are grouped by medium or provenance; others spill out onto LongHouse's pond-side plaza. Most fantastic of all are large Asian pots marching through the sand dunes from the Gatehouse to the Pavilion.

All told, the mix is as rich as a patisserie, jam-packed with works dating over five millennia. The opportunity to see similar forms in diverse materials, from cultures worlds apart in time and place – all in one space – is a rare one, well worth the stress of Hampton highways.

--

Jack Lenor Larsen

Published in conjunction with the *100 VESSELS at LongHouse* exhibition on view through October 11, 2008 at LongHouse Reserve, East Hampton, NY. This exhibition is made possible with the generous support by Johnson Family Foundation, Edward R. Roberts Family Foundation, and Barbara Slifka.

For more information, please visit www.longhouse.org.

A. Jomon-Doki
Japan, 1500-400 BC
handbuilt stoneware
23.5 x 15 x 15
collection LongHouse Reserve
purchase, Larsen Fund, 1999

B. *Dame Lucie Rie*
Tall Form, *1976*
thrown porcelain, Sgraffito
9.25 x 5.25 x 5.25
collection Jack Lenor Larsen

C. *Dale Chihuly*
Tabac Basket Set with Black Lip Wraps, *1986-87*
blown glass
11 x 29 (overall dimension)
collection LongHouse Reserve gift, Jack Lenor Larsen, 1996

D. *Priscilla Henderson*
Basket, *c. 1970*
rattan, wood; woven, incised, painted, lacquered
14 x 20.5 x 20.5
collection Jack Lenor Larsen

E. *Shoji Hamada*
Vessel, *not dated*
glazed stoneware
9 x 6.5 x 3.5
collection LongHouse Reserve, gift of Marielle Bancou-Segal, 2003

F. *Chunghi Choo*
Lily Vase, *1980*
copper, silver plate; electro formed, 23 x 4.75 x 4
collection Jack Lenor Larsen

G. *Linda Bills*
Japanese Armor, *1985*
wood; bent, pegged
12.75 x 26.5 x 11.75
collection Jack Lenor Larsen

H. Bone Container
Japan, c. 300 AD
clay, 13 x 17
collection LongHouse Reserve

I. *David Ellsworth*
Tall Closed Vase, *1984*
redwood pitch burl
24 x 13 x 13
collection LongHouse Reserve gift of Jane and Arthur Mason, 2006

J. *Unknown Artist*
Vessel
Thailand, c. 2500 BCE
pottery, coiled, honed
22.5 x 18 x 18
collection Jack Lenor Larsen

K. *Chunghi Choo*
Vessel, *1990*
copper, acrylic, lacquer; cast and painted, 7 x 7.25 x 7.5
collection Jack Lenor Larsen

L. *Richard DeVore*
Vessels
various dates and dimensions
collection LongHouse Reserve gift of Jack Lenor Larsen

M. *Masha D. Berenston*
Vessel, *1984*
unglazed porcelain
9 x 10 x 10
collection Jack Lenor Larsen

N. *Toshiko Takaezu*
Vessels
various date and dimensions
collection LongHouse Reserve gift of Jack Lenor Larsen

Objects in the Jack Lenor Larsen collection are promised gifts to LongHouse Reserve.

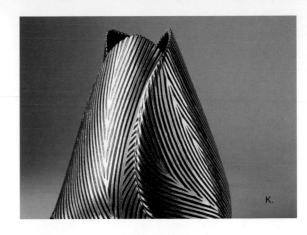

K.

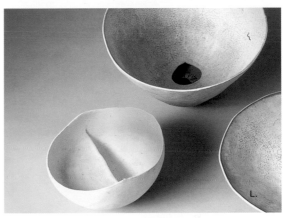

L.

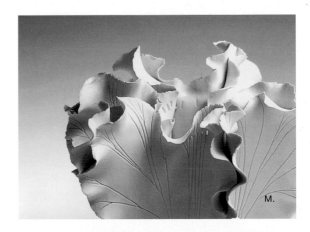

M.

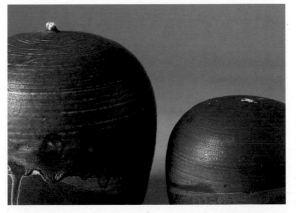

hibitors

Peter Schmid/Michael Zobel, **Pendant**
18k rose gold, 24k gold, jade, 9.13 ct. cats-eye tourmaline, 0.21 tcw. green diamonds, 5 inches diameter
photo: Fred Thomas

Aaron Faber Gallery

20th - 21st C: studio jewelry and period design in precious metals
Staff: Edward Faber; Patricia Kiley Faber; Felice Salmon; Jackie Wax;
Jesse Freed; Alex Gadilov; Erika Rosenbaum; Claudia Andrada

666 Fifth Avenue
New York, NY 10103
voice 212.586.8411
fax 212.582.0205
info@aaronfaber.com
aaronfaber.com

Representing:
Rami Abboud
Marianne Anderson
Glenda Arentzen
Marco Borghesi
Petra Class
Angela Hübel
Sydney Lynch
Enric Majoral
Bernd Munsteiner
Tom Munsteiner
Tod Pardon
Linda Kindler Priest
Yumi Ueno
Ginny Whitney
Jeff Wise
Susan Wise
Michael Zobel/Peter Schmid

Enric Majoral, **Ring,** *2008,*
115 ct. Munsteiner-cut rutilated quartz set in 18k gold

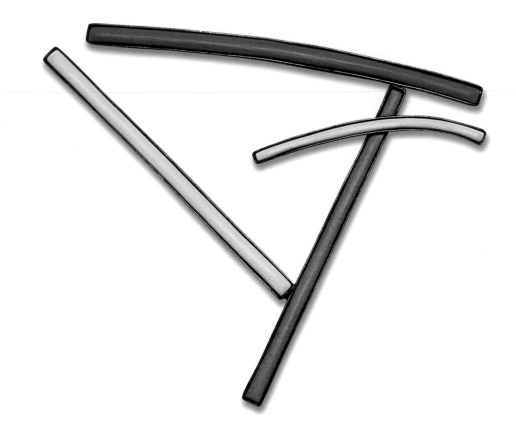

Ginny Whitney, **Brooch,** *2007*
hand-stoned vitreous enamel, darkened sterling and fine silver, 4 x 4.5

Aaron Faber Gallery

Pan Pacific: a spotlight on Asian techniques and influences in contemporary studio jewelry

Representing:
Glenda Arentzen
Harlan Butt
Yuyen Chang
Susan Chin
Margot Di Cono
Devta Doolan
Peggy Eng
April Higashi
Steve Midgett
Komelia Okim
So Young Park
Kim Rawdin
George Sawyer
Noriko Sugawara
Tadakazu Tanaka
Yas Tanaka
Chie Teratani
Kiwon Wang
Gill Galloway Whitehead
Ginny Whitney
Sayumi Yokouchi
Michael Zobel/Peter Schmid

Kiwon Wang, **Fabric of Life** *brooch*
washi paper, ink, sterling silver, pearl, silk, lacquer, 3 x 1.25

Marlene Rose, **Yellow Lotus,** *2007*
glass, metal, 34 x 14 x 7

Adamar Fine Arts

Contemporary sculpture and painting by established and emerging national and international artists
Staff: Tamar Erdberg, owner/director; Adam Erdberg, owner

4141 NE 2nd Avenue
Suite 107
Miami, FL 33137
voice 305.576.1355
fax 305.576.1922
adamargal@aol.com
adamargallery.com

Representing:
Niso Maman
Zammy Migdal
Rene Rietmeyer
Marlene Rose
Tolla
Luis Efe Velez

Rene Rietmeyer, **Venetzia,** *2007*
Murano glass, silver leaf, 17 x 6.25 x 4.5

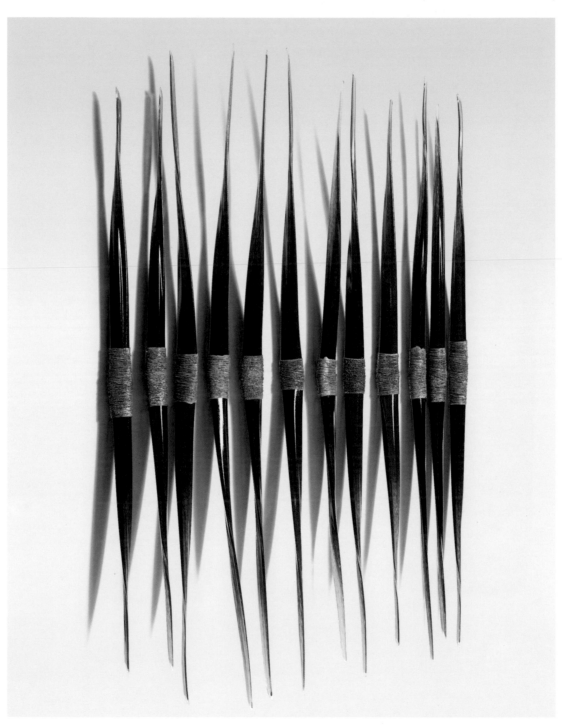

John Paul Robinson, **Water Under Embers,** *2008*
solid glass, copper, steel, 66 x 42 x 6
photo: HIMAGIA

Andora Gallery

Unique sculptural objects and jewelry in a variety of media
Staff: Sue Bass; Mary Bosco; Hilary Gabel; Sandra Rusnak

77 West Huron Street
Chicago, IL 60610
voice 312.274.3747
fax 312.274.3748
info@andoragallery.com
andoragallery.com

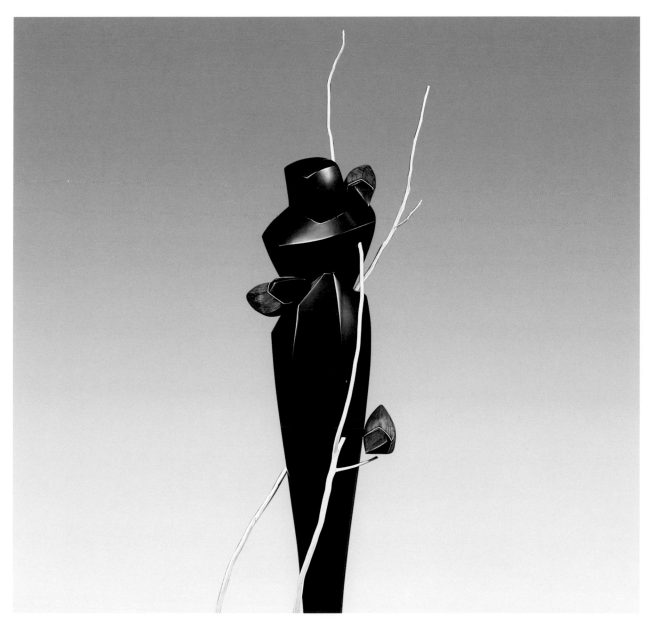

Representing:
Susan Collett
Paul Elia
Mark Gardner
Ursula Morley Price
John Paul Robinson
Carol Stein
Joël Urruty

Joël Urruty, **Lady of the Woods***, 2008*
mahogany, maple, twigs, milk paint, concrete, 85 x 16 x 16
photo: Tim Barnwell

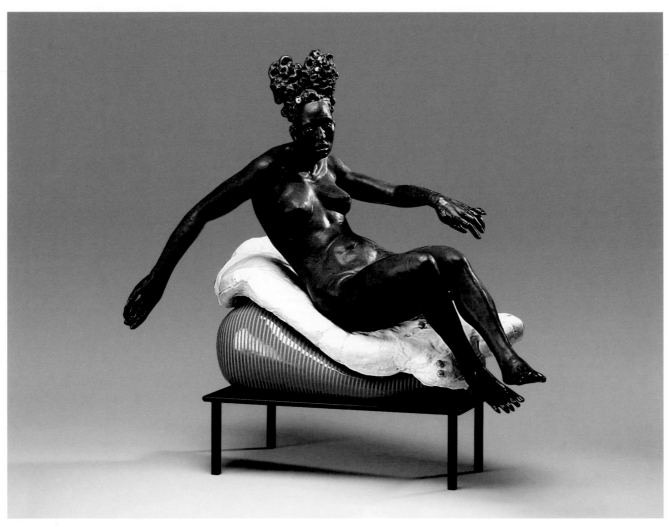

Cristina Cordova, **Dulce,** *2007*
ceramic, mixed media, 21 x 24 x 16

Ann Nathan Gallery

Contemporary figurative and realist painting, sculpture, and artist-made furniture by established and emerging artists
Staff: Ann Nathan, owner/director; Victor Armendariz, assistant director; Philip Nadasdy, gallery assistant

212 West Superior Street
Chicago, IL 60610
voice 312.664.6622
fax 312.664.9392
nathangall@aol.com
annnathangallery.com

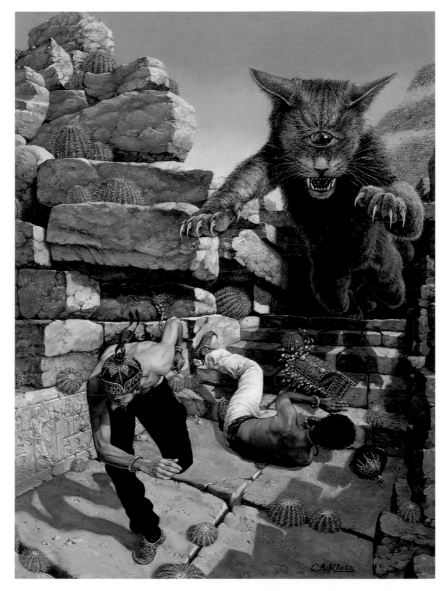

Christopher A. Klein, **Easy Money**, *2008*
oil on panel, 20.5 x 16.5

Representing:
Pavel Amromin
Mary Borgman
Gordon Chandler
Cristina Cordova
Michael Gross
Peter Hayes
Chris Hill
John Jensen
Christopher A. Klein
Cynthia Large
Juan Perdiguero
Jesus Curia Perez
Anne Potter
Jim Rose
John Tuccillo
Jerilyn Virden

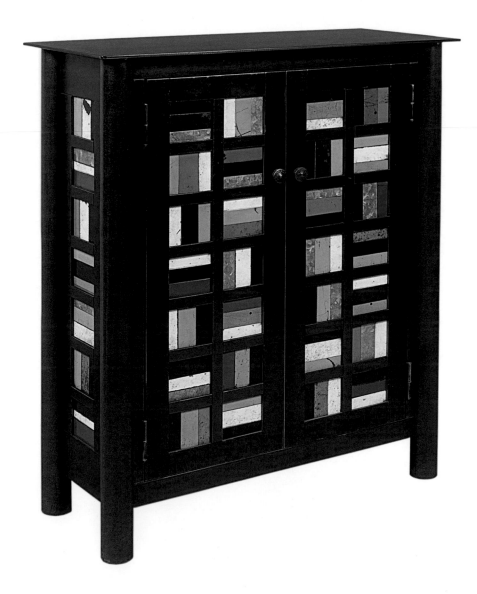

Jim Rose, **Quilt Cupboard (green, blue, black and white),** *2007*
steel, found colored panels, 42.5 x 35 x 14.5

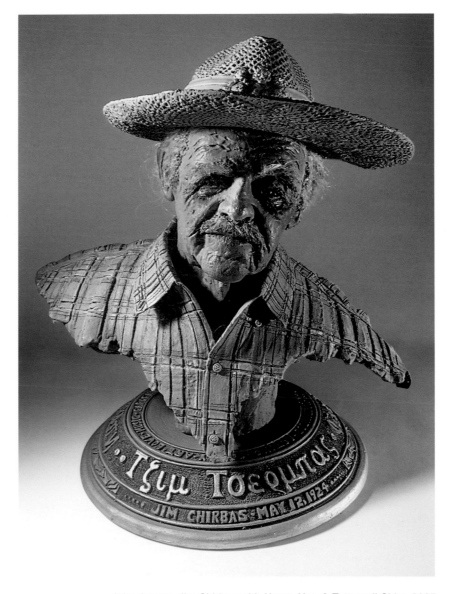

John Jensen, Jim Chirbas with Heart, Hat, & Tattersall Shirt, *2007*
ceramic, mixed media, 21 x 24 x 13

Satoshi Yabuuchi, **Mi K,** *2007*
Japanese cypress, natural pigments, Japanese lacquer, 13.5 x 13.5 x 5.25
photo: Katsura Endo

Art Miya

Contemporary art by Japanese artists
Staff: Madoka Moore; Nobuko Inagaki

2-8-7, 701 Nakameguro
Meguro-ku, Tokyo 153-0061
Japan
voice 81.3.5704.2451
cell 646.596.9085
fax 81.3.5704.3932
sachikotsuchiya@artmiya.com
artmiya.com

Representing:
Karen Kang
Yasuhisa Kohyama
Miyuki Komudo
Mary Stacy Mazzone
Mae Miyake
Wakae Nakamoto
Ushio Shimizu
Dai Takayama
Kazuo Takayama
Kou Takayama
Kazuo Takiguchi
Yoji Toyota
Satoshi Yabuuchi
Yusuke Yamamoto
Kazuya Yoshida

Yoji Toyota, **Information Overflow,** *2007*
wood, 8.5 x 16 x 13
photo: Yoji Toyota

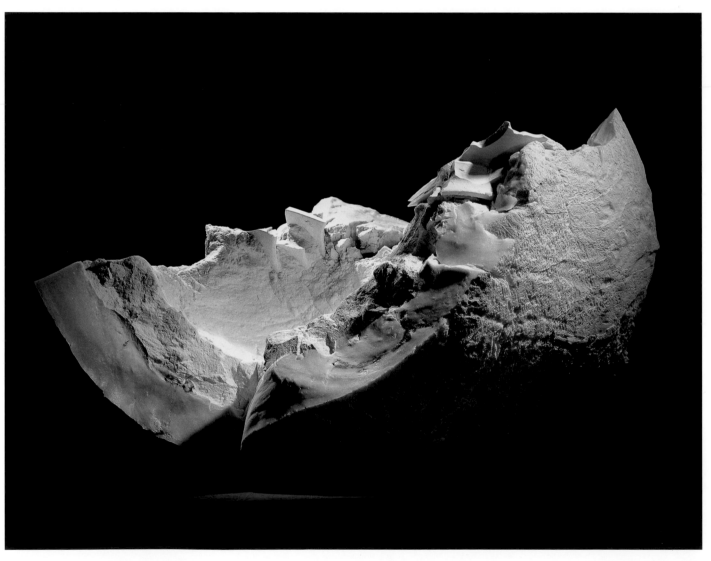

Jun Nishida, **Zetsu,** *2001*
ceramic, 22.75 x 31.5 x 30.5
photo: Seiji Toyonaga

ARTCOURT Gallery - Yagi Art Management, Inc.

Contemporary established and emerging artists in various genres
Staff: Mitsue Yagi, director; Hiroshi Yamaoka; Masako Saimura; Miwa Ohba

Tenmabashi 1-8-5
Kita-ku, Osaka 530-0042
Japan
voice 81.6.6354.5444
fax 81.6.6354.5449
info@artcourtgallery.com
artcourtgallery.com

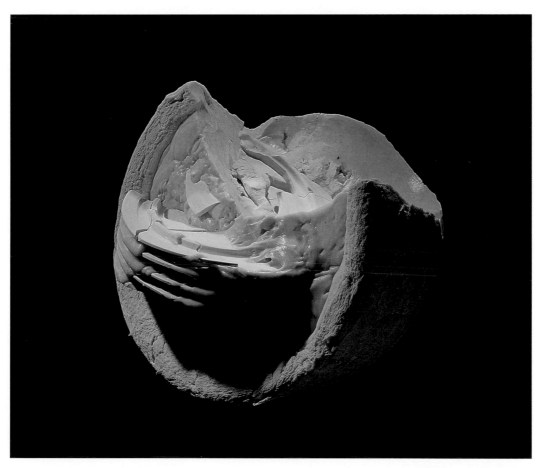

Representing:
Koichi Ishino
Koichi Kurita
Jun Nishida
Kozo Nishino

Jun Nishida, **Zetsu,** *2001*
ceramic, 25.5 x 29.25 x 28
photo: Seiji Toyonaga

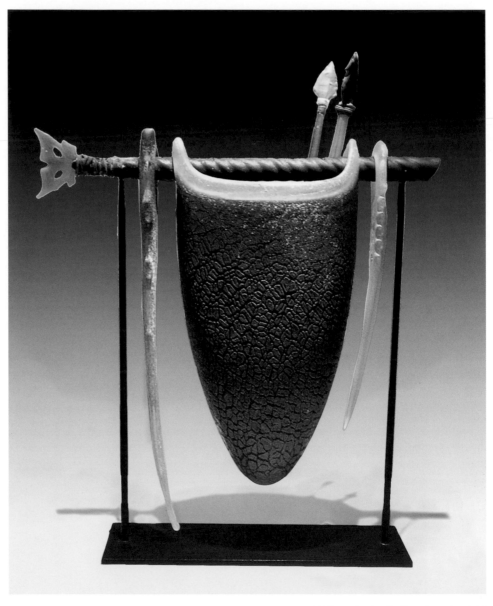

William Morris, **Artifact Pouch,** *1993*
glass, 24 x 20 x 6

Barry Friedman Ltd.

Cutting edge contemporary furniture, objects, photography, and painting;
art and design from European avant-garde movements of the 20th century
Staff: Barry Friedman, owner; Carole Hochman, director; Lisa Jensen; Osvaldo DaSilva; Jessica Nicewarner

515 West 26th Street
New York, NY 10001
voice 212.239.8600
fax 212.239.8670
contact@barryfriedmanltd.com
barryfriedmanltd.com

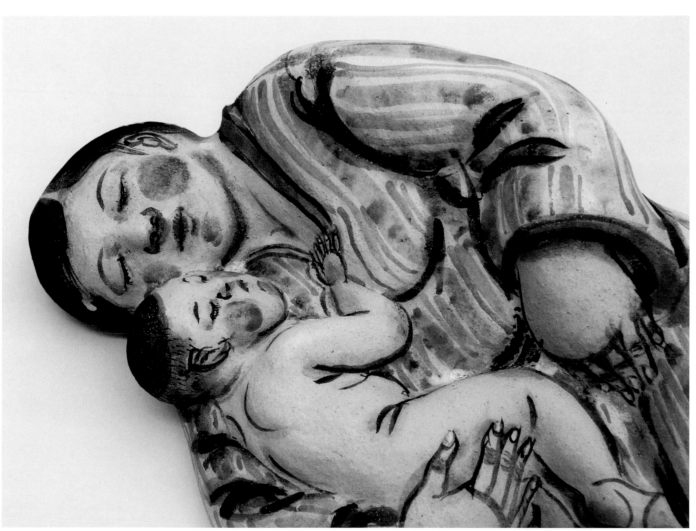

Representing:
Jaroslava Brychtová
Wendell Castle
Laura de Santillana
Ingrid Donat
Michael Glancy
Takahiro Kondo
Stanislav Libenský
Arno Rafael Minkkinen
William Morris
Yoichi Ohira
David Regan
Alev Ebüzziya Siesbye
Beth Cavener Stichter
Akio Takamori
Kukuli Velarde
František Vízner
Hervé Wahlen
Toots Zynsky

Akio Takamori, **Sleeping Mother and Child,** *2007*
stoneware clay, underglaze, 5 x 22 x 9

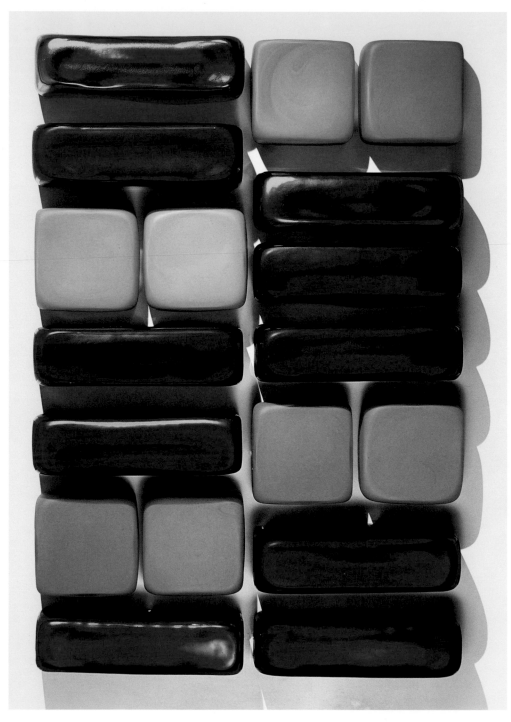

Rene Rietmeyer, **Murano-Venezia,** *2007*
blown and sand-blasted Murano glass, 64 x 36

Berengo Studio

Modern and contemporary glass and glass art
Staff: Adriano Berengo, director; Valter Brunello, sales

Fondamenta Vetrai 109/A
Murano, Venice 30141
Italy
voice 39.041.739.453
cell 646.826.9558
fax 39.041.527.6588
adberen@berengo.com
berengo.com

Berengo Collection
Calle Larga San Marco 412/413
Venice 30124
Italy
voice 39.041.241.0763
fax 39.041.241.9456

Ursula Huber, **Egocenter Installation,** *2007
hand-shaped and sand-blasted Murano glass*

Representing:
Luigi Benzoni
Dusciana Bravura
Marco Bravura
Pino Castagna
Ursula Huber
Rene Rietmeyer
Silvio Vigliaturo

Richard Zane Smith, **Untitled,** *2008*
natural clay, paint made of natural pigments, 10.5 x 14.5

Blue Rain Gallery

Redefining contemporary Native American art
Staff: Leroy Garcia, owner; Peter Stoessel, executive director; Denise Phetteplace, director

130 Lincoln Avenue
Suite D
Santa Fe, NM 87501
voice 505.954.9902
fax 505.954.9904
info@blueraingallery.com
blueraingallery.com

Representing:
Tony Abeyta
Tammy Garcia
Les Namingha
Preston Singletary
Richard Zane Smith

Preston Singletary, **Killer Whale Totem***, 2008*
hand-blown and sand-carved glass, 27 x 11 x 5
photo: Russell Johnson

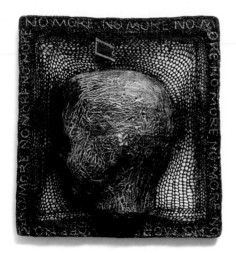
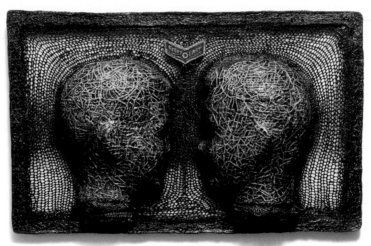
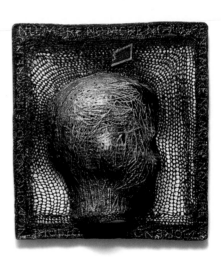

Norma Minkowitz, **Brothers No More,** *2008*
fiber, resin, paint, 14.75 x 53
photo: Tom Grotta

browngrotta arts

Focusing on art textiles and fiber sculpture for more than 20 years
Staff: Rhonda Brown and Tom Grotta, co-curators; Roberta Condos, associate

Wilton, CT
voice 203.834.0623
fax 203.762.5981
art@browngrotta.com
browngrotta.com

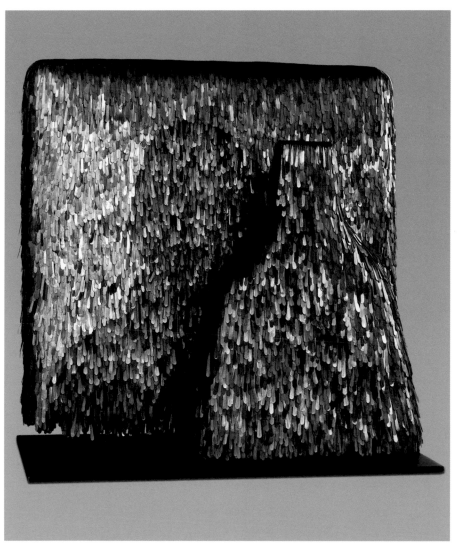

Mary Giles, **Shadow Fragment,** *2007*
waxed linen, copper, iron, 25 x 25 x 7
photo: Tom Grotta

Representing:

Adela Akers
Jeanine Anderson
Dona Anderson
Jane Balsgaard
Jo Barkor
Dorothy Gill Barnes
Caroline Bartlett
Dail Behennah
Nancy Moore Bess
Birgit Birkkjaer
Sara Brennan
Jan Buckman
Pat Campbell
Gali Cnaani-Sherman
Lia Cook
Chris Drury
Lizzie Farey
Ceca Georgieva
Mary Giles
Linda Green
Françoise Grossen
Norie Hatekayama
Ane Henricksen
Maggie Henton
Helena Hernmarck
Sheila Hicks
Marion Hildebrandt
Agneta Hobin
Kazue Honma
Kate Hunt
Kiyomi Iwata
Ritzi Jacobi
Kristín Jónsdóttir

Christine Joy
Glen Kaufman
Ruth Kaufmann
Tamiko Kawata
Anda Klancic
Lewis Knauss
Masakazu Kobayashi
Naomi Kobayashi
Nancy Koenigsberg
Yasuhisa Kohyama
Irina Kolesnikova
Markku Kosonen
Lilla Kulka
Kyoko Kumai
Lawrence Labianca
Gyöngy Laky
Sue Lawty
Åse Ljones
Astrid Løvaas
Dawn MacNutt
Ruth Malinowski
Dani Marti
Mary Merkel-Hess
Norma Minkowitz
Judy Mulford
Keiji Nio
Simone Pheulpin
Valerie Pragnell
Ed Rossbach
Scott Rothstein
Mariette Rousseau-
 Vermette
Axel Russmeyer

Debra Sachs
Heidrun Schimmel
Toshio Sekiji
Hisako Sekijima
Kay Sekimachi
Hiroyuki Shindo
Karyl Sisson
Britt Smelvær
Jin-Sook So
Grethe Sørenson
Ethel Stein
Kari Stiansen
Aleksandra Stoyanov
Noriko Takamiya
Chiyoko Tanaka
Hideho Tanaka
Tsuroko Tanikawa
Blair Tate
Lenore Tawney
Jun Tomita
Deborah Valoma
Claude Vermette
Ulla-Maija Vikman
Kristen Wagle
Wendy Wahl
Lena McGrath Welker
Katherine Westphal
Merja Winqvist
Chang Yeonsoon
Jiro Yonezawa
Masako Yoshida
Shin Young-ok

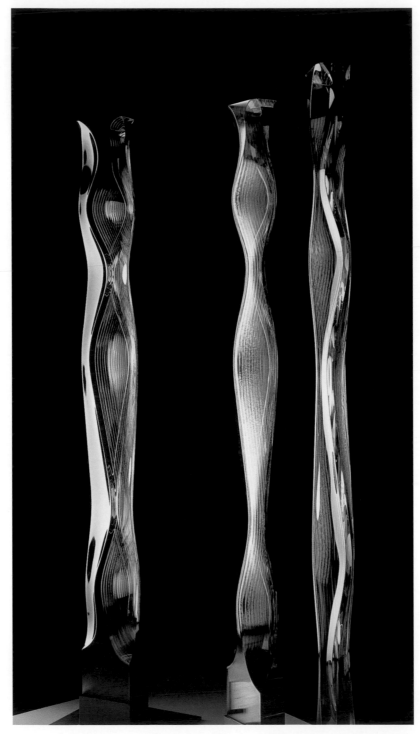

Toshio Iezumi, **M080301**, *2008*
carved laminated plate glass, stainless steel base, 84.5 x 8 x 4.75 each

Chappell Gallery

Contemporary glass sculpture

Staff: Richard L. Chappell, chairman; Alice M. Chappell, director; Kathleen M. Pullan, gallery manager; Carol L. Chappell, direct mail manager

526 West 26th Street
Suite 317
New York, NY 10001
voice 212.414.2673
fax 212.414.2678
amchappell@aol.com
chappellgallery.com

Alex Gabriel Bernstein, **Amber Spring,** *2008*
cast and carved glass, 18.5 x 12.5 x 3.5

Representing:
Mary Ann Babula
Alex Gabriel Bernstein
Emma Camden
Hilary Crawford
Kathleen Holmes
Toshio Iezumi
Kazumi Ikemoto
Matsuo Itchou
Laurie Korowitz-Coutu
Pipaluk Lake
David Murray
Etsuko Nishi
Kait Rhoads
Naomi Shioya
Ethan Stern
Sasha Zhitneva

Annamaria Zanella, **Colana Veneziana** *necklace, 2007*
iron, gold, glass beads

Charon Kransen Arts

Contemporary innovative jewelry from around the world
Staff: Adam Brown; Lisa Granovsky; Charon Kransen

By Appointment Only
456 West 25th Street, Suite 2
New York, NY 10001
voice 212.627.5073
fax 212.633.9026
charon@charonkransenarts.com
charonkransenarts.com

Representing:

Efharis Alepedis
Ralph Bakker
Julia Barello
Rike Bartels
Roseanne Bartley
Nicholas Bastin
Michael Becker
Liv Blavarp
Julie Blyfield
Daniela Boieri
Sophie Bouduban
Frederic Braham
Florian Buddeberg
Shannon Carney
Anton Cepka
Yu Chun Chen
Annemie de Corte
Giovanni Corvaja
Simon Cottrell
Elinor De Spoelberch
Saskia Detering
Dan DiCaprio
Babette von Dohnanyi
Sina Emrich
Peter Frank
Martina Frejd
Claudia Geese
Sophie Hanagarth
Mirjam Hiller
Leonore Hinz
Marian Hosking
Linda Hughes
Meiri Ishida
Reiko Ishiyama

Hiroki Iwata
Hilde Janich
Mette Jensen
Megghan Jones
Machteld van
 Joolingen
Ike Juengar
Junwon Jung
Masumi Kataoka
Susanne Kaube
Martin Kaufmann
Ulla Kaufmann
Jennifer Howard
 Kicinski
Jeong Yoon Kim
Jimin Kim
Yael Krakowski
Gail Leavitt
Dongchun Lee
Felieke van der Leest
Hilde Leiss
Nel Linssen
Susanna Loew
Stefano Marchetti
Vicki Mason
Sharon Massey
Christine Matthias
Rachel McKnight
Bruce Metcalf
Choonsun Moon
Sonia Morel
Evert Nijland
Carla Nuis
Angela O'Kelly
Daniela Osterrieder

Barbara Paganin
Anya Pinchuk
Natalya Pinchuk
Beverley Price
Anthony Roussel
Jackie Ryan
Lucy Sarneel
Yuki Sasaki
Isabell Schaupp
Marjorie Schick
Claude Schmitz
Frederike
 Schuerenkaemper
Karin Seufert
Elena Spano
Betty Stoukides
Dorothee Striffler
Barbara Stutman
Janna Syvanoja
Salima Thakker
Terhi Tolvanen
Henriette Tomasi
Martin Tomasi
Silke Trekel
Catherine Truman
Flora Vagi
Christel Van Der Laan
Julia Walter
Caro Weiss
Francis Willemstijn
Jin-Soon Woo
Jung-Gyu Yi
Annamaria Zanella

Lucy Sarneel, **Brooch,** *2007*
zinc, rough diamonds, paint, silver pin, 4 x 5.25 x .25

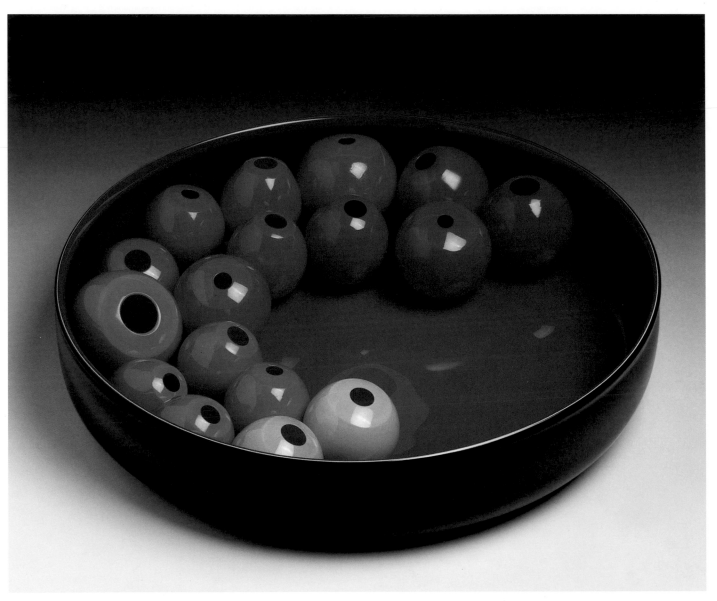

Rachael Woodman, **Red Centre**, *2007*
glass, 2.25 x 12.75 x 12.75

Clare Beck at Adrian Sassoon

Contemporary British studio ceramics, glass, silver and jewelry
Staff: Clare Beck; Adrian Sassoon; Andrew Wicks

By Appointment
14 Rutland Gate
London SW7 1BB
United Kingdom
voice 44.20.7581.9888
fax 44.20.7823.8473
email@adriansassoon.com
adriansassoon.com

Representing:
Tessa Clegg
Angela Jarman
Kate Malone
Junko Mori
Adam Paxon
Bruno Romanelli
Rupert Spira
Hiroshi Suzuki
David Watkins
Rachael Woodman

Junko Mori, **A Silver Organism; Pine,** *2007*
forged Fine silver 999, 3090g, 6.25 x 6.5 x 6.25

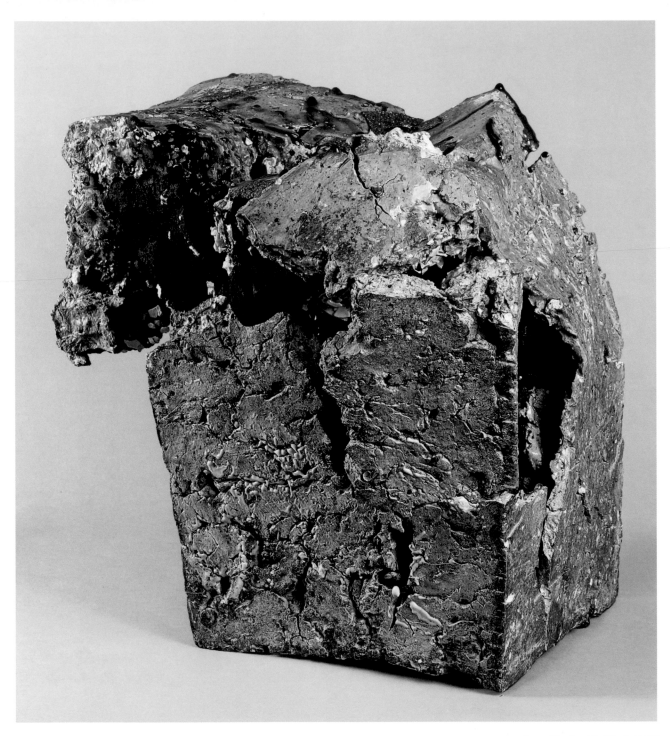

Anne Verdier, **Untitled,** *2007*
stoneware, porcelain, 22.75 x 23.5 x 21.5

Collection Ateliers d'Art de France

Works by contemporary artists in a variety of media
Staff: Anne-Laure Roussille

4 Rue de Thorigny
Paris 75003
France
voice 33.1.4278.6774
fax 33.1.4277.4201
collection@ateliersdart.com
ateliersdart.com

Representing:
Martine Hardy
Armel Hédé
Franck Loret
Gérald Vatrin
Anne Verdier

Gérald Vatrin, **Batracien,** *2007*
blown, enameled and engraved glass, 8.5 x 7.75 x 13.25

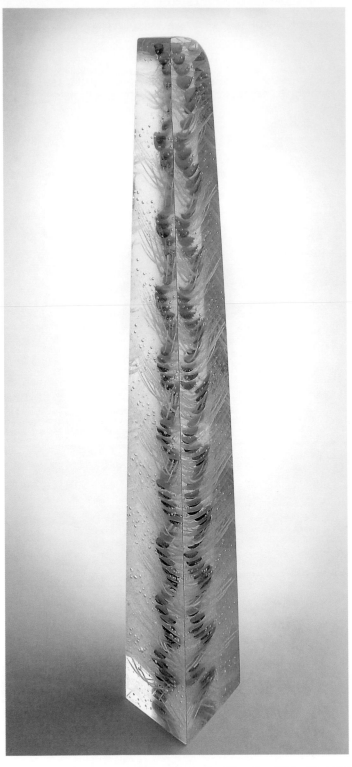

Emma Varga, **One Fine Day-White #4,** *2008*
fused, cast, ground and polished glass, 22.5 x 3.5 x 3

Compendium Gallery

Object and framed art with a particular emphasis on Pacific-inspired work
Staff: Pamela Elliott, director

5 Lorne Street
Auckland 1010
New Zealand
voice 649.300.3212
fax 649.300.3212
sales@compendiumgallery.com
compendiumgallery.com

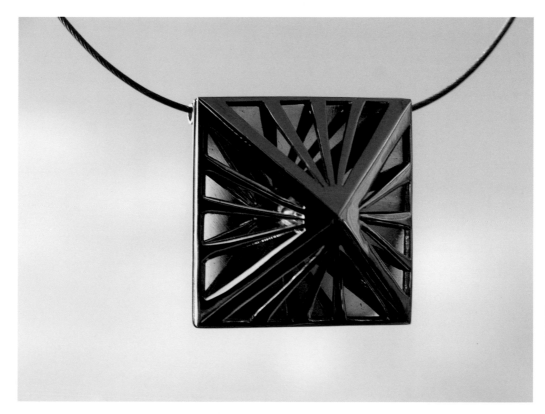

Representing:
Eva Berg
Hans-Leo Peters
Emma Varga

Eva Berg, **Secret of the Light** *pendant, 2008*
gold, silver, stainless steel, reflection, Op Art, 1.25 x 1.25
photo: Hans-Leo Peters

Hans-Leo Peters, **Dream Time,** *2008*
silver, Braille art, stainless steel, 7.5 x 3.75

Hans-Leo Peters, **True Love** *pendant, 2008*
white gold, diamonds, Braille art, 2.25 x .75
photo: Hans-Leo Peters

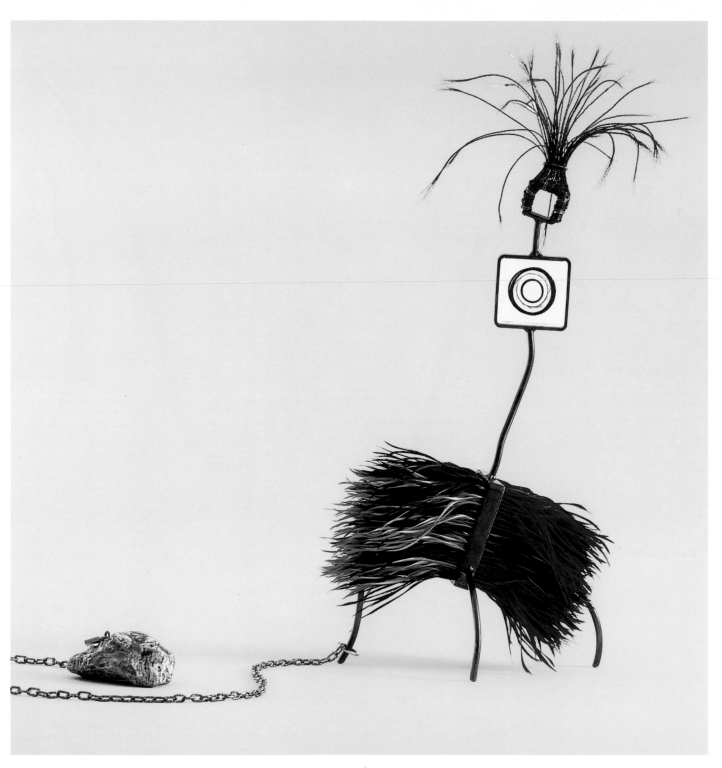

Élyse De Lafontaine, **Jeune déesse hawaïenne amoureuse d'Icare,** *2007*
steel, feathers, horse hair, acrylic, stone, chain, lock, 31 x 18.75 x 11.75

CREA Gallery

Select contemporary fine craft works in a variety of media by emerging, established and internationally recognized Quebec artist who are on the cutting edge of design in their respective fields
Staff: Linda Tremblay; Patricia Gelinas

350 St. Paul East
Montreal, Quebec H2Y 1H2
Canada
voice 514.878.2787, ext. 2
fax 514.861.9191
crea@metiers-d-art.qc.ca
creagallery.com

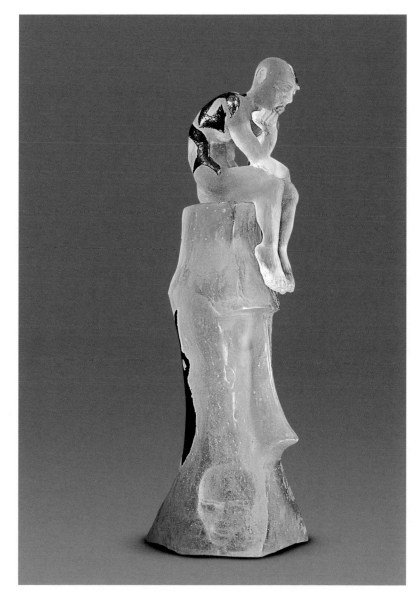

Stephen Pon, **Rapanui,** *2008*
pâte de verre, crystal, 25 x 8 x 9
photo: Fabienne Carbonneau

Representing:
Maude Bussières
Marie-Andrée Côté
Élyse De Lafontaine
Carole Frève
Chantal Gilbert
Catherine Labonté
Antoine Lamarche
Christine Larochelle
Lynn Légaré
Francesc Peich
Stephen Pon
Patrick Primeau
Natasha St. Michael
Luci Veilleux

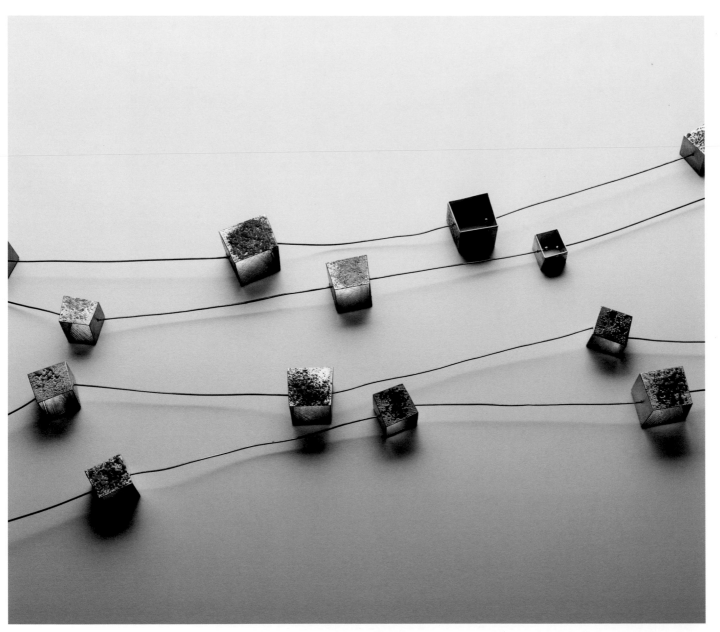

Graziano Visintin, **Necklace**, *2007*
18k yellow and white gold, green enamel, gold leaf

The David Collection

International fine arts with a specialty in contemporary studio jewelry
Staff: Jennifer David, director; Yuki Ishii

44 Black Spring Road
Pound Ridge, NY 10576
voice 914.764.4674
jkdavid@optonline.net
thedavidcollection.com

Representing:
Sara Bacsh
Alexander Blank
Adrean Bloomard
Patrizia Bonati
Jessica Calderwood
Giorgio Chiarcos
Barbara Christie
Georg Dobler
Nina Ehmck
Eva Eisler
Kyoko Fukuchi
Michael Hamma
Yu Hiraishi
Yoko Izawa
Helfried Kodré
Constantinos Kyriacou
Ingrid Larssen
Rita Marcangelo
Jesse Mathes
Suzanne Otwell Negré
Maria Phillips
Alessandra Pizzini
Claudia Rinneberg
Marianne Schliwinski
Carol-lynn Swol
Fabrizio Tridenti
Graziano Visintin
Anoush Waddington
Erich Zimmermann

Helfried Kodré, **Brooch***, 2008*
sterling silver, 18k gold, lapis lazuli, 3 x 2.25

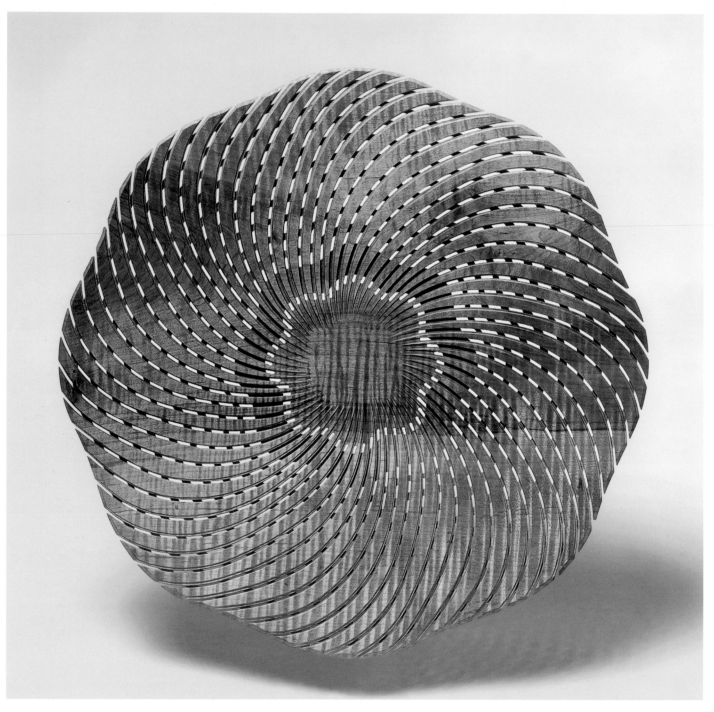

Harvey Fein, **Untitled,** *2008*
maple, 18.25 x 1.75
photo: D. James Dee

del Mano Gallery

Turned and sculptured wood, fiber, teapots and jewelry
Staff: Ray Leier; Jan Peters; Kirsten Muenster; Linda Dzhema; Amanda Bowen

11981 San Vicente Boulevard
Los Angeles, CA 90049
voice 310.476.8508
fax 310.471.0897
gallery@delmano.com
delmano.com

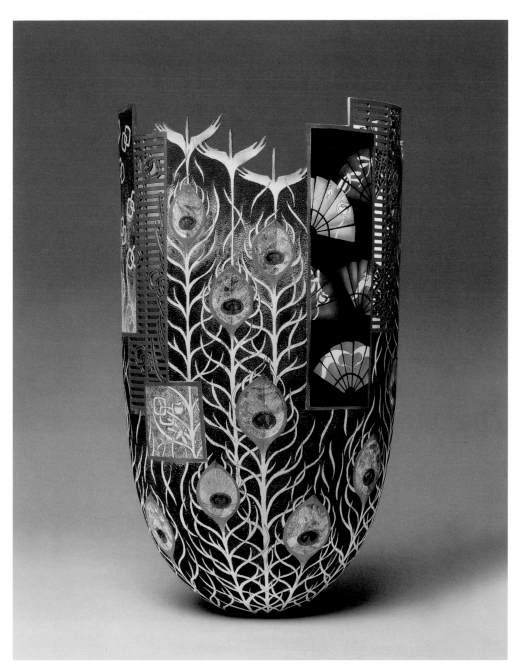

Binh Pho, **Realm of Dream**, 2007
box elder, acrylic paint, metal leaf, 14.5 x 8.5
photo: David Peters

Representing:

Gianfranco Angelino	Milo Mirabelli
Michael Bauermeister	William Moore
Mark Bressler	Matt Moulthrop
Christian Burchard	Philip Moulthrop
Marilyn Campbell	Gordon Pembridge
David Carlin	George Peterson
Robert Cutler	Michael Peterson
J. Kelly Dunn	Binh Pho
David Ellsworth	Larissa Podgoretz
Harvey Fein	Graeme Priddle
J. Paul Fennell	Tania Radda
Ron Fleming	Merryll Saylan
Stephen Hatcher	Peter Schlech
Robyn Horn	Steve Sinner
David Huang	Fraser Smith
William Hunter	Laurie Swim
John Jordan	Neil Turner
Ron Kent	Grant Vaughan
Bud Latven	Jacques Vesery
Ron Layport	Hans Weissflog
Alain Mailland	Jakob Weissflog
Bert Marsh	

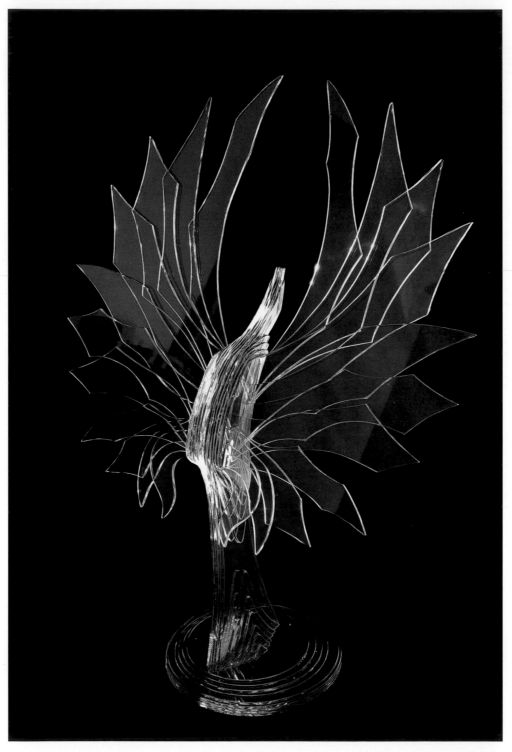

Satoshi Nishizaki, **Phoenix,** *2008*
cut glass, 37 x 28 x 13

DF ART INTERNATIONAL

Contemporary art glass and ceramics
Staff: Kikuko Izumi, owner; Toshinori Izumi, director

1-7-3 Hozumi
Toyonaka, Osaka 561-0856
Japan
voice 81.6.6866.1405
fax 81.6.6866.2104
art@watouki.com
watouki.com

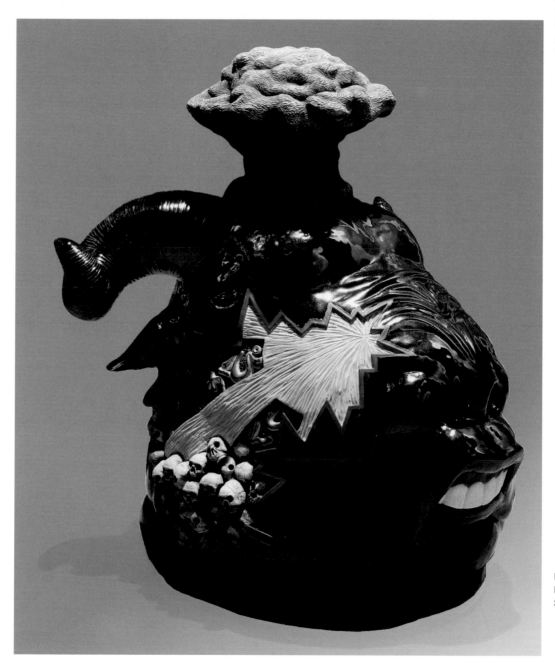

Representing:
Kenjiro Kitade
Satoshi Nishizaki

Kenjiro Kitade, **Pika-Don,** *2008*
white earthenware, glaze and underglaze, 22 x 19 x 19

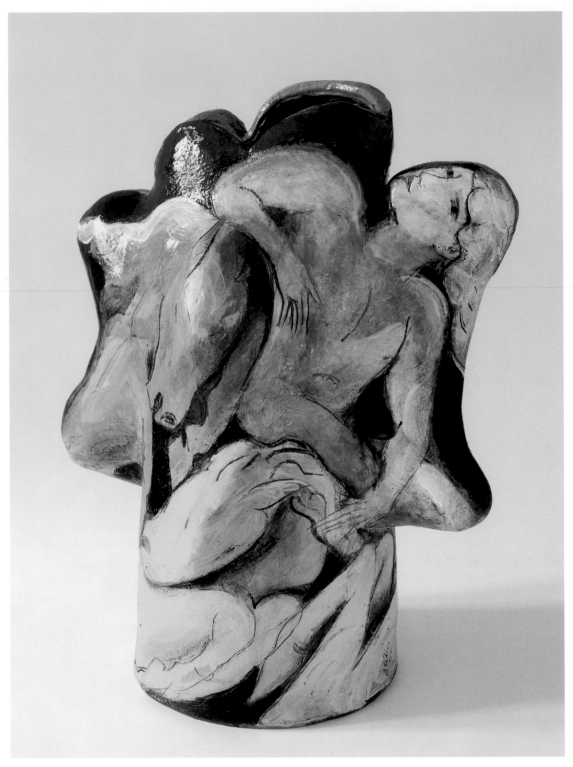

Rudy Autio, **Adorato***, 1983*
glazed ceramic, 34 x 32 x 15.5

Donna Schneier Fine Arts

Modern masters in ceramics, glass, fiber, metal and wood
Staff: Donna Schneier; Leonard Goldberg; Jesse Sadia

By Appointment
PO Box 3209
Palm Beach, FL 33480
voice 561.202.0137
cell 518.441.2884
dnnaschneier@mhcable.com

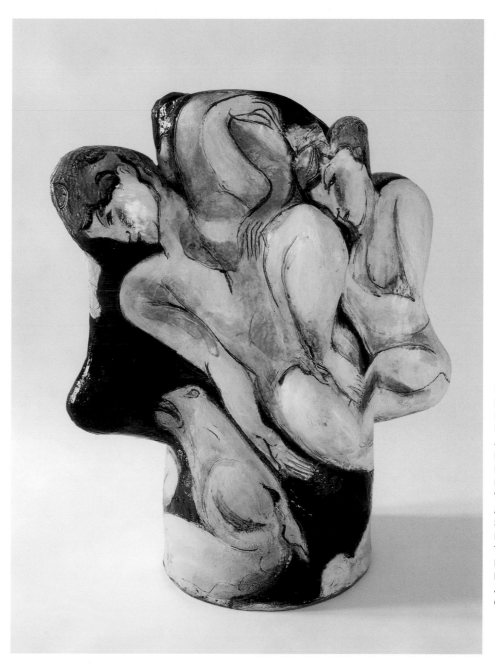

Rudy Autio, **Adorato***, 1983*
glazed ceramic, 34 x 32 x 15.5

Representing:
Rudy Autio
Dale Chihuly
Richard DeVore
Joey Kirkpatrick
Michael Lucero
Flora Mace
Norma Minkowitz
William Morris
Albert Paley
Stephen Powell
Lino Tagliapietra
Toshiko Takaezu
František Vízner
Peter Voulkos
Janusz Walentynowicz
Czeslaw Zuber

Jenny Pohlman and Sabrina Knowles, **Sankofa Bird Pot,** *2008*
blown and sculpted glass, bead adornment, 40 x 14 x 14
photo: Russell Johnson

Duane Reed Gallery

Contemporary painting, sculpture, ceramics, glass, and fiber by internationally recognized artists
Staff: Duane Reed; Merrill Strauss; Gabrielle Naus; Glenn Scrivner

7513 Forsyth Boulevard
St. Louis, MO 63105
voice 314.862.2333
fax 314.862.8557
duane@duanereedgallery.com
duanereedgallery.com

Laurel Lukaszewski, **Balance**, *2008*
stoneware, 56 x 14 x 14

Representing:
Rudy Autio
Sabrina Knowles
Beth Lo
Michael Lucero
Laurel Lukaszewski
Mari Meszaros
Danny Perkins
Jenny Pohlman
Bonnie Seeman

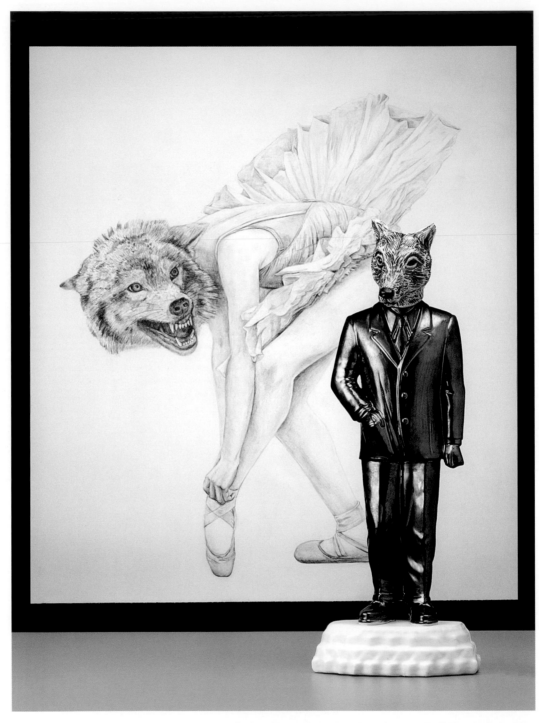

*Cynthia Consentino, **Wolf Ballerina** and **Wolf Man in Suit**, 2008*
pencil on paper; stoneware, glaze, brass, epoxy, 36 x 32; 18.25 x 7 x 4.5
photo: John Polak

Ferrin Gallery

Ceramic art and sculpture from throughout the country and
contemporary art, photography and sculpture by artists from the region
Staff: Leslie Ferrin; Donald Clark; Tracy Eller; Michael McCarthy; Jazu Stine

437 North Street
Pittsfield, MA 01201
voice 413.442.1622
fax 413.634.8811
info@ferringallery.com
ferringallery.com

Representing:
Chris Antemann
Cynthia Consentino
Debra Fritts
Giselle Hicks
Sergei Isupov
Emmett Leader
Maggie Mailer
Richard Notkin
Katy Rush
Mark Shapiro
Mara Superior
Susan Thayer
Jason Walker
Kurt Weiser
Red Weldon-Sandlin

Sergei Isupov, **Prince and the Pauper,** *2008*
porcelain; charcoal on paper, 6 x 4.25 x 3.5
photo: John Polak

Claudi Casanovas working on a Memorial to the Fallen of the Spanish Civil War, 2004
stoneware, mixed clays

Galerie Besson

International contemporary ceramics
Staff: Anita Besson, owner; Matthew Hall; Louisa Anderson

15 Royal Arcade
28 Old Bond Street
London W1S 4SP
United Kingdom
voice 44.20.7491.1706
fax 44.20.7495.3203
enquiries@galeriebesson.co.uk
galeriebesson.co.uk

Representing:
Neil Brownsword
Claudi Casanovas
Hans Coper
Bernard Dejonghe
Yasuhisa Kohyama
Jennifer Lee
Shozo Michikawa
Lucie Rie

Yasuhisa Kohyama, **Sculptural form no. 14 and no. 3,** *2007*
anagama fired stoneware, 10.5 x 9.25 x 4.75; 14 x 13.5 x 5.5
photo: Alan Tabor

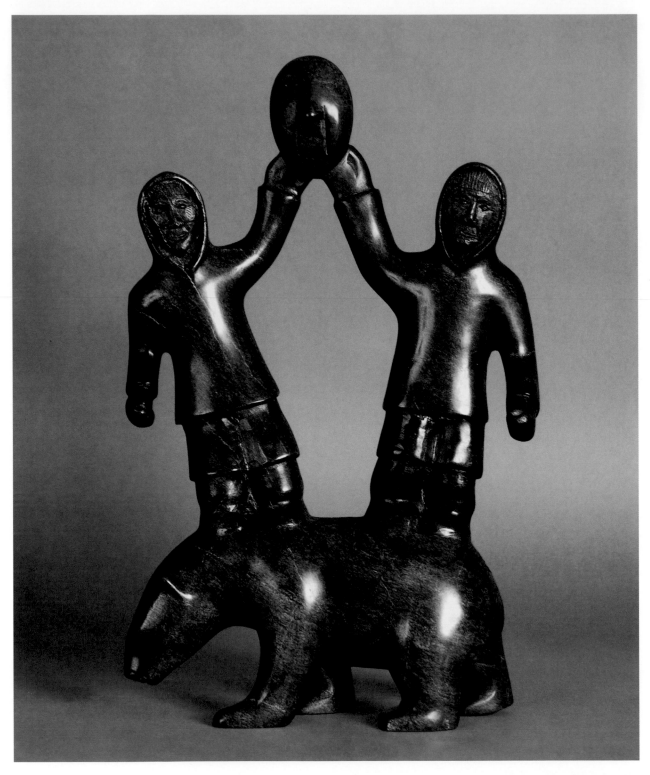

Etidloie Adla, **Shaman,** *2007*
serpentine, 16.5 x 10 x 3.5

Galerie Elca London

Contemporary and historic Inuit artworks in all media
Staff: Mark London, president; Dale Barrett, associate

224 St. Paul Street West
Montreal, Quebec H2Y 1Z9
Canada
voice 514.282.1173
fax 514.282.1229
info@elcalondon.com
elcalondon.com

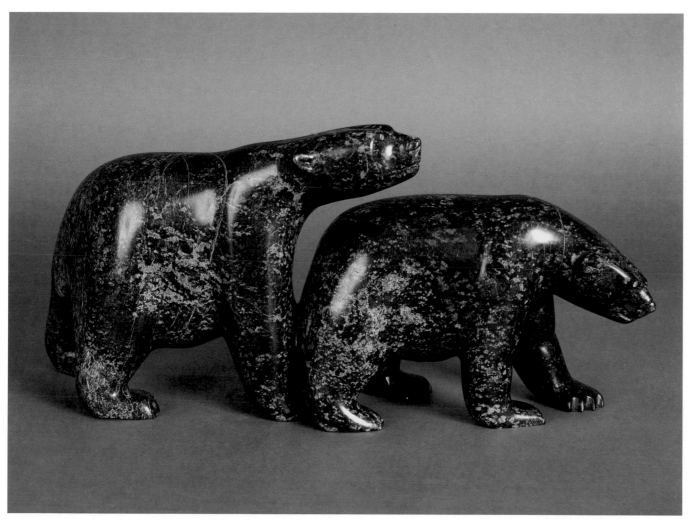

Representing:
Etidloie Adla
Irene Avaalaaqiaq
Taqialuq Nuna
Nuna Parr
David Ruben Piqtoukun
Kananginak Pootoogook
Axangayuk Shaa
Toonoo Sharky
Ashevak Tunnillie
Ovilu Tunnillie

Ashevak Tunnillie, **Polar Bears**
serpentine, 7 x 16 x 5.5

Palolo, **Mimoico,** *2007*
cast iron, terracotta, 50 x 19 x 20

Galerie Vivendi

Established and emerging artists in contemporary art
Staff: Alex Hachem, director

28 Place des Vosges
Paris 75003
France
voice 33.1.4276.9076
fax 33.1.4276.9547
vivendi@vivendi-gallery.com
vivendi-gallery.com

Representing:
Lee Kui Dae
Carlos Cruz-Diez
Philip Letts
Palolo
Jin Park Kwang
Dario Perez-Flores
Robert Silvers
Julien Taylor
Victor Vasarely

Lee Kui Dae, **Mémoires de Voyages,** *2007*
mixed media, 36 x 36

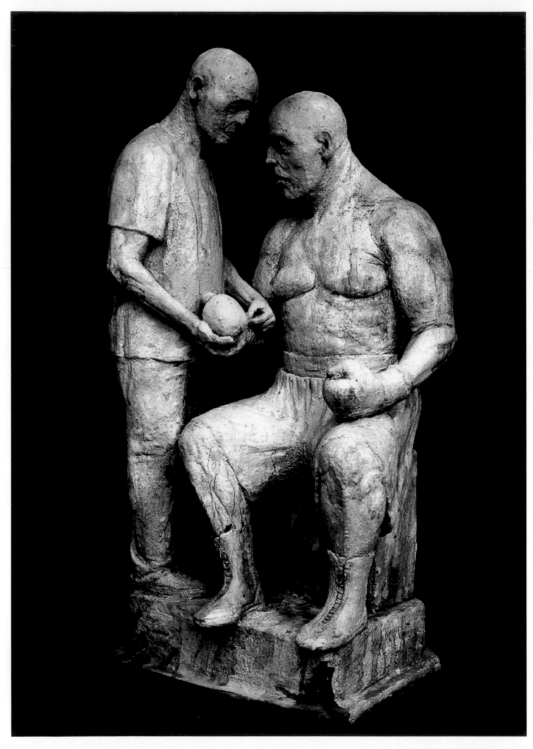

Lars Calmar, **Boxer and Coach,** *2008*
ceramic, 28 inches high
photo: Lars Calmar

Galleri Udengaard

Contemporary fine art
Staff: Lotte Udengaard Dahl; Bruno Udengaard Dahl

Vester Allé 9
Åarhus C, 8000
Denmark
voice 45.86.259.594
udengaard@c.dk
galleriudengaard.com

Representing:
Lars Calmar
Björn Ekegren
Maria Engholm
Keld Moseholm

Keld Moseholm, **Untitled,** *2007*
bronze, 8 inches high
photo: Keld Moseholm

DongHwa Chun, **Cutting,** *2008*
ceramic, 19.75 x 86.5 x 15.75
photo: Jung Man Kim

Gallery 31

Outstanding Korean arts and crafts
Staff: JungKyu Choi; Daniel Choi

31 KwanHoon Dong
JongRo Koo, Seoul
Korea
voice 82.2.732.1290
gallery31korea@yahoo.com

Representing:
Daniel Choi
DongHwa Chun
KilYang Heo

KilYang Heo, **Arahan,** *2007*
gingko woods, 13 x 10.5 x 7.5
photo: Myung Wook Heo

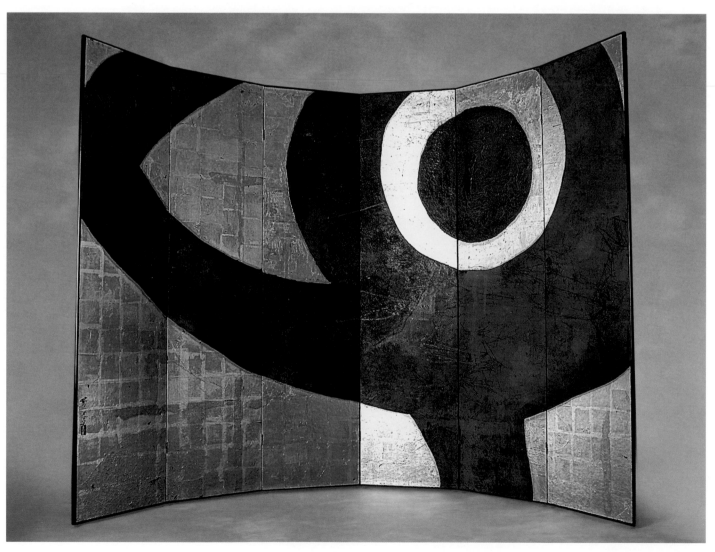

Yoshiaki Yuki, **Nichi-Rin (Revolving Sun),** *2007*
six panel screen, 72 x 108
photo: Tamotsu Kawaguchi

gallery gen

A broad spectrum of contemporary art from Japan
Staff: Shinya Ueda; Masahiko Tasaki; Marybeth Welch

158 Franklin Street
New York, NY 10013
voice 212.226.7717
fax 212.226.3722
info@gallerygen.com
gallerygen.com

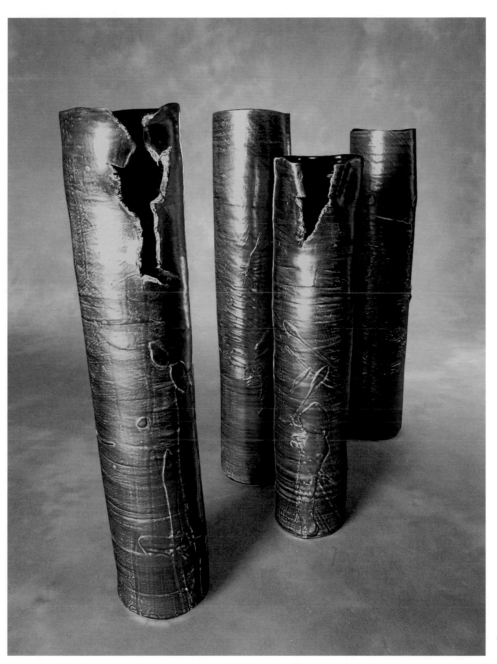

Representing:
Junichi Arai
Yoshiaki Yuki

Yoshiaki Yuki, **Silver Cylinder Vase,** *2007*
ceramic, various sizes
photo: Tamotsu Kawaguchi

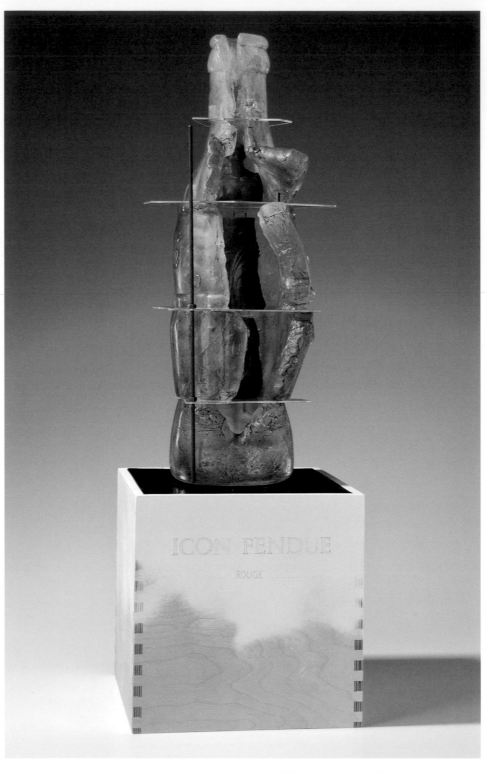

Clifford Rainey, **Icon Fendue (rouge),** *2007*
cast glass, metal, wood, pigment, 36 x 12 x 12
photo: Lee Fatherree

Habatat Galleries Chicago

Internationally recognized gallery specializing in the finest contemporary glass sculpture
Staff: Karen Echt, owner/director; Michael Hofer, manager; Emily Henry, gallery assistant; Karl Nelson, preparator

222 West Superior Street
Chicago, IL 60610
voice 312.440.0288
fax 312.440.0207
info@habatatchicago.com
habatatchicago.com

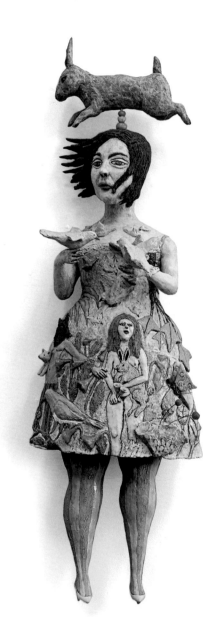

Representing:
Oben Abright
Martin Blank
Daniel Clayman
Pearl Dick
Matt Eskuche
David Fox
Gregory Grenon
Shayna Leib
Clifford Rainey
Kathy Ruttenberg

Kathy Ruttenberg, **What Really Happened,** *2007*
ceramic, 43 x 11 x 9
photo: Fionn Reilly

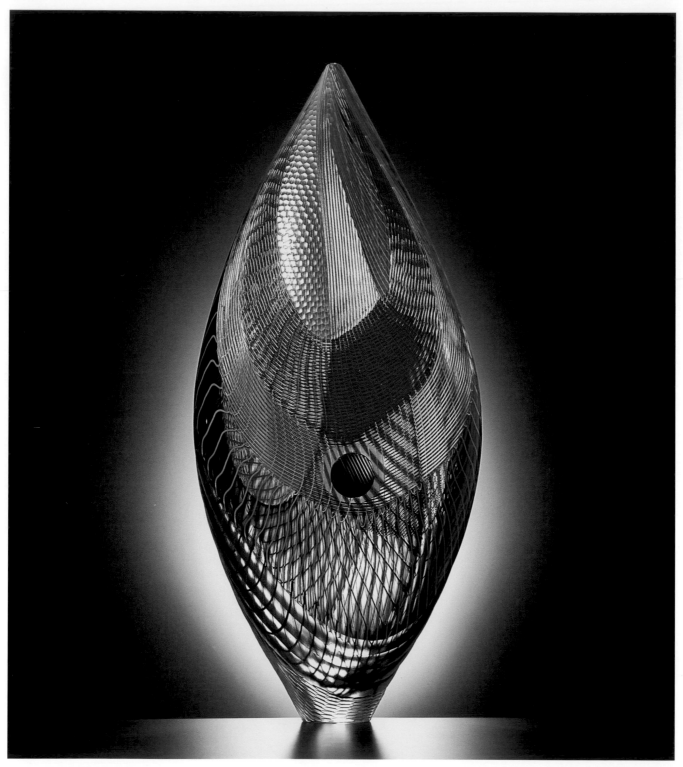

Lino Tagliapietra, **Makah,** *2008*
glass, 27 x 11.75 x 6.75
photo: Russell Johnson

Heller Gallery

Exhibiting sculpture using glass as a fine art medium since 1973
Staff: Douglas Heller; Katya Heller; Michael Heller

420 West 14th Street
New York, NY 10014
voice 212.414.4014
fax 212.414.2636
info@hellergallery.com
hellergallery.com

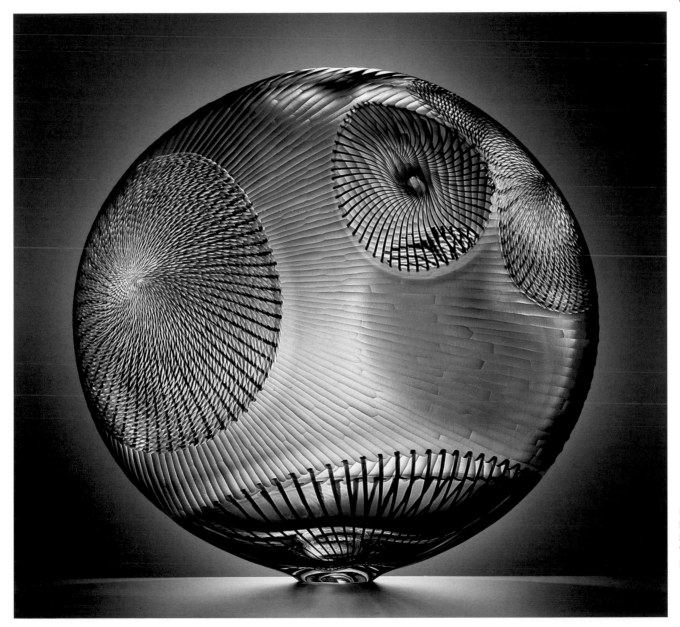

Representing:
Nicole Chesney
Steffen Dam
Tobias Møhl
Lino Tagliapietra

Lino Tagliapietra, **Medusa**, *2007*
glass, 17.75 x 18.5 x 7.25
photo: Russell Johnson

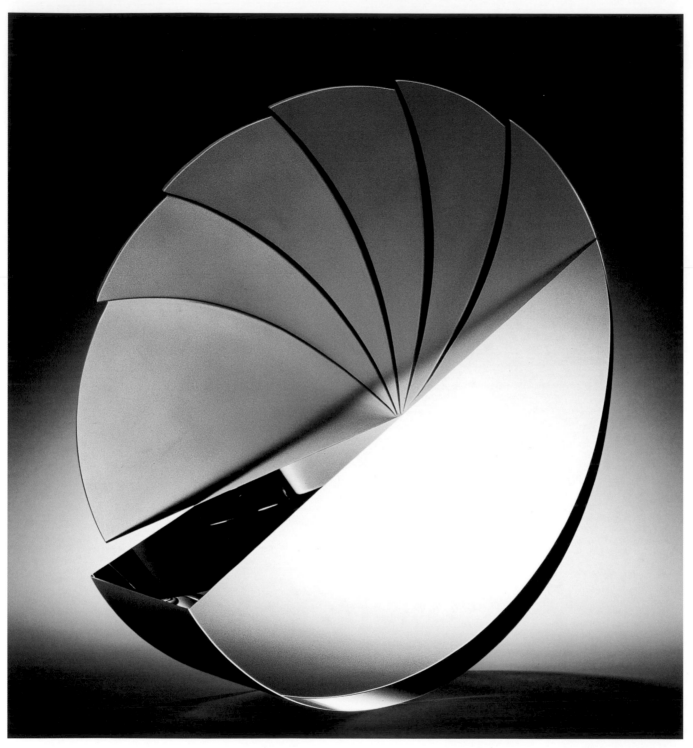

Martin Rosol, **Iris***, 2007*
glass, 19 x 18.5 x 5.5
photo: David Stansbury

Holsten Galleries

Contemporary glass sculpture and installations by internationally prominent artists
Staff: Kenn Holsten, owner/director; Jim Schantz, art director; Mary Childs, co-director; Stanley Wooley, associate

3 Elm Street
Stockbridge, MA 01262
voice 413.298.3044
artglass@holstengalleries.com
holstengalleries.com

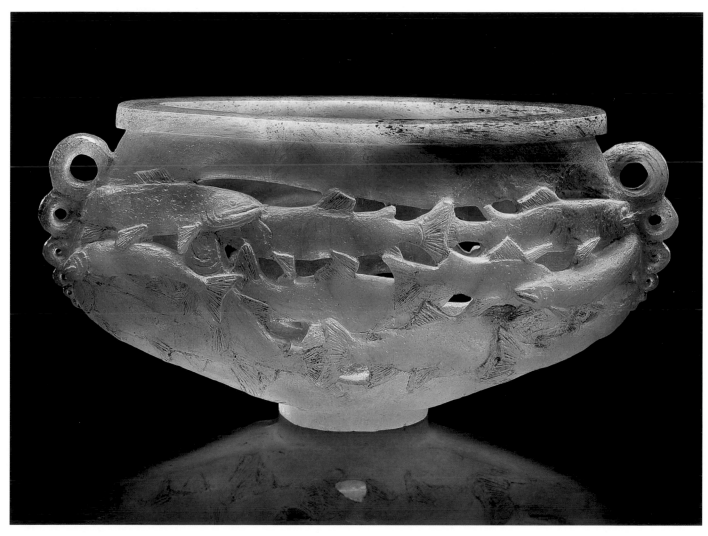

Representing:
Charles Miner
Martin Rosol

Charles Miner, **Gila Trout***, 2008*
glass, 10.5 x 22 x 4.5
photo: Wendy McEahern

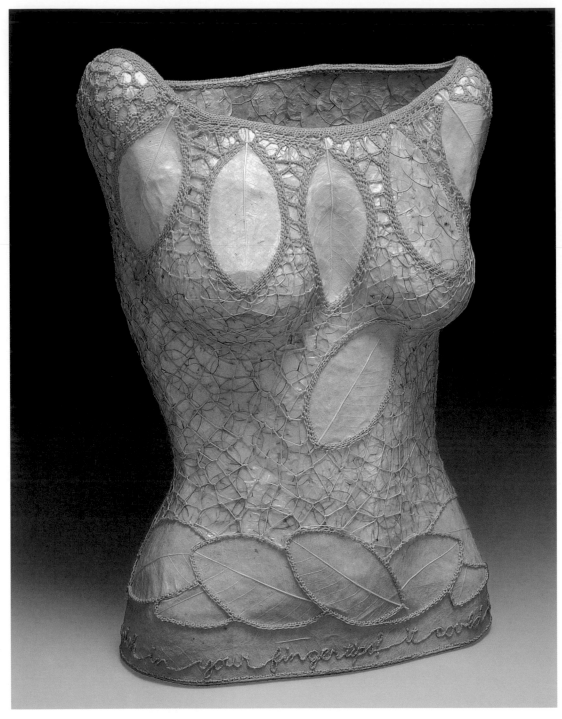

Jan Hopkins, **Fade to Light***, 2008*
silver dollar pod centers, skeleton leaves, yellow cedar bark, waxed linen, 19.5 x 14 x 9
photo: Ken Rowe

Jane Sauer Gallery

Innovative work by internationally recognized artists in a variety of media
Staff: Jane Sauer, owner/director; Glynn Anderson; Carie Bowers; Jorden Nye; Rachel Simonson

652 Canyon Road
Santa Fe, NM 87501
voice 505.995.8513
fax 505.995.8507
jsauer@jsauergallery.com
jsauergallery.com

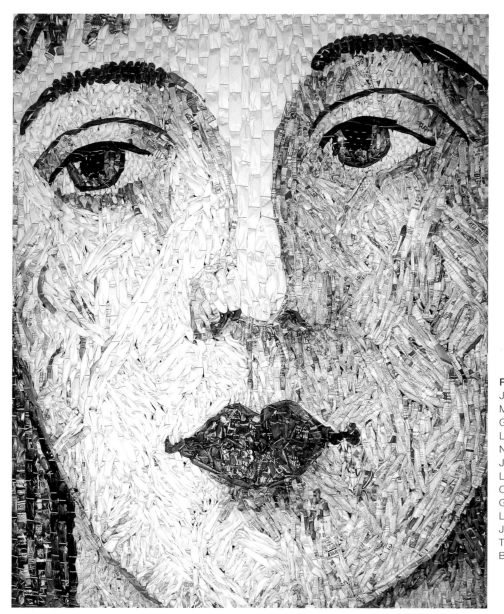

Gugger Petter, Female Head Madonna #6, *2008*
woven newspaper, hemp, 72 x 59

Representing:
James Bassler
Michael Bergt
Giles Bettison
Latchezar Boyadjiev
Noel Hart
Jan Hopkins
Lissa Hunter
Charla Khanna
Gugger Petter
Lesley Richmond
Jon Eric Riis
Tim Tate
Brent Kee Young

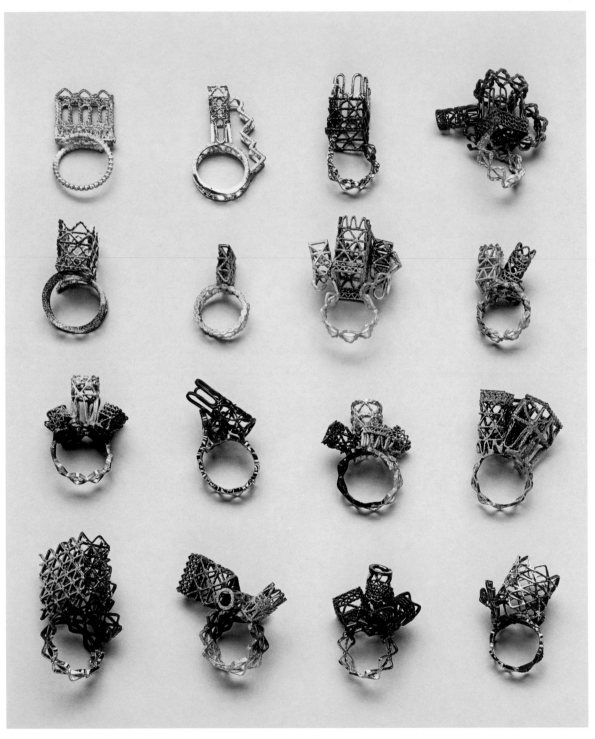

Robert Baines, GOLD RINGS make a very sweet tune, *2008*
silver, gold plate, powder coat, paint

Jewelers' Werk Galerie

Innovative jewelry by international artists
Staff: Ellen Reiben, director

3319 Cady's Alley NW
Washington, DC 20007
voice 202.337.3319
fax 202.337.3318
ellen@jewelerswerk.com
jewelerswerk.com

Representing:
Robert Baines
Iris Bodemer
Bettina Dittlmann
Karl Fritsch
Inkyoung Hwang
Michael Jank
Svenja John
Hermann Jünger
David Neale
Shari Pierce
Karen Pontoppidan
Axel Russmeyer
Vera Siemund
Peter Skubic

Karl Fritsch, **Ring***, 2007*
silver, diamond, crystal, sapphire, zirkon

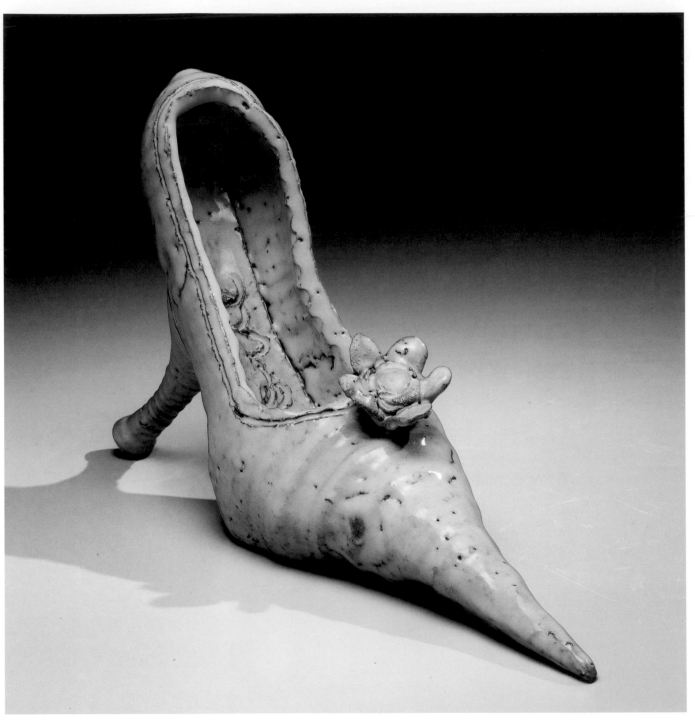

Miwa Ryôsaku, **Ai no tame ni (For Love)**, *1966*
Hagi-glazed stoneware, 7.75 x 11.5 x 3.25
photo: Richard Goodbody

Joan B. Mirviss LTD

Fine modern and contemporary Japanese ceramics
Staff: Joan B. Mirviss, president; Laura Mueller, gallery director; Rie Homura, researcher; Sarah Coulter, gallery administrator

39 East 78th Street
4th floor
New York, NY 10075
voice 212.799.4021
fax 212.721.5148
joan@mirviss.com
mirviss.com

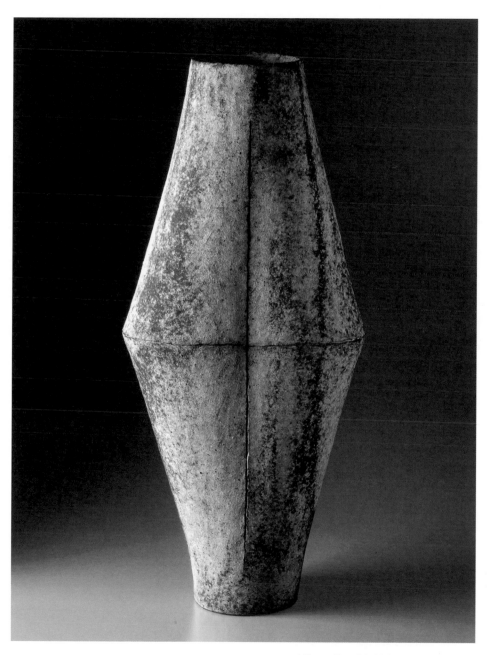

Representing:
Akiyama Yô
Fukami Sueharu
Fukumoto Fuku
Futamura Yoshimi
Hamada Shôji
Hoshino Kayoko
Kakurezaki Ryûichi
Kaneta Masanao
Katsumata Chieko
Kishi Eiko
Koike Shoko
Kondo Takahiro
Mihara Ken
Mishima Kimiyo
Miwa Kazuhiko
Miwa Ryôsaku
Miyashita Zenji
Morino Taimei
Ogata Kamio
Ogawa Machiko
Sakiyama Takayuki
Sakurai Yasuko
Suzuki Goro
Takegoshi Jun
Wada Morihiro

Mihara Ken, **Multi-fired Vessel,** *2007*
stoneware with natural ash glaze, 25 x 11 x 7
photo: Kobayashi Tsunehiro

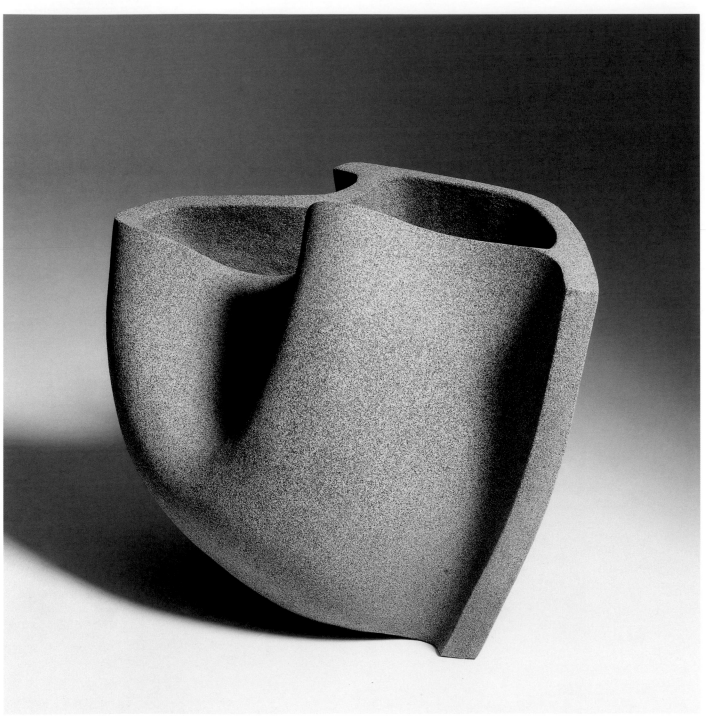

Fernando Casasempere, **Wall Series,** *2007*
stoneware with industrial waste, 25.5 x 33 x 22.5
photo: Michael Harvey

Joanna Bird Pottery

Sculptural and vessel works in clay by leading international studio artists; also works by historic pioneers in the field
Staff: Joanna Bird, owner; George Bird, assistant

By Appointment
19 Grove Park Terrace, Chiswick
London W4 3QE
United Kingdom
voice 44.20.8995.9960
fax 44.20.8742.7752
joanna@joannabirdpottery.com
joannabirdpottery.com

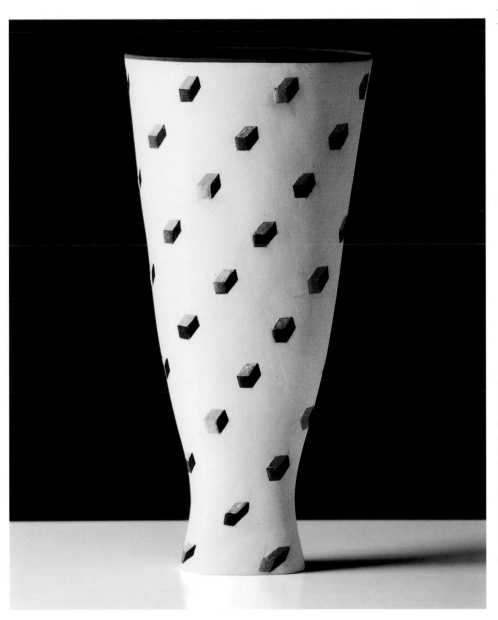

Representing:
Helen Beard
Michael Cardew
Fernando Casasempere
Carina Ciscato
Joanna Constantinidis
Hans Coper
Natasha Daintry
Elizabeth Fritsch
Shôji Hamada
Bernard Leach
Lucie Rie
Suleyman Saba
Tatsuzo Shimaoka
Annie Turner

Elizabeth Fritsch, **Optical Vase,** *2007*
hand-built stoneware, applied colored slips, 11.5 x 5.5 x 2
photo: Alexander Brattell

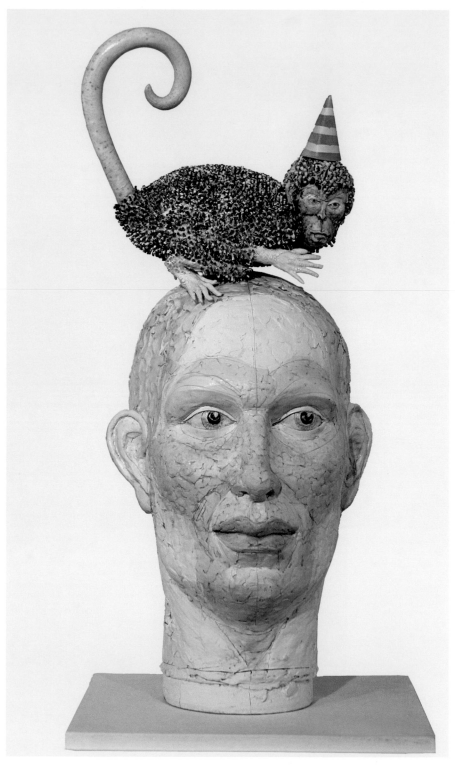

Lisa Clague, **Vanquished,** *2007*
clay, metal, 26 x 16 x 14
photo: Michael Trask

John Natsoulas Gallery

California figurative ceramics
Staff: John Natsoulas, owner/curator; Stephen Rosenzweig, marketing director; Nancy Resler, director

521 First Street
Davis, CA 95616
voice 530.756.3938
art@natsoulas.com
natsoulas.com

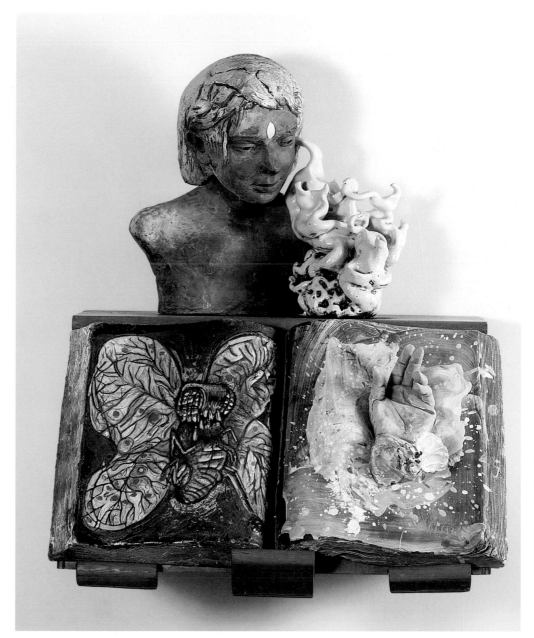

Representing:
Wesley Anderegg
Robert Arneson
Stephen Braun
Lisa Clague
Arthur Gonzalez
Richard Shaw
Esther Shimazu
Barbara Spring
Yoshio Taylor

Arthur Gonzalez, **Book of Whispers,** *2003*
ceramic, wood, 36 x 21 x 20
photo: Michael Trask

Ueda Kyoko, **Her Life,** *2008*
silk, hand-dyed with red iron oxide, 40 x 38 x 1.5
photo: Kobayashi Yu

KEIKO Gallery

Contemporary Japanese arts and crafts
Staff: Keiko Fukai, director

121 Charles Street
Boston, MA 02114
voice 617.725.2888
fax 617.725.2888
keiko.fukai@verizon.net
keikogallery.com

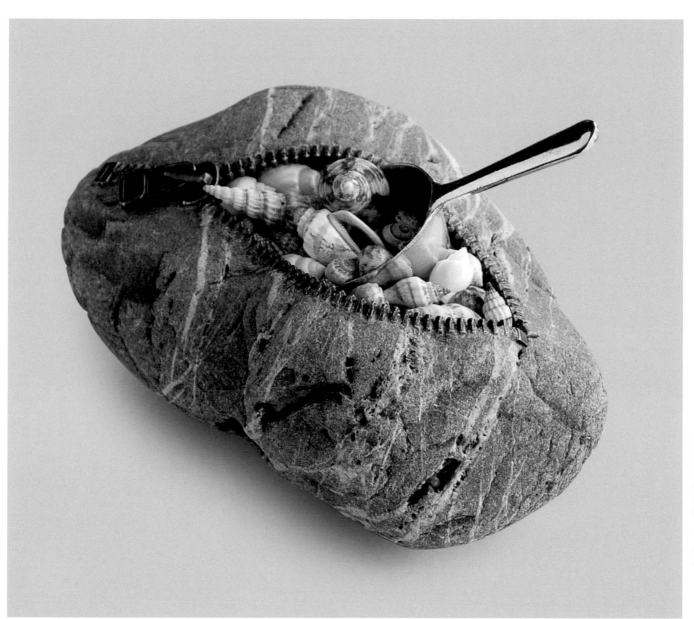

Representing:
Hoshi Mitsue
Ito Hirotoshi
Nishimura Yuko
Sakamoto Madoka
Sakamoto Rie
Shinohara Nanae
Takeda Asayo
Tanaka Kazuhiko
Ueda Kyoko
Yamanaka Kazuko

Ito Hirotoshi, **Memory of an Ocean,** *2008*
rock, metal, shell

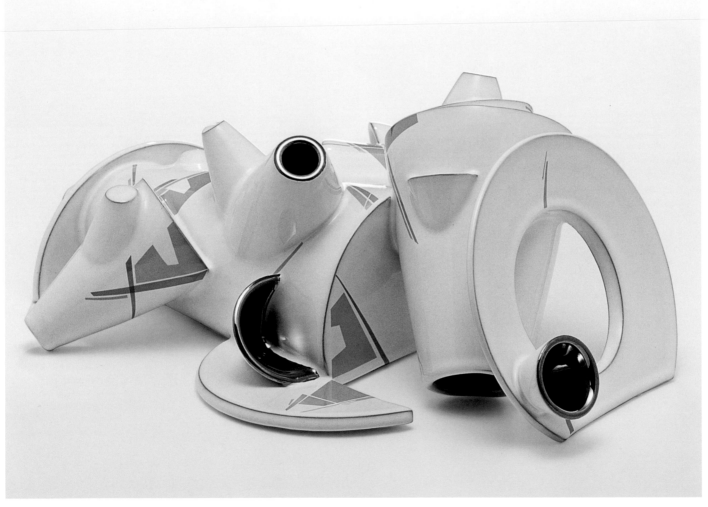

Michael Geertsen, **Wall Object,** *2007*
earthenware with decals and platinum, 7 x 10 x 15.5
photo: Søren Nielsen

Køppe Gallery - contemporary objects

Danish contemporary objects
Staff: Bettina Køppe, director; Helle Elgaard, assistant

Bredgade 66
Copenhagen K, 1260
Denmark
voice 45.3333.0087
info@koppegallery.com
koppegallery.com

Representing:
Michael Geertsen
Castello Hansen
Louise Hindsgavl
Steen Ipsen
Bodil Manz
Stig Persson
Anders Ruhwald
Mette Saabye
Bente Skjøttgaard
Grethe Wittrock

Bodil Manz, **Composition***, 2007*
porcelain, 3, 6, and 4.5 inches high
photo: Søren Nielsen

Barbro Åberg, **Momentum,** *2007*
clay, terra sigillata with black stain and rutile, 17.25 x 26.5 x 9.75
photo: Lars Henrik Mardahl

Lacoste Gallery

Contemporary ceramics: vessel and sculpture
Staff: Lucy Lacoste; Linda Lofaro; Alinda Zawierucha

25 Main Street
Concord, MA 01742
voice 978.369.0278
fax 978.369.3375
info@lacostegallery.com
lacostegallery.com

Representing:
Barbro Åberg
Ruth Borgenicht
Anne Currier
Morten Løbner Espersen
Chris Gustin
Margaret Keelan
Warren MacKenzie
Malene Müllertz
Don Reitz
Tim Rowan
Alev Ebüzziya Siesbye

Anne Currier, **Lockport,** *2008*
glazed ceramic, 11 x 17.5 x 11

107

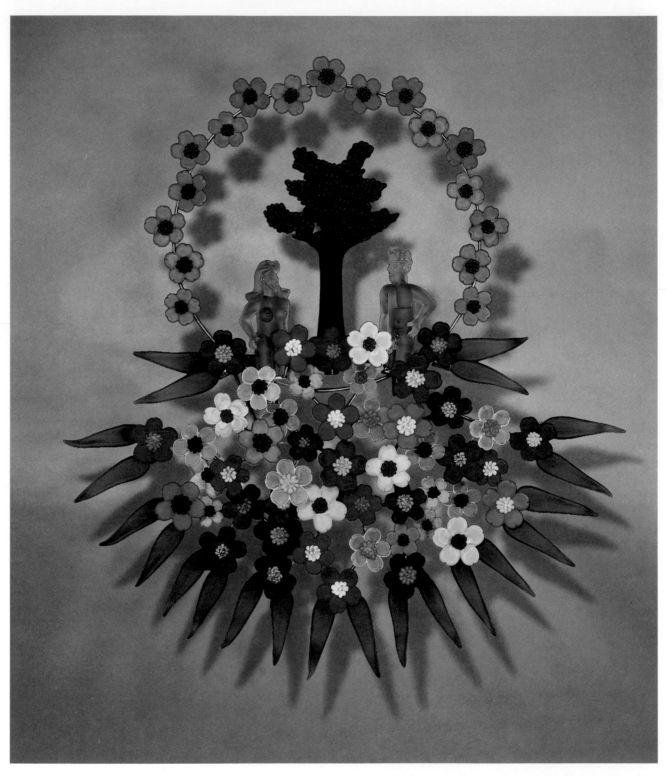

Richard Jolley, **Garden #10,** *2007*
glass, metal, 57 x 53 x 14

Leo Kaplan Modern

Representing established artists in contemporary glass sculpture and studio art furniture
Staff: Scott Jacobson; Terry Davidson; Eric Troolin

41 East 57th Street
7th floor
New York, NY 10022
voice 212.872.1616
fax 212.872.1617
lkm@lkmodern.com
lkmodern.com

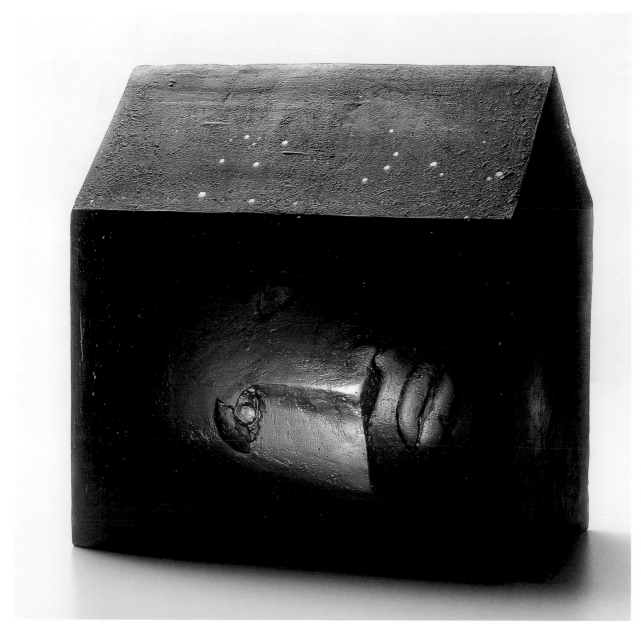

Representing:
Garry Knox Bennett
Greg Bloomfield
Yves Boucard
William Carlson
José Chardiet
Scott Chaseling
KéKé Cribbs
Dan Dailey
David Huchthausen
Richard Jolley
John Lewis
Tom Loeser
Linda MacNeil
Seth Randal
Paul Seide
Tommy Simpson
Jay Stanger
Michael Taylor
Gianni Toso
Steven Weinberg
Ann Wolff
Loretta Yang
Jirina Zertova

Ann Wolff, **Domus**, *2007*
cast glass, 14.5 x 14 x 9

Shin Sang Ho, **Fired Painting**, *2006*
glazed ceramic, 79 x 98.75

Loveed Fine Arts

Contemporary ceramics, glass, modern and contemporary art
Staff: Edward R. Roberts, chairman; Daniel Hamparsumyan, Ronald A. Kuchta, Nancy C. Roberts, directors; Cindi Levy, manager

575 Madison Avenue
Suite 1006
New York, NY 10022
voice 212.605.0591
fax 212.605.0592
loveedfinearts@earthlink.net
loveedfinearts.com

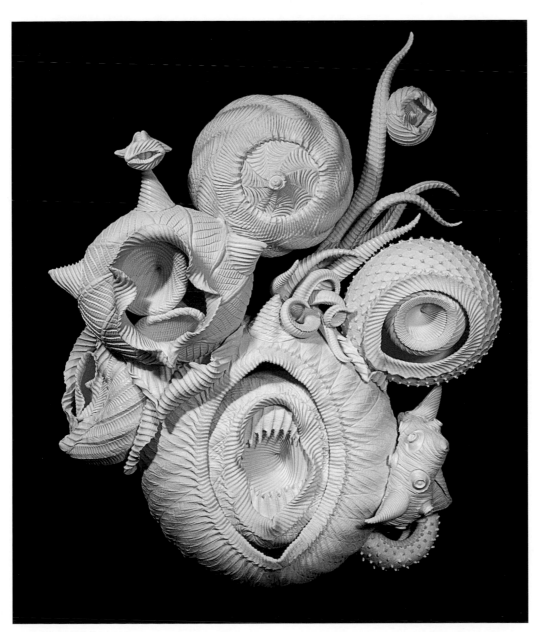

Charles Birnbaum, **Floating Wall Piece #2**, *2007*
porcelain, 22.5 x 16.75 x 8.75

Representing:

Beril Anilanmert	Ole Lislerud
Rudy Autio	Nancy Lovendahl
Gordon Baldwin	Louis Mendez
Charles Birnbaum	Jeffrey Mongrain
Thom Bohnert	Steven Montgomery
Regis Brodie	Sylvia Nagy
Christie Brown	Otto Natzler
Veronica Juyoun Byun	Gilda Oliver
Peter Callas	Alena Ort
Mary Carroll	Maria Rudavska
Nino Caruso	Shin Sang Ho
Paul Chaleff	Robert Sperry
Anne Currier	Victor Spinski
Gary Erickson	Dong Hee Suh
Tom Folino	Neil Tetkowski
Marian Heyerdahl	Xavier Toubes
Barry Hood	Rouska Valkova
Margie Hughto	Marja Vallila
Jong Sook Kang	Grace Bakst Wapner
Yih-Wen Kuo	Patti Warashina
Pat Lay	Betty Woodman
Marc Leuthold	Yiannes

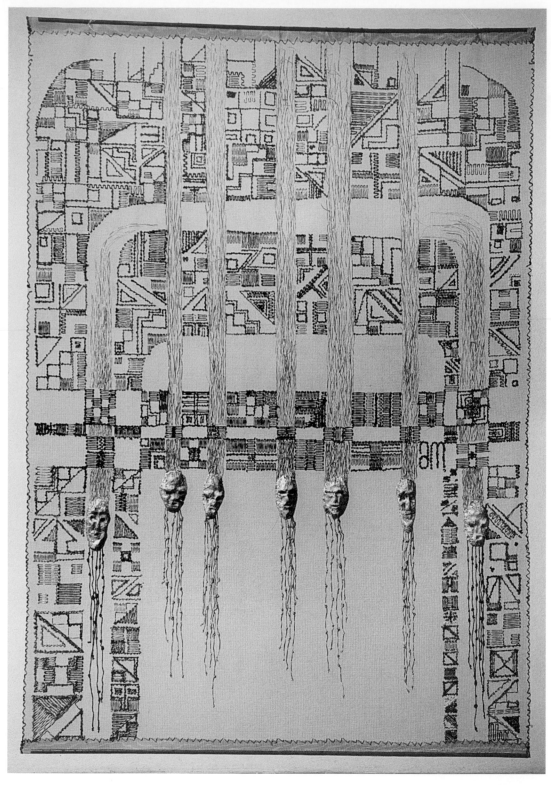

Ana Mazzoni, **Booty Heads II**
hand-embroidered silk on transparent canvas, 60 x 40

Maria Elena Kravetz

Contemporary art with an emphasis in Latin American expressions
Staff: María Elena Kravetz, director; Raúl Nisman; Matías Alvarez, assistant

San Jerónimo 448
Córdoba X5000AGJ
Argentina
voioo 54.351.422.1290
mek@mariaelenakravetzgallery.com
mariaelenakravetzgallery.com

Representing:
Silvina Bottaro
Gloria Corbetta
Karina Delsavio
Lea Dolinsky
Carolina Dutari
Ariane Garnier
Elizabeth Gavotti
Sol Halabi
Ana Mazzoni
María Ester Pañeda
Feyona Van Stom
María Inés Varela

Elizabeth Gavotti, **Girl Standing with a Green Towel**
bronze, 32 x 11 x 5.25

Lea Dolinsky, **Image of an Artist**, *2000*
hand-made white clay, 13 inches high
photo: Boris Dikerman

María Inés Varela, **The Colorina***, 2007*
stoneware with glaze and engobe, 12 inches high

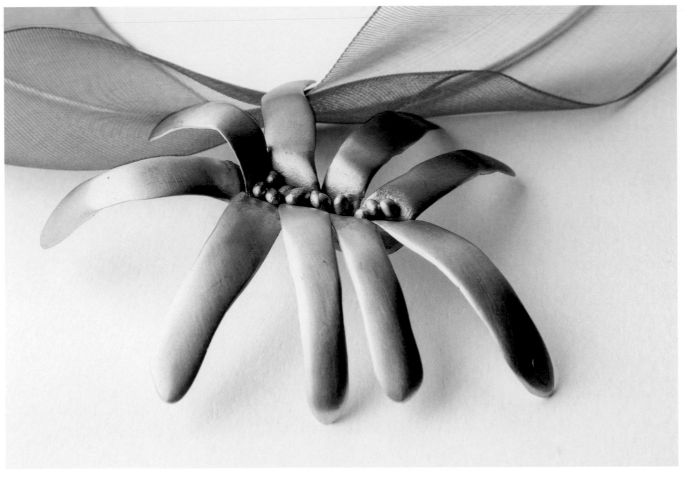

Carolina Dutari, **Margarita Spider** *pendant, 2006*
fine silver, 2 x 2

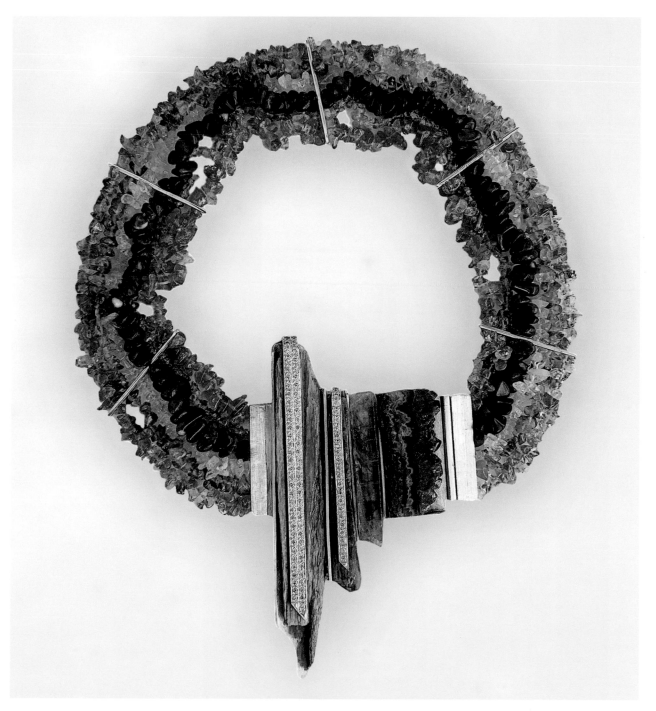

Gloria Corbetta, **Spring Flowers** *necklace, 2006*
silver, synthetic diamonds, green and blue amethysts and cyanites, 5.75 inches diameter

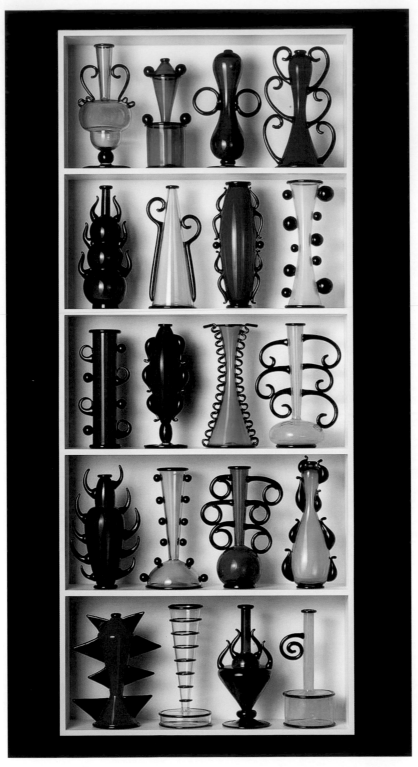

Dante Marioni, **Colored Vessel Display,** *2007*
blown glass, 45 x 19 x 5

Marx-Saunders Gallery LTD

Representing the most innovative artists working with glass in the world
Staff: Bonnie Marx; Ken Saunders; Donna Davies, director

230 West Superior Street
Chicago, IL 60610
voice 312.573.1400
fax 312.573.0575
marxsaunders@earthlink.net
marxsaunders.com

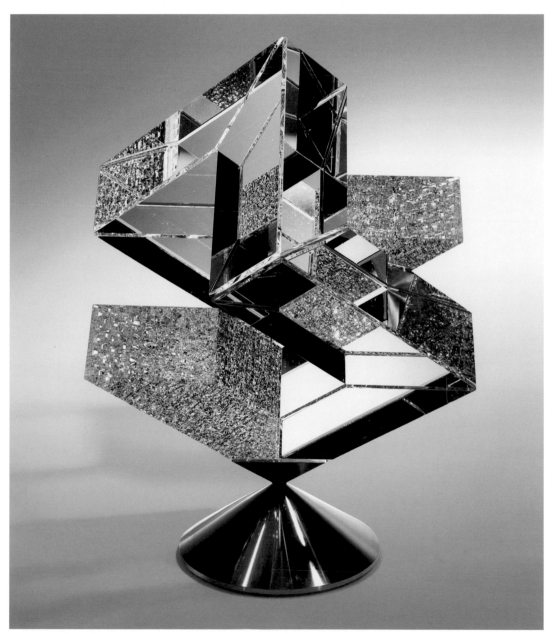

Representing:
Rick Beck
William Carlson
KéKé Cribbs
Sidney Hutter
Jon Kuhn
Dante Marioni
Stephen Powell
Richard Royal
David Schwarz
Thomas Scoon
Paul Stankard
Bertil Vallien
Richard Whiteley

Jon Kuhn, **Queen Anne's Lace,** *2007
laminated glass, 17.5 x 12.5 x 12.5*

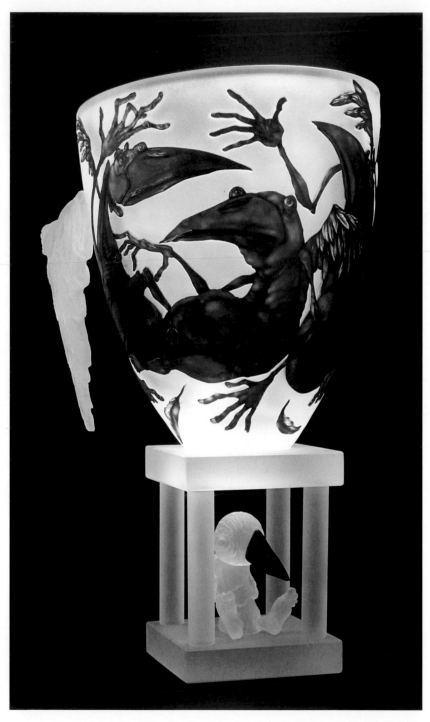

Miroslaw Stankiewicz, **Nocturnal Bird Conversation,** *2008*
glass, 13 x 9
photo: Miroslaw Stankiewicz

Mattson's Fine Art

Contemporary glass art and unique jewelry
Staff: Gregory Mattson, director; Walter Mattson; Skippy Mattson

2579 Cove Circle, NE
Atlanta, GA 30319
voice 404.636.0342
fax 404.636.0342
sundew@mindspring.com
mattsonsfineart.com

Duncan McClellan, **Oblivious**, *2008*
blown glass, overlay and sand-carved, 19 x 16 x 16
photo: Randall Smith

Representing:
Rafal Galazka
Duncan McClellan
Michael Angelo Menconi
Sharon Meyer
Miroslaw Stankiewicz
Maciej Zaborski

Sharon Meyer, **The Empress,** *2007*
Burmese jade, faceted black onyx, diamond, 18k gold
photo: Sharon Meyer

Michael Angelo Menconi, **Result of an Act,** *2007*
blown glass, 16 inches high
photo: Michael Angelo Menconi

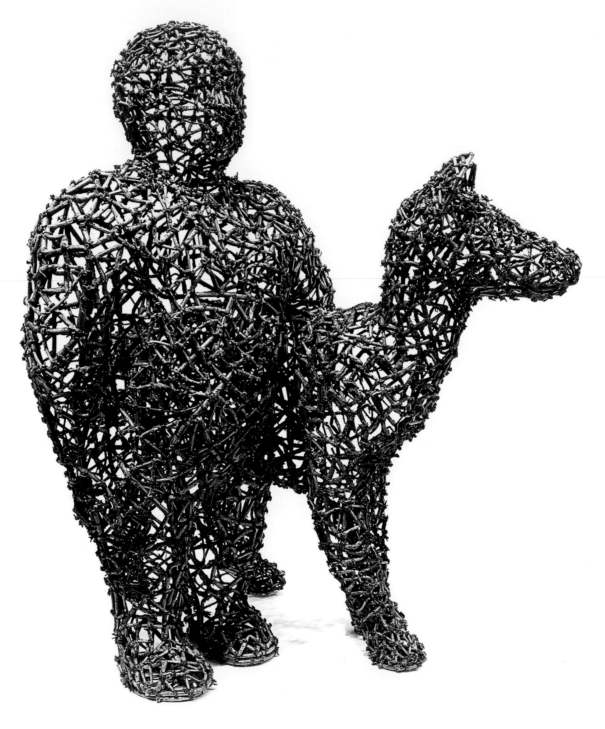

John McQueen, **Man and Dog,** *2008*
willow, string, 25 x 15 x 25
photo: Aimee Fix

Mobilia Gallery

20th and 21st century decorative arts, sculpture and studio jewelry with an emphasis on installations
Staff: Libby Cooper; JoAnne Cooper; Cristina Dias; Aimee Fix; Karsten Lyngsie; Yuka Saito; Victoria Wasik

358 Huron Avenue
Cambridge, MA 02138
voice 617.876.2109
fax 617.876.2110
mobiliaart@verizon.net
mobilia-gallery.com

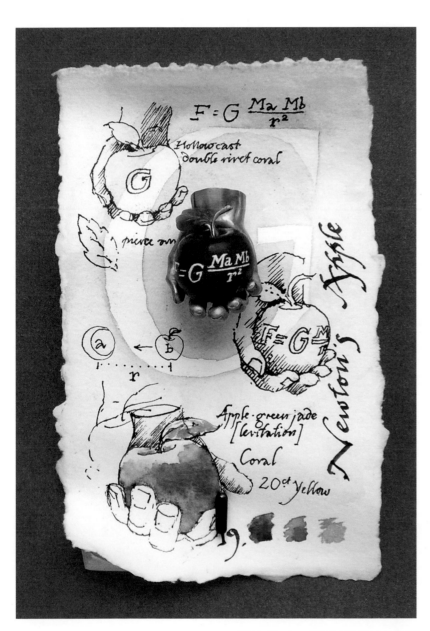

*Kevin Coates, **Newton's Apple**, 2007*
20k gold, carved and engraved coral (recycled), carved apple
green jade, 18k red gold, 18k white gold pin, 1.25 x 1
photo: Clarissa Bruce

Representing:

Renie Breskin Adams	Emi Fujita	Kyoko Okubo
Jeanette Ahlgren	John Garrett	Yoko Okuno
Donna Barry	Lydia Gerbig-Fast	Joan Parcher
Kim Bass	Noa Goen Amir	Sarah Perkins
Linda Behar	Elizabeth Goluch	Robin Quigley
Hanne Behrens	Laurie Hall	Wendy Ramshaw CBE
Lanny Bergner	Dorothy Hogg MBE	Ann Coddington Rast
Flora Book	Mary Lee Hu	Suzan Rezac
Sharon Church	Dan Jocz	Yuka Saito
Kirsten Clausager	Anna King	Joyce J. Scott
Kevin Coates	Tadashi Koizumi	Richard Shaw
Alexia Cohen	Shana Kroiz	Yoko Shimizu
Lia Cook	Mariko Kusumoto	Kiff Slemmons
Susan Cross	Jee-Hye Kwon	Christina Smith
Marilyn da Silva	Asagi Maeda	Etsuko Sonobe
Linda Darty	Jennifer Maestre	Blanka Sperkova
Jenny Deans	Donna Rhae Marder	Cynthia Toops
Margot Di Cono	Bruno Martinazzi	Jennifer Trask
Cristina Dias	Tomomi Maruyama	Donna Veverka
Georg Dobler	Elizabeth McDevitt	Barbara Walter
Jennifer Falck-Linssen	John McQueen	Alexandra Watkins
Diane Falkenhagen	Leah Meleski	Heather White
Dorothy Feibleman	Nancy Michel	Ellen Wieske
Arline Fisch	Kazumi Nagano	Joe Wood
Gerda Flockinger CBE	Harold O'Connor	Yoshiko Yamamoto
Nora Fok	Miwha Oh	

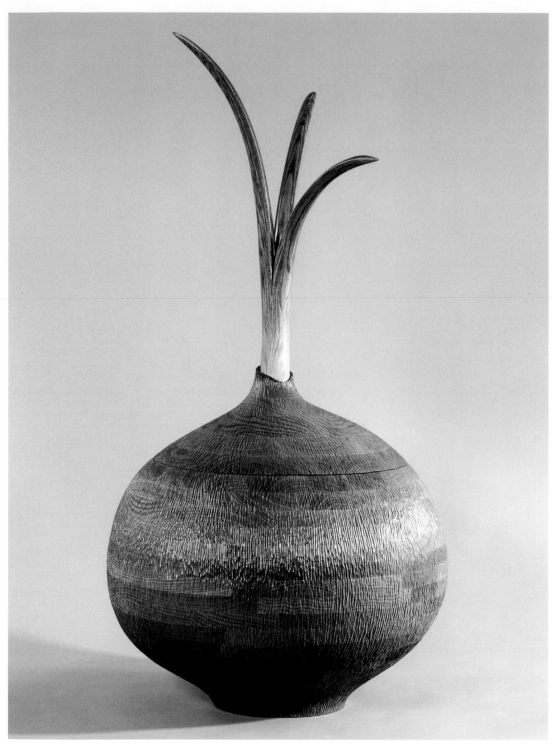

David Ebner, **Onion Blanket Chest**, *2006*
red oak, 54 x 28
photo: Gil Amiaga

Moderne Gallery

Vintage and contemporary works from the American Craft Movement, 1920-2008

Staff: Robert Aibel, owner; Michael Gruber, designer; Cynthia Tyng, manager; Sarah Aibel, Joshua Aibel and Jessica Rowe, associates

111 North 3rd Street
Philadelphia, PA 19106
voice 215.923.8536
fax 215.923.8435
raibel@aol.com
modernegallery.com

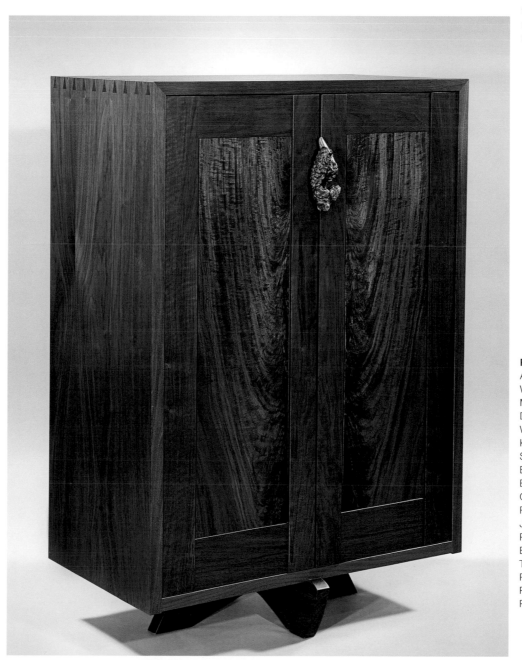

Representing:
Arthur Espenet Carpenter
Wendell Castle
Michael Coffey
David Ebner
Wharton Esherick
Ken Ferguson
Sam Maloof
Emil Milan
Ed Moulthrop
George Nakashima
Rude Osolnik
James Prestini
Paul Soldner
Bob Stocksdale
Toshiko Takaezu
Robert Turner
Peter Voulkos
Pamela Weir-Quiton

George Nakashima, **Bahut,** *1990*
claro walnut, 55 x 36 x 20
photo: Michael J. Joniec

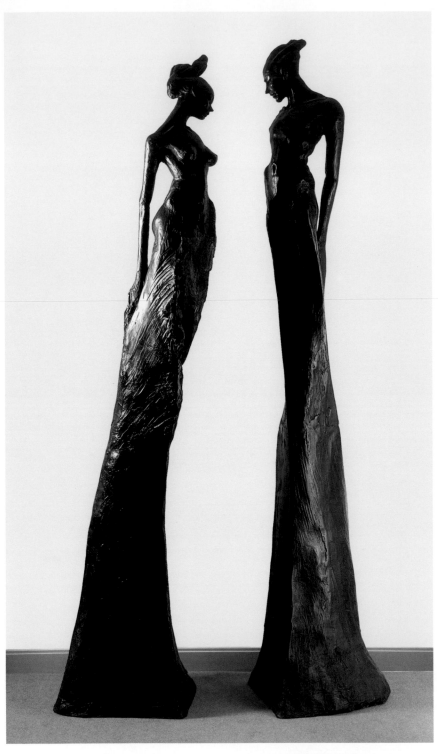

Milthon, **Complicite 1,** *limited edition, 2007*
resin, bronze, 73 inches high
photo: Philippe Schlienger

Modus Art Gallery

An emphasis on contemporary original works of art, excellence of execution and genuineness of style and content
Staff: Karl Yeya, owner; Mana Asselli, manager; Joseph Kaady; Stan Mink; Chris Abchi; Richard Elmir; Sophie Montcarat

23 Place des Vosges
Paris 75003
France
voice 33.1.4278.1010
cell 917.257.6606
fax 33.1.4278.1400
modus@galerie-modus.com
galerie-modus.com

Lindsey de Ovies, **Maternity,** *2008*
ceramic, 4 x 11.75 x 11.75

Representing:
Françoise Abraham
Luigi Bona
Leon Bronstein
Bruno Catalano
Pascal Crucq
Lindsey De Ovies
Loni Kreuder
Milthon
Edmondo Solari

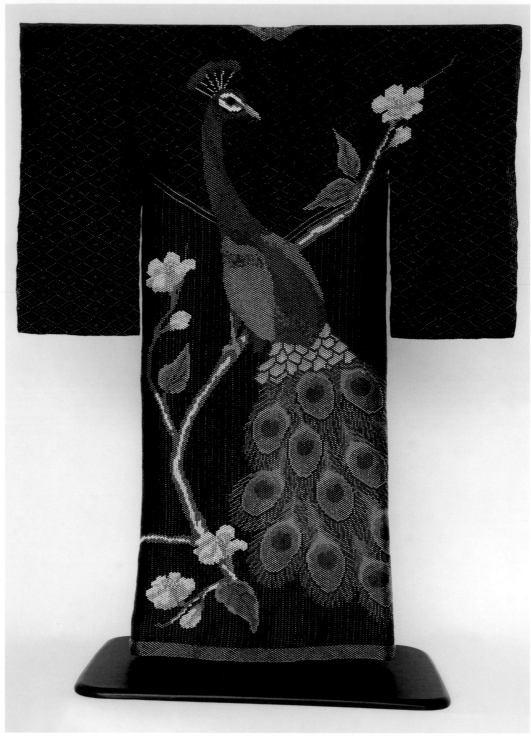

Madelyn Ricks, **Peacock Imperial Kimono,** *2007*
woven Japanese glass beads, 21 x 16
photo: Mark Ross

Mostly Glass Gallery

Glass art, novel and technically challenging; esthetics is a pre-requisite
Staff: Sami Harawi, owner

34 Hidden Ledge Road
Englewood, NJ 07631
voice 201.503.9488
fax 201.503.9522
info@mostlyglass.com
mostlyglass.com

Representing:
Khalid Assakr
Mary Darwall
Miriam Di Fiore
Wendy Ellsworth
Ivana Houserova
Vlastislav Janacek
Fabienne Picaud
Gateson Recko
Madelyn Ricks
Cesare Toffolo
Sharmini Wirasekara
Alexandra Zonis

*Sharmini Wirasekara, **Talavera II**, 2008*
woven Japanese glass beads, 12.5 x 11
photo: Barbara Cohen

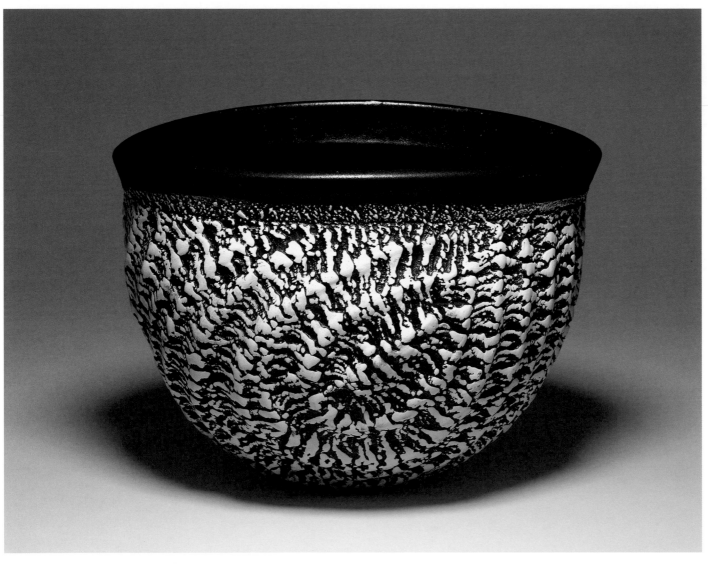

Jae Cheon Sim, **Bowl**, *2008*
wood-fired stoneware, 10.75 x 12.25 x 15.25
photo: Myunguk Huh

Naun Craft

Contemporay artists honoring tradition and exploring new ways to work in clay
Staff: Hyunja Jang, director; Chukyung Kwak, curator; Myunguk Huh, photographer

Hilton Hotel F1
395 Namdaemunro-5ga
Jung-gu, Seoul 100-095
Korea
voice 82.2.779.2259
fax 82.2.318.2846
brian4915@hanmail.net
nauncraft.com

Representing:
Jae Cheon Sim

Jae Cheon Sim, **Bottle***, 2008*
wood-fired stoneware, 6.75 x 5.5 x 5.5
photo: Myunguk Huh

Abe Anjin, Colored Bizen Water Jar, *2007*
ceramic, 7.75 x 7.75 x 7.75

Onishi Gallery

Contemporary work by Asian artists in new and traditional media
Staff: Nana Onishi, owner; Brian Miller

521 West 26th Street
New York, NY 10001
voice 212.695.8035
fax 212.695.8036
info@onishigallery.com
onishigallery.com

Representing:
Abe Anjin
Hiraiwa Tomoyo
Nakagawa Mamoru
Ohi Toshio

Nakagawa Mamoru, **Flower Vase Sekisei (Evening Sky Clearing)**, *2005*
metal with inlay of copper-silver alloy, 8.75 x 6.75 x 9.5

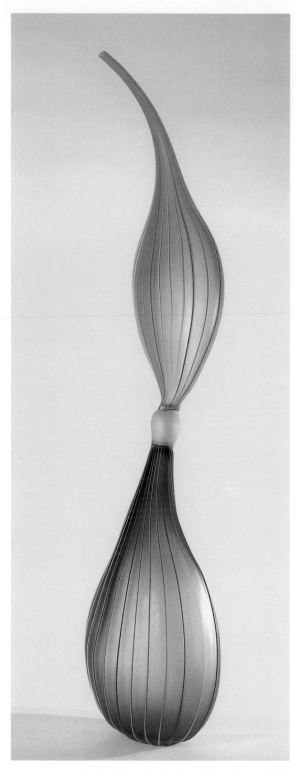

Jay Macdonell, **Allium Bulb-Corn Yellow Cane,** *2008*
blown and etched glass, 50 x 9 x 12.5

Option Art

Work by outstanding Canadian contemporary mixed media and craft artists; established in 1985
Staff: Barbara Silverberg, director; Philip Silverberg, associate

4216 de Maisonneuve Blvd. West
Suite 302
Montreal, Quebec H3Z 1K4
Canada
voice 514.932.3987
info@option-art.ca
option-art.ca

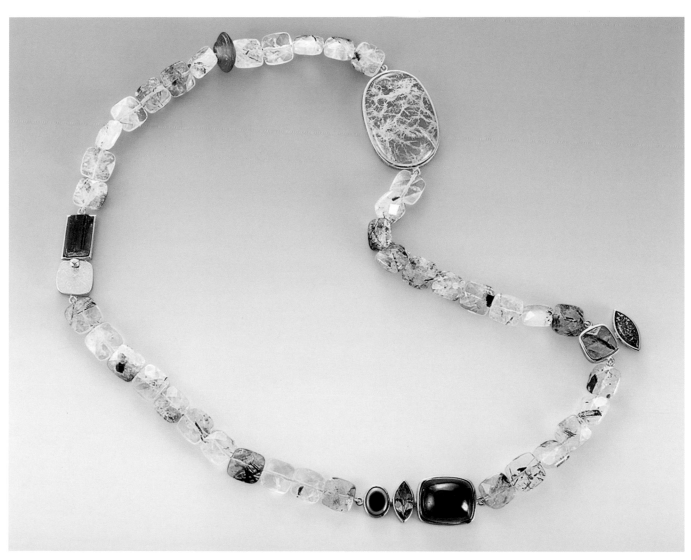

Representing:
Jeanne Bellavance
Stopher Christensen
Marina Dempster
Carolina Echeverria
Jean Louis Emond
Janis Kerman
Jay Macdonell
Mel Munsen
Susan Rankin
Donald Robertson
David Samplonius
Orest Tataryn
Lily Yung

Janis Kerman, **Necklace,** *2008*
18k yellow gold, peridot, agate, chrome tourmaline, rutilated beryl,
amber, glass bead, tourmaline crystal and rutilated tourmaline beads

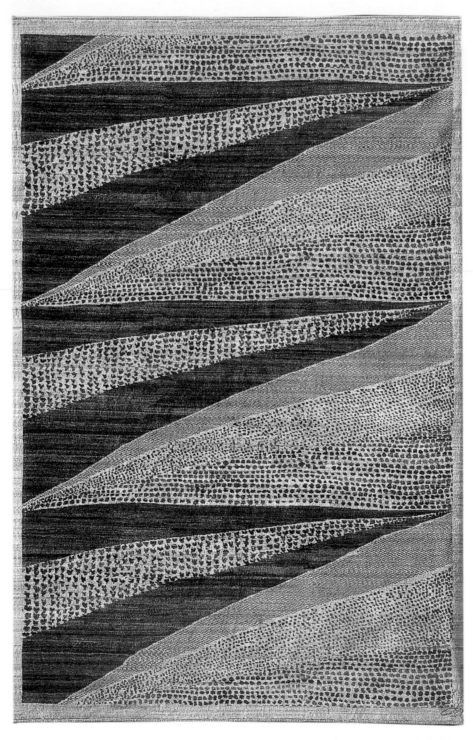

Bahram Shabahang, **Untitled,** *2007*
fiber, 72 x 108

Orley & Shabahang

Contemporary Persian carpets
Staff: Ashleigh Gersh; Geoffrey Orley; Bahram Shabahang

241 East 58th Street
New York, NY 10022
voice 646.383.7511
fax 646.383.7954
orleyshabahang@gmail.com
orleyshabahang.com

240 South County Road
Palm Beach, FL 33480
voice 561.655.3371
shabahangorley@gmail.com

223 East Silver Spring Drive
Whitefish Bay, WI 53217
voice 414.332.2486
shabahangcarpets@gmail.com

By Appointment
5841 Wing Lake Road
Bloomfield Hills, MI 48301
voice 586.996.5800

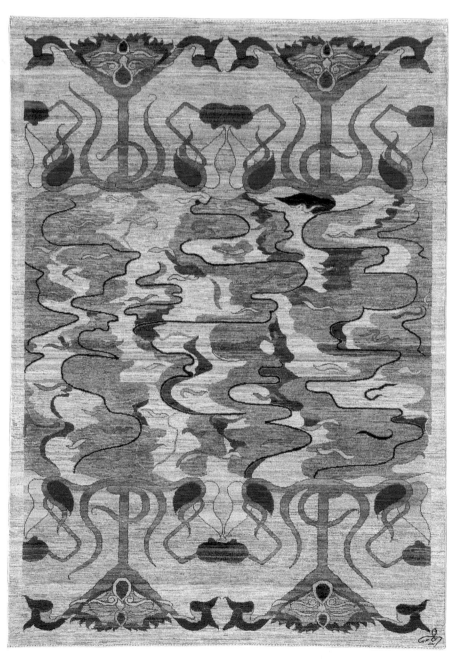

Representing:
Bahram Shabahang

Bahram Shabahang, **Untitled,** *2007*
fiber

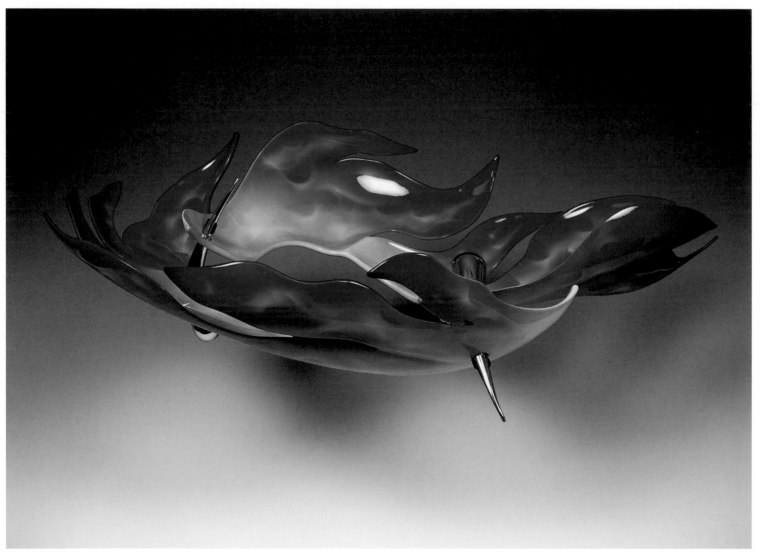

Dan Jocz, **Fire Water Necklace,** *2007*
aluminum, copper, auto body lacquer, chrome, 16 x 12 x 5
photo: Dan Jocz

Ornamentum

Contemporary international jewelry
Staff: Laura Lapachin; Stefan Friedemann

506.5 Warren Street
Hudson, NY 12534
voice 518.671.6770
fax 518.822.9819
info@ornamentumgallery.com
ornamentumgallery.com

Representing:

Body Politics
Sara Borgegard
Juliane Brandes
Dorothea Brill
Johanna Dahm
Donna D'Aquino
Gemma Draper
Sam Tho Duong
Iris Eichenberg
Ute Eitzenhoefer
Jantje Fleischhut
Maria Rosa Franzin
Lisa Gralnick
Batho Guendra
Hanna Hedman
Sergey Jivetin
Dan Jocz
Jiro Kamata
Jutta Klingebiel
Beate Klockmann

Helena Lehtinen
Wolli Lieglein
Marc Monzo
Eija Mustonen
Ted Noten
Joan Parcher
Ruudt Peters
Camilla Prasch
Mary Preston
Katja Prins
Gerd Rothmann
Philip Sajet
Constanze Schreiber
Giovanni Sicuro
Silke Spitzer
Claudia Stebler
Julia Turner
Tarja Tuupanen
Luzia Vogt

Katja Prins, **Continuum Brooch***, 2007*
silver, sealing wax, 3.25 x 3 x 1.5
photo: Francis Willemstijn

Daniela Turrin, **Ebb**
Gaffer cast glass, aluminum, 32 x 19 x 2.5
photo: Franca Turrin

PRISM Contemporary Glass

Representing a new standard in contemporary glass by both emerging and renowned artists
Staff: D. Scott Patria, director; Amy Hajdas, senior associate

1048 West Fulton Market
Chicago, IL 60607
voice 312.243.4885
info@prismcontemporary.com
prismcontemporary.com

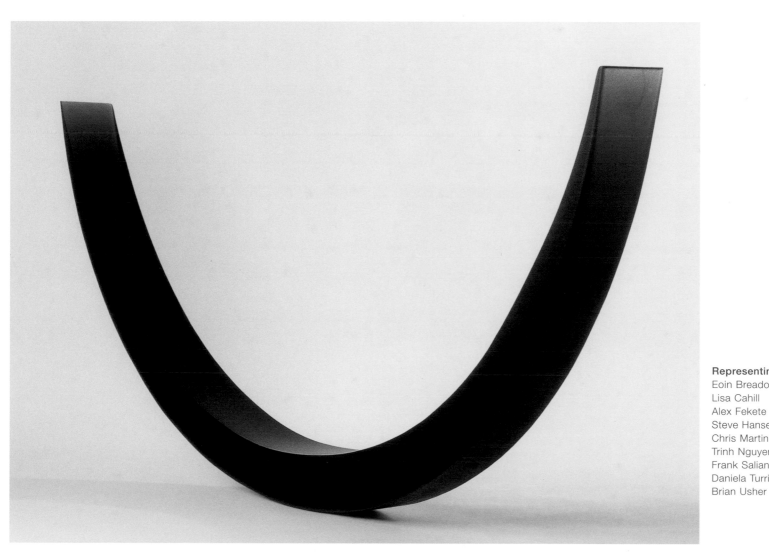

Representing:
Eoin Breadon
Lisa Cahill
Alex Fekete
Steve Hansen
Chris Martin
Trinh Nguyen
Frank Saliani
Daniela Turrin
Brian Usher

Brian Usher, **The Inevitability of Agnus**
cast glass, 79 x 37.5 x 6

Jean Dubuffet, **Arbuste d'Apartment (House Plants)**, *1997*
acrylic on galvanized aluminum, 81 x 25 x 30

Ruth Lawrence Fine Art

Unusual artwork by internationally recognized and established artists
Staff: Nan Miller, owner; Jenna Miller, art consultant; Gail Leess, director

3450 Winton Place
Rochester, NY 14623
voice 585.292.1430
fax 585.292.1254
nmg3450@frontiernet.net
nanmillergallery.com

Representing:
Hamilton Aguiar
Niki de Saint Phalle
Jean Dubuffet
Michael Kalish
Brian O'Neill
Albert Paley

Hamilton Aguiar, **Solitude Sculpture,** *2008*
oil on aluminum, 96 x 21 x 21

Jamie Bennett, **Untitled Brooch,** *2008*
enamel, copper, silver, 4 x 1.5 x .75
photo: Kevin Sprague

Sienna Gallery

International contemporary art and object
Staff: Sienna Patti, director

80 Main Street
Lenox, MA 01240
voice 413.637.8386
info@siennagallery.com
siennagallery.com

Representing:
Shihoko Amano
Giampaolo Babetto
Jamie Bennett
Melanie Bilenker
Lola Brooks
Raissa Bump
Noam Elyashiv
Susie Ganch
Myra Mimlitsch Gray
Gesine Hackenberg
Lauren Kalman
Anya Kivarkis
Esther Knobel
Daniel Kruger
Seung-Hea Lee
Jacqueline Lillie
Tina Rath
Barbara Seidenath
Sondra Sherman
Bettina Speckner
Tracy Steepy
Sayumi Yokouchi

Lauren Fensterstock, **Garden Pile,** *2008*
mixed media, 10 x 8 x 7
photo: Kevin Sprague

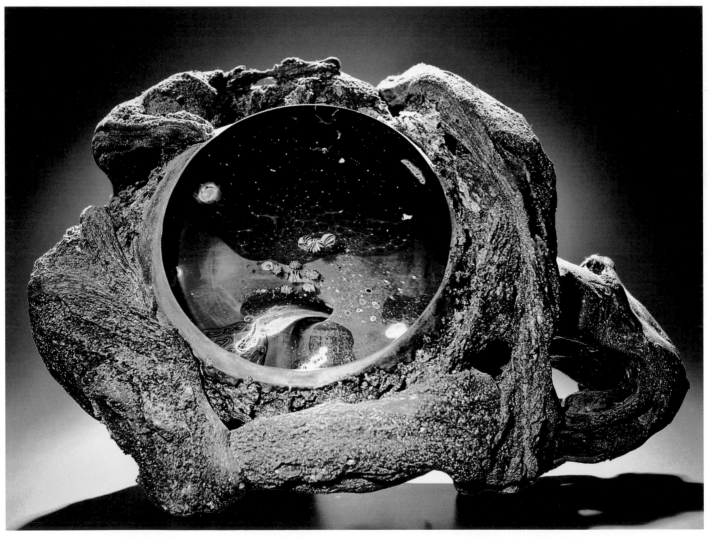

Josh Simpson, **Tektite Portal,** *2005*
meteorite glass sculpture with inclusions of filigrana cane and precious metals, 9 x 12.5 x 8.25
photo: Tim Ryan Smith

Signature Gallery

Contemporary fine craft gallery representing 200 American artists since 1989
Staff: Karen M. Corp, director; Blanka Allgood; Judy Cameron; Kathy Fisher; Tracey Sykes

2364 Whitesburg Drive
Huntsville, AL 35801
voice 256.536.1960
fax 256.539.8192
siggallery@aol.com
signaturegallery.com

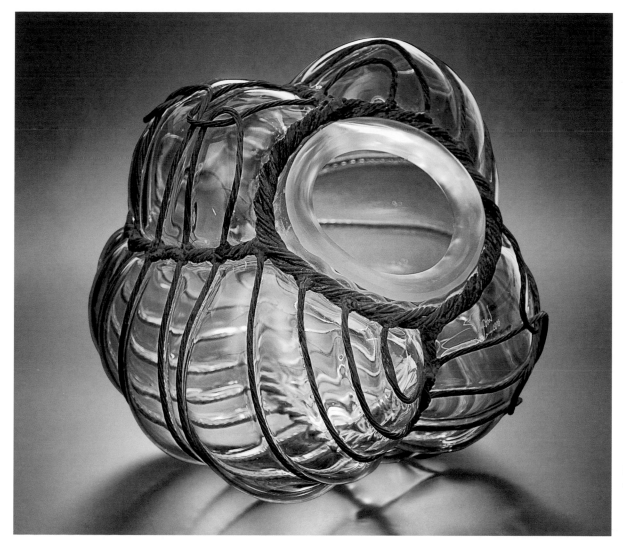

Representing:
Josh Simpson

Josh Simpson, **Copper Basket**, *1996*
welded copper wire basket with blown glass interior, 13.5 x 15.25 x 14.75
photo: Tim Ryan Smith

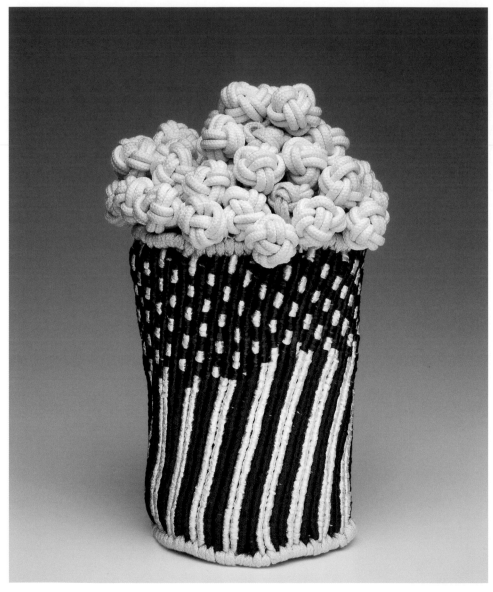

Ed Bing Lee, **Pop Corny,** *2007*
knotted nylon, cotton and raffia, 10 x 8 x 8
photo: Ken Yanoviak

Snyderman-Works Galleries

Contemporary fiber/textiles, ceramics, jewelry, furniture, wood, glass, painting and sculpture
Staff: Ruth and Rick Snyderman, proprietors; Bruce Hoffman, director, Snyderman-Works;
Francis Hopson, director, Works Gallery; Kathryn Moran, assistant director; Chris Lawrence, preparator; Leeor Sabbah, associate

303 Cherry Street
Philadelphia, PA 19106
voice 215.238.9576
fax 215.238.9351
bruce@snyderman-works.com
snyderman-works.com

Blanka Sperkova, **Blackberry Necklace**
hand-knitted colored copper and sterling wire with beads, 46 inch lariat
photo: Scott Niebaurer

Representing:

Kate Anderson
Lanny Bergner
Karin Birch
Yvonne Pacanovsky
 Bobrowicz
John Eric Byers
Jane Chavez
Sonya Clark
Mardi Jo Cohen
Nancy Crow
Joan Dreyer
Steven Ford
David Forlano
Karen Gilbert
Tim Harding
Ron Isaacs
Kim Kamens
Shizuko Kimura
Sonja Landweer
Ed Bing Lee
Marcia Macdonald
Ruth McCorrison
Ron Meyers
Nancy Middlebrook

Christy Mirabelli
Milo Mirabelli
Mark Newport
Matt Nolen
Marilyn Pappas
Huib Petersen
Orfeo Quagliata
Cynthia Schira
Warren Seelig
Karen Shapiro
Barbara Lee Smith
Blanka Sperkova
Klaus Spies
Jo Stealey
Eva Steinberg
Anna Torma
Deborah Warner
Helen Frost Way
David Williamson
Roberta Williamson
Yoko Yagi
Xiang Yang
Soonran Youn

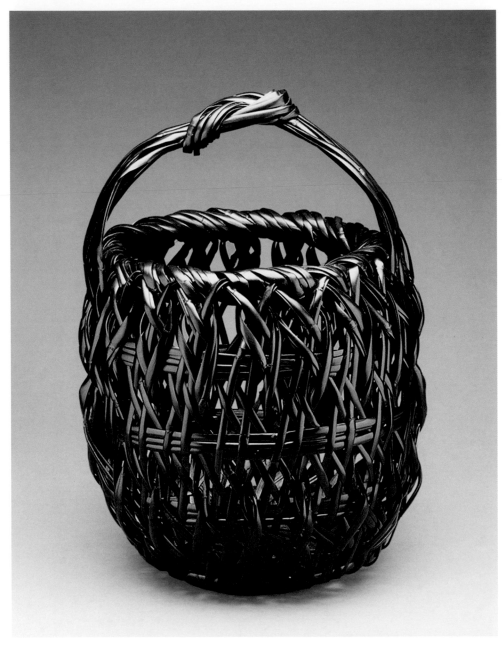

Katsushiro Soho, **Morning Glow in the Forest,** *2005*
bamboo, 17.5 x 12.5 x 13
photo: Gary Mankus

TAI Gallery

Contemporary Japanese bamboo art and photography
Staff: Robert Coffland and Mary Kahlenberg, owners; Cathy Berkley, director;
Trina Hall, manager; Amber Jordan, assistant manager

1601B Paseo de Peralta
Santa Fe, NM 87501
voice 505.984.1387
fax 505.989.7770
gallery@textilearts.com
taigallery.com

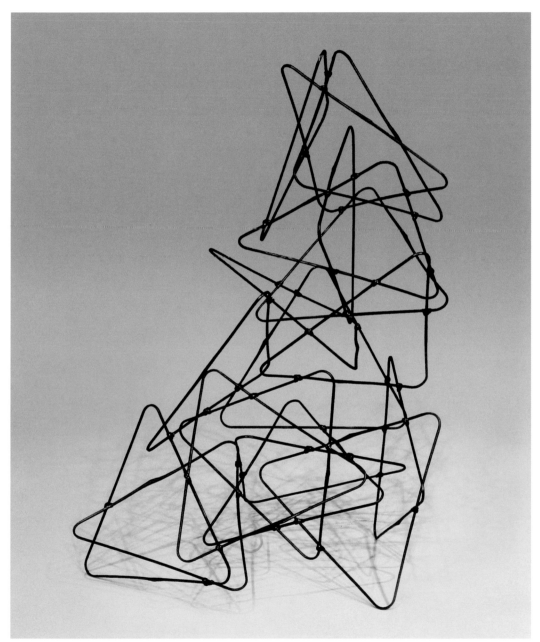

Representing:
Abe Motoshi
Fujinuma Noboru
Fujitsuka Shosei
Hatakeyama Seido
Hayakawa Shokosai V
Honda Syoryo
Honjo Naoki
Honma Hideaki
Isohi Setsuko
Kajiwara Aya
Kajiwara Koho
Katsushiro Soho
Kawano Shoko
Kawashima Shigeo
Kibe Seiho
Mimura Chikuho
Monden Kogyoku
Morigami Jin
Nagakura Kenichi
Nakatomi Hajime
Tanabe Takeo
Tanaka Kyokusho
Toda Seiju
Torii Ippo
Ueno Masao

Nakatomi Hajime, **Prism,** *2007*
bamboo, 16 x 8 x 11
photo: Trina Badarak

Elisabett Gudmann, **Time Stories,** *2007*
etched copper panel, chemical patinas, 24 x 24 x 3

ten472 Contemporary Art

Contemporary art
Staff: Hanne Sorensen; Elis Gudmann; Catherine Conlin

10472 Alta Street
Grass Valley, CA 95945
voice 707.484.2685
fax 707.484.2685
info@ten472.com
ten472.com

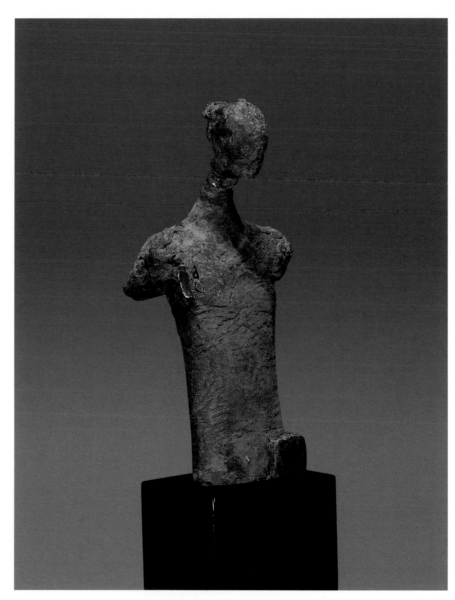

Representing:
Elisabett Gudmann
Edwin Riveria
Kirk H. Slaughter

Elisabett Gudmann and Kirk H. Slaughter, **Feminine Torso: Number 4,** *2007*
bronze, 18 x 4 x 3

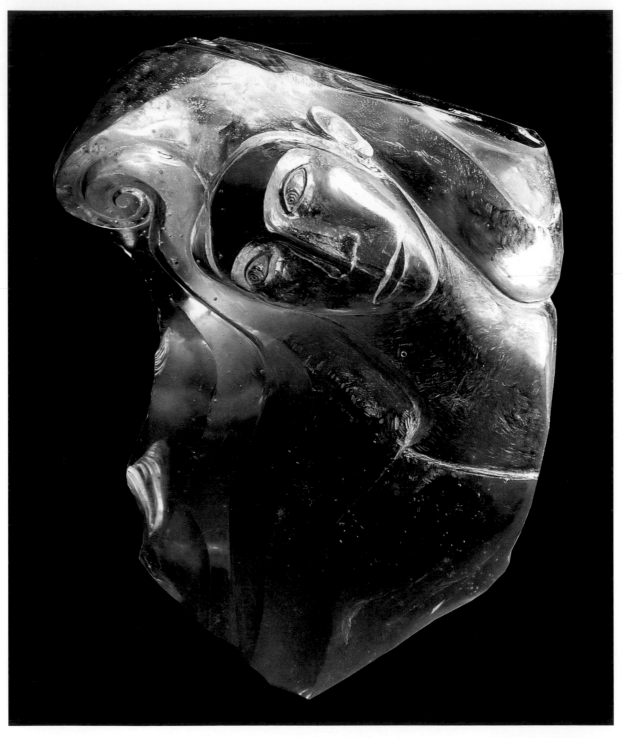

Yucel Kale, **Untitled,** *2007*
glass, brass, 23.75 x 19.75 x 17.75
photo: Ebru Yilmaz Kale

Turkish Cultural Foundation

Devoted to promoting and preserving Turkish culture, art and heritage
Staff: Guler Koknar, Washington, DC; Hulya Yurtsever, Istanbul;
Carol Ann Jackson, Boston; Dr. Nurhan Atasoy and Dr. Sumiyo Okumura, resident scholars

Boston, MA
Istanbul, Turkey
Washington, DC
director@turkishculture.org
turkishculturalfoundation.org

Representing:
Yucel Kale
Erkin Saygi
Ruhcan Topaloglu

Erkin Saygi and Ruhcan Topaloglu, Tale, *2006*
glass, 8.5 x 4.5
photo: Mehmet Akgul

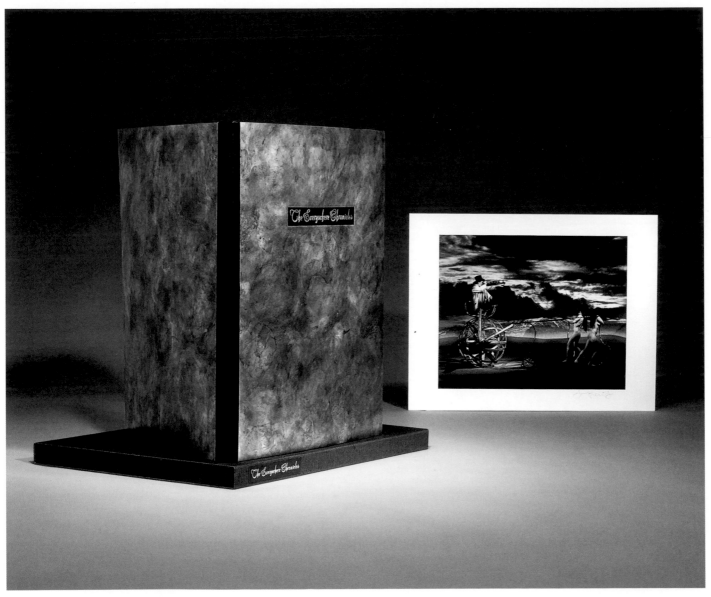

Jamie Baldridge, **The Everywhere Chronicles,** *2008*
handbound book, 20 x 16
photo: Walter Colley

21ST Editions

Publishers of handmade, limited edition books illustrated with original prints
Staff: Steven Albahari; Lance Speer; Pam Clark; Crissy Welzen

9 New Venture Drive, #1
South Dennis, MA 02660
voice 508.398.3000
fax 508.398.0343
21st@21steditions.com
21steditions.com

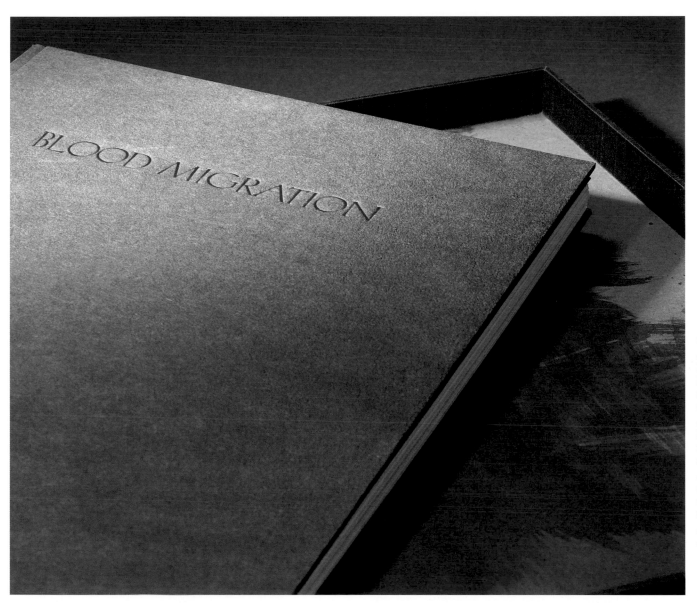

Representing:
Jamie Baldridge
Brigitte Carnochan
Flor Garduno
Misha Gordin
Greg Gorman
Jefferson Hayman
Eikoh Hosoe
Michael Kenna
Sally Mann
John Metoyer
Sheila Metzner
Robert ParkeHarrison
Shana ParkeHarrison
Josephine Sacabo
Joel-Peter Witkin

John Metoyer, **Blood Migration**, *2008*
handbound book, 22 x 15
photo: Walter Colley

159

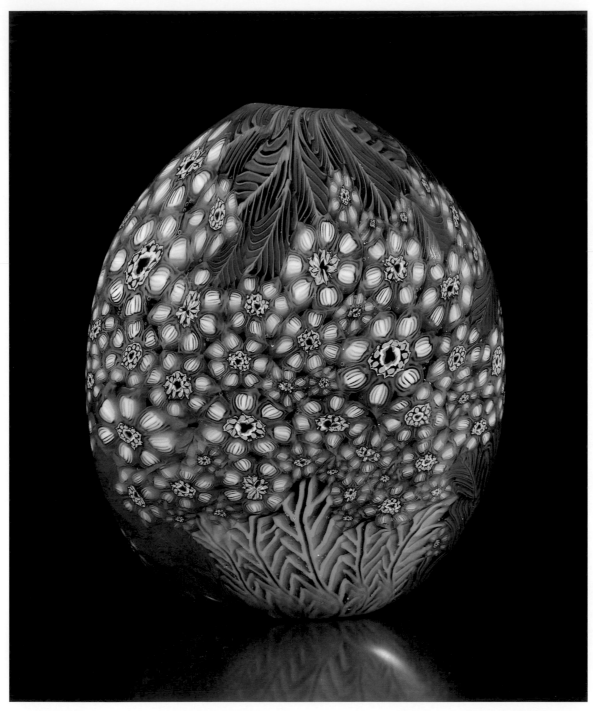

Martie Negri, **Indigo Spirit Vessel,** *2007*
fused, blown and cold-worked glass, 10 x 8 x 2.75
photo: Nick Saraco

UrbanGlass

An international center for new art made from glass
Staff: Dawn Bennett, executive director; Becki Melchione, associate director

647 Fulton Street
Brooklyn, NY 11217
voice 718.625.3685
fax 718.625.3889
info@urbanglass.org
urbanglass.org

Representing:
Deborah Faye Adler
Charlene Foster
Martie Negri
Erica Rosenfeld
Helene Safire
Melanie Ungvarsky

Charlene Foster, **3 Tiers**, *2008*
sublime green and clear glass, solid 14k yellow gold, 18k vermeil
photo: Irene Stergios

Valentin Magro, **Angelfish of the Sea Brooch**, *2006*
photo: John Timen

Valentin Magro New York

Exquisite craftsmanship in creating unique and whimsical designs in semi and precious metals and stones
Staff: Valentin Magro, director; Terry Magro, assistant director

42 West 48th Street
New York, NY 10036
voice 212.575.9044
fax 212.575.9045
valentin@valentinmagro.com
valentinmagro.com

Representing:
Valentin Magro

Valentin Magro, **Lattice Bracelet,** *2007*
photo: John Timen

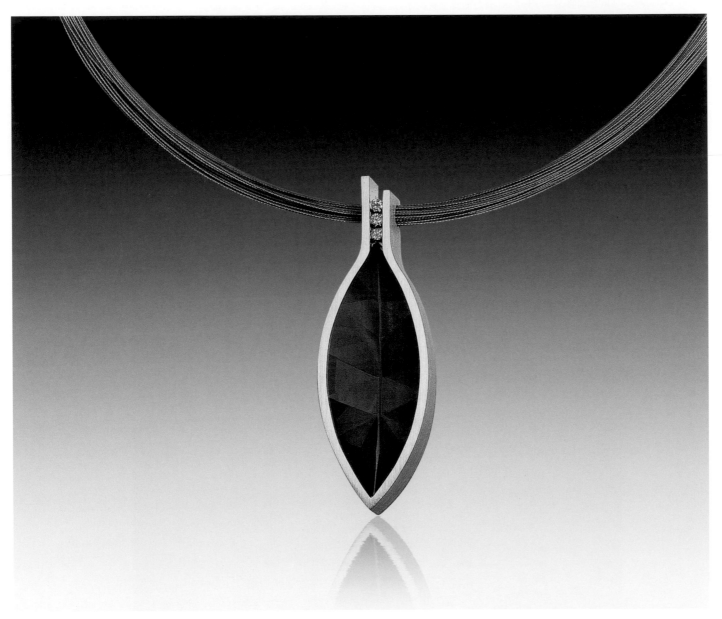

Claudia Endler, **Scissor Cut Pendant,** *2007*
14k yellow gold, smoky quartz, diamond, 2.75 x .75 x .5
photo: Barry Blau

William Zimmer Gallery

Fine, functional, and decorative arts by American and European artists
Staff: William Zimmer and Lynette Zimmer, owners; Ken Tolces, Barbara Hobbs and Owen Edwards, associates

PO Box 263
Mendocino, CA 95460
voice 707.937.5121
fax 707.937.2405
wzg@mcn.org
williamzimmergallery.com

Representing:
Carolyn Morris Bach
Bennett Bean
Afro Celotto
David Crawford
John Dodd
Owen Edwards
Claudia Endler
Ted Gall
Rebecca Gouldson
Karl Harron
Barbara Heinrich
Elizabeth Rand
Cheryl Rydmark
Kent Townsend

Bennett Bean, **Master #1463**
pit-fired, painted and gilded earthenware, 9.5 x 14.75 x 8.25
photo: Bennett Bean Studio

Anat Gelbard, **Ruby Necklace,** *2007*
21 x .25 x .25
photo: R.H. Hensleigh

Yaw Gallery

Representing national and international goldsmiths and metalsmiths
Staff: Nancy Yaw; Jim Yaw; Jacqueline Michaels

550 North Old Woodward Avenue
Birmingham, MI 48009
voice 248.647.5470
fax 248.657.3715
yawgallery@msn.com
yawgallery.com

Representing:

Diana Alymeda	Rauni Higson
Nati Amiols	Meital Hillel
Curtis H. Arima	Lynn Hull
Nick Grant Barnes	Ion Ionescu
Heather Bayless	Olle Johanson
Candace Bearsley	Mark Johns
Nirit Berman	Shay Lahover
Myron Bikakis	Barbara Minor
Linda Brown	Shea Murray
Harlan Butt	Efrat Nordman
Jack da Silva	Itay Noy
Marilyn da Silva	Miel Marguerita Pardes
Nirit Dekel	Helen Shirk
Haya Elfasi	Suzanne Stem
Mary Esses	Pamela Morris Thomford
Anat Gelbard	James Thurman
Kimberely Harrell	Russell Trusso
Christopher Hentz	Yoshiko Yamamoto

Shay Lahover, **Diamond Ring,** *2007*
1 x 1 x 1
photo: R.H. Hensleigh

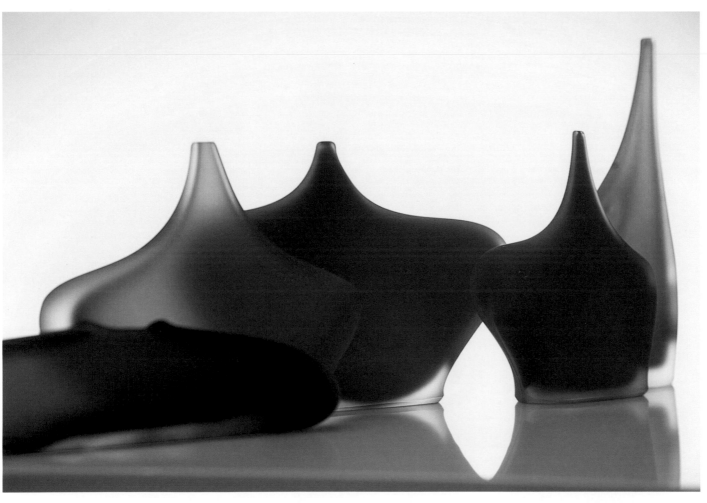

Adam Aaronson, **Autumn Stones,** *2007*
blown glass, various sizes

Zest Contemporary Glass Gallery

Established and emerging British contemporary glass artists
Staff: Nell Reid; Adam Aaronson

Roxby Place
London SW6 1RS
United Kingdom
voice 44.20.7610.1900
fax 44.20.7610.3355
nell@zestgallery.com
zestgallery.com

Representing:
Adam Aaronson
Lucy Alexandra Batt
Katharine Coleman
Sam Herman
Max Jacquard
Alison Kinnaird MBE
Naoko Sato

*Max Jacquard, **Tryst #1**, 2008*
electroplated branch in fine silver with cast glass, 14 x 6 x 4

Res

Resources

ources

NOVEMBER 2007

Art
&ANTIQUES

FOR COLLECTORS OF THE FINE AND DECORATIVE ARTS

CLAUDIO BRAVO | DÜRER PRINTS | SHOPPING PARIS | BARNES FOUNDATION

2007 TOP TREASURES

For Collectors of the Fine and Decorative Arts.

THE NEW *ART&ANTIQUES* is edited for the serious art aficionado, a reader whose passion is acquiring and living with art, antiques and fine collectibles. The magazine's aim is to inspire interest in the fine and decorative arts through informed news and commentary, exciting discovery articles, and in-depth features that showcase beautiful and important treasures, frequently in the context of collectors' homes. Our new editorial focus is enhanced by an elegant new design, a wider trim size, and heavier, more luxurious paper. By creating a truly refined environment in which connoisseurship is cultivated and curiosity is rewarded, the new *Art & Antiques* delivers a community of collectors and connoisseurs whose love of the arts and appreciation for an excellent magazine is without parallel.

LOUISE BLOUIN MEDIA

THE

Unique in its conception and
features and debate. Repor[t]
month THE ART NEWSPA[PER]

"*The Art Newspaper* is an invalua[ble]
Philippe de Montebello, director, M[et]

"...*the art world's most respected pu[b]*
The Sunday Telegraph

NEWS, EVENTS

Grab
your copy

INTERNATIONAL EDITION

ART NEWSPAPER

pe, each issue provides over 70 pages of news, interviews, on everything from old masters to conceptualism, each brings you the important stories from around the globe.

ource of information about art and the art world.”
politan Museum of Art, New York

on”

OLITICS, BUSINESS, ART, MONTHLY

ADVERTISING: +1 212 343 0727
UBSCRIPTION: +1 800 783 4903
WW.THEARTNEWSPAPER.COM

Revista Arte Latinoamericano

Información
787-781-6816
grupoalejandroalfonso@gmail.com

LUIGI STEFANO CANNELLI

PABLO MARCANO GARCÍA
LA PINTURA COMO COMPENSACIÓN

DOMINGO
MAESTRO DE MAESTROS

Dionisio Blanco:
Un arte en transición

Williams Carmona: Surrealismo Tropical

ALBERTO PANCORBO
UNO DE LOS MEJORES PINTORES ESPAÑOLES DEL MOMENTO

Arte
Latinoamericano
número 15 · enero a junio 2008
$5.00 USA

FRANK ANDUJAR
y su nueva polifonía surrealista

Subasta de Arte Latinoamericano
Por Alejandro Alfonso

Información y
consignación de obras:
787-923-ARTE (2783)
subasta@coqui.net
787-781-6816
grupoalejandroalfonso@gmail.com

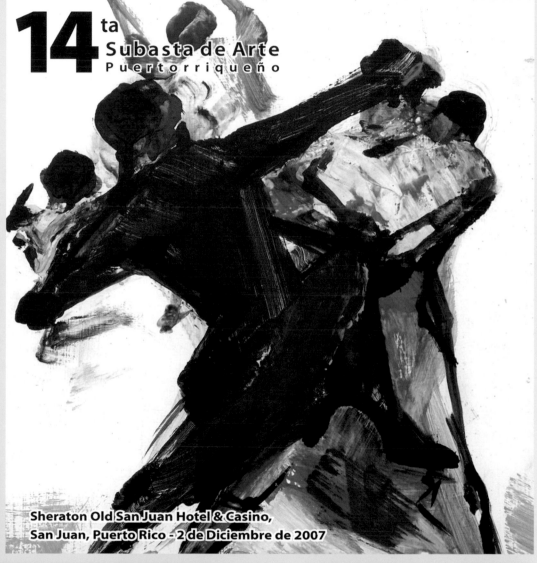

14ta Subasta de Arte Puertorriqueño

Sheraton Old San Juan Hotel & Casino,
San Juan, Puerto Rico - 2 de Diciembre de 2007

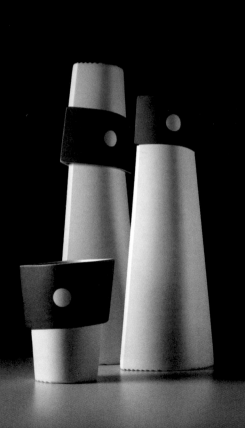
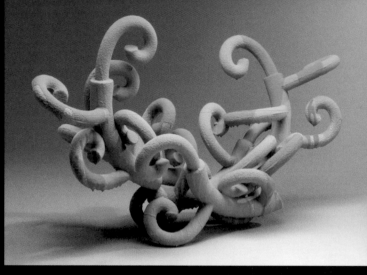

- membership newsletter
- FREE online gallery space
- meeting & workshops
- discounts

- practical tips & techniques
- connect with other artists
- online artist galleries
- online bookstore

Publications Company, 600 N. Cleveland Ave. – Suite 210, Westerville OH 43082 • 866-721-3322

Exploring the world of Craft Arts…

Craft Arts International is one of the oldest and most respected periodicals in its field. It has attracted world-wide acclaim for its "international scope" of the variety of contemporary visual and applied arts it documents in a lucid editorial style and graphic format. In 2008 the magazine celebrates 24 years of continuous publishing. Our on-line index includes every article and artist that has appeared in the magazine since it was launched in 1984. And access to this resource, one of the most comprehensive available on the Internet, is free.

Each issue of *Craft Arts International* contains 128 pages in full colour, with over 400 color images of innovative concepts and new work by leading artists and designer/makers, supported by authoritative and comprehensive texts, that is essential reading for anyone interested in the contemporary visual and applied arts.

Visit our secure website to subscribe online.

craft arts
INTERNATIONAL

AUSTRALIA $16.50
(incl. GST)
US$15, UK £8
NZ $22.50 (incl. GST)
JAPAN ¥1680
(本体¥1600)

70

ABSTRACT GLASS PORTRAITURE BY JIRI HARCUBA
PUBLIC SCULPTURE BY TOM BASS, CERAMICS BY ANNE
CURRIER, TOVE ANDERBERG & PIET STOCKMANS
GLASS BY CHRISTINE CATHIE, WOOD BY RON LAYPORT

ISSN 1038-846X

Sculpture by Anne Currier (US)

AUSTRALIA $16.50
(incl. GST)
US$15, UK £8
NZ $22.50 (incl. GST)
JAPAN ¥1680
(本体¥1600)

71

PRINTMAKING BY RON McBURNIE & NORMANA WIGHT
CERAMICS BY ROBIN WELCH & SIMONE FRASER
GLASS BY ANN WOLFF, HILARY CRAWFORD & TEVITA HAVEA
PAINTING BY MITJILI NAPANANKA GIBSON

ISSN 1038-846X

Ceramics by Robin Welch (UK)

craft arts
INTERNATIONAL

AUSTRALIA $16.50
(incl. GST)
US$15, UK £8
NZ $22.50 (incl. GST)
JAPAN ¥1680
(本体¥1600)

72

SCULPTURE FOR THE BODY BY MARJORIE SCHICK
CERAMICS BY MERRAN ESSON; WOOD BY RON FLEMING
PAINTING BY JUDY NAPANGARDI WATSON
GLASS BY RICHARD JOLLEY, B. JANE COWIE & BEN SEWELL

ISSN 1038-846X

Sculpture for the body by Marjorie Schick (USA)

Craft Arts International
PO Box 363, Neutral Bay, NSW 2089, Australia
Tel: +61-2 9908 4797, Fax: +61-2 9953 1576
Limited stocks of back issues may be ordered from our secure website.

www.craftarts.com.au

CRAFTS

THE MAGAZINE FOR CONTEMPORARY CRAFT

NEW ROMANTIC
SIMON SCHOFIELD'S
DIGITAL LANDSCAPES

CRYSTAL GAZING
THE FESTIVAL PATTERN
GROUP REMEMBERED

FACTORY RECORDS
WHY STOKE INSPIRES
NEIL BROWNSWORD

SLOPPY CRAFT

HOW PRACTICE
MAKES IMPERFECT

SEE THE BEST OF ALL CRAFT FORMS FROM THE UK AND AROUND THE WORLD

SPECIAL OFFER

7 stunning issues for the price of 6

Annual subscription just $75
Offer open to new subscribers until 31 July 2008

Become a subscriber today
Visit: www.craftscouncil.org.uk/crafts
Telephone: +44 (0) 20 7806 2542
Email: subscriptions@craftscouncil.org.uk
Please quote promotion code SOFANY08 in any
correspondence to claim your FREE issue

APR|MAY 2008

*Fiber*ARTS

CONTEMPORARY
TEXTILE ART
AND CRAFT

PAPER
LAYERED • PRINTED
FELTED • STITCHED

SHOWCASING
FIBER ART
AND ARTISTS

SHARING INSPIRATION
AND INNOVATIONS

PROVIDING RESOURCES
AND INFORMATION

The Korean Art
of *Joomchi*
"Felting" Paper

From Weaving
to Monoprint
Control & Spontaneity

Book Arts
Where Form & Content Meet

PLUS
Art Dolls

Wearable Art

Pricked:
Extreme Embroidery

 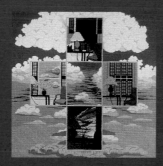 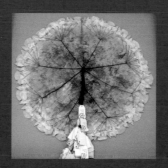

UrbanGlass is a leading resource for both aspiring and established artists wishing to create with glass. We foster innovative art and advance the use and appreciation of glass as a creative medium.

UrbanGlass

647 Fulton Street · Brooklyn, NY 11217 · 718.625.3685 · info@urbanglass.org · www.urbanglass.org

Your window to Europe!

Between art and craft.

With the aim of shedding light on clay as a design medium, KeramikMagazin bridges the gap between art and craft. Going beyond German-speaking countries, KeramikMagazin is a technical journal with a European focus. In addition to exhibition reviews, portraits of artists, and reports from studios and workshops, the magazine provides information on major international competitions and symposia. It profiles galleries, museums and markets, discusses topical issues relevant to the ceramics scene, and examines historical matters. Every issue contains a comprehensive round-up of forthcoming exhibitions, competitions, and museum and market events, and looks at recently published books. KeramikMagazin is published 6 times annually.

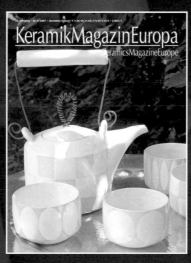

METALSMITH

Metalsmith shines its spotlight on the "why" of jewelry and metalsmithing.

• Inspirational, innovative, and thought-provoking
• Fascinating articles, intriguing artists
• Engrossing guest columns
• Captivating exhibition and book reviews
• Gorgeous images of stunning work
• Stimulating intellectual and visual interest

TO SUBSCRIBE:
541.345.5689
Info@snagmetalsmith.org

SUZANNE RAMLJAK, Editor
203.792.5599
fax 203.792.5588
editor@snagmetalsmith.org

JEAN SAVARESE, Advertising Director
413.585.8478
fax 413.585.8430
advertising@snagmetalsmith.org

DANA SINGER, Executive Director

Published five times a year, by the
Society of North American Goldsmiths,
the premier organization for jewelers,
designers and metalsmiths

SUBSCRIBE TODAY for only $34 at
www.snagmetalsmith.org

METALSMITH

JEWELRY ▪ DESIGN ▪ METAL ARTS

Hip Hop Jewelry

Form and Performance

Drawn from the Land

volume 27 number 1
www.snagmetalsmith.org

NEUES GLAS
NEW GLASS

The Best of International

NEW CERAMICS

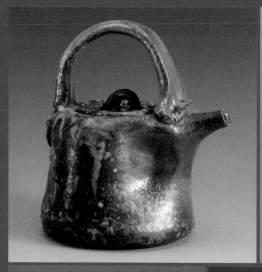 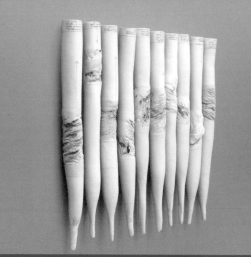 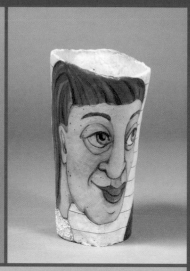

 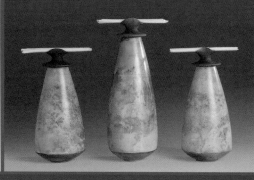

The **NEWS** reports on the latest from the ceramics scene in Germany, Austria and Switzerland, but it also includes what is going on in other countries in Europe as well as internationally. **This is where you can find the most important dates for competitions, events and new developments.**

PORTRAITS OF ARTISTS form the main part of the magazine. Craftspeople, designers and artists working with ceramics are presented with their work, their methods and techniques, and their artistic careers.

Reports about current **EXHIBITIONS, WORKSHOPS AND SYMPOSIA** are the second focal point.

In **FORUM**, philosophical and historical topics are taken up, explained and discussed.

In **HISTORY**, interesting historical developments in ceramics are covered.

Other permanent sections in **NEW CERAMICS** include:

KNOWLEDGE & SKILL - with techniques, new developments and the necessary background knowledge.

CERAMICS & TRAVEL shows the way to ceramically interesting destinations.

GALLERY GUIDE lists dates and details from European and international galleries.

BOOK REVIEWS covers the latest publications and offers standard works for ceramics.

And we give listings of **COURSES, MARKETS** and **ADVERTISEMENTS.**

NEW CERAMICS PRINT & ONLINE EDITION: www.neue-keramik.de www.new-ceramics.com

NEW CERAMICS - 6 issues a year
ANNUAL SUBSCRIPTION:
Europe: surface mail € 44 | US$ 54 | £ 35
World: surface mail € 46 . | US$ 54 | £ 35
World: airmail € 59 | US$ 72 | £ 41
Ask for a trial copy € 7.50 | US$ 9.50 | £ 6

NEW CERAMICS GmbH, Steinreuschweg 2
D-56203 Hoehr-Grenzhausen, Germany
Tel. +49(0)26 24-94 80 68 Fax: -94 80 71
www.neue-keramik.de info@neue-keramik.de
ONLINE-SUBSCRIPTION: www.new-ceramics.com

NEW CERAMICS

THE EUROPEAN CERAMICS MAGAZINE

Gives a clear overview of the international developments in
ceramics, focussing particularly on the situation in Europe

STUDIO EDITION

object

55

A SPECIAL ISSUE THAT
TAKES US ACROSS
THE GLOBE AND INTO THE
PRIVATE WORK SPACES
OF A DIVERSE GROUP OF
MAKERS AND DESIGNERS.

0 74470 99328 5 55
A$15.00 (INC GST)
NZ$17.50 (INC GST)

objectmagazine

For a fresh perspective on craft and design.

Australia's leading craft and design
magazine brings you inspiration, innovation
and information from Australia,
New Zealand and across the globe.

SUBSCRIBE

→ **one issue free**

→ **free delivery to your door**

→ **your copy before it hits the stores**

→ **great gift idea**

Australia $45.00 (incl. GST)
New Zealand/Asia A$80.00
USA/Europe A$95.00

**Simply copy this form
and fax to: + 61 2 9361 4533
Telephone: + 61 2 9361 4555
Email object@object.com.au**

☐ **Yes, I would like a four-issue subscription
delivered to my door, starting with issue no:** _____
Australia $45.00 (inc. GST) / New Zealand & Asia A$80.00 / USA & Europe A$95.00

OR

☐ **Yes, I would like to become an Object Supporter, to receive additional benefits
to my subscription, such as invitations to exhibition opening nights.**
A$75.00 (inc. GST)

☐ **Yes, I would like to stay up-to-date with Object exhibitions and events.
Please email me the free Object e-flier.**

☐ **Yes, this is a gift subscription for:**

Name _____

Address _____

Please complete the form below, then either:

Fax to: +61 2 9361 4533
Mail to: Object: Australian Centre for Craft and Design
 PO Box 63 Strawberry Hills NSW 2012
or email to: object@object.com.au
Telephone: +61 2 9361 4555

Your Details:

Name _____

Address _____

Telephone _____

Email _____

Payment Details:

TOTAL $ _____

☐ Cheque (in A$) payable to: Object: Australian Centre for Craft and Design

☐ Please charge my card: ☐ MasterCard ☐ Visa ☐ Amex ☐ Diners

Card no: ___ ___ ___ ___ ___ ___ ___ ___ ___ ___ ___ ___ ___ ___ ___ ___

Card expiry: ___ ___ / ___ ___

Name on card: _____

Cardholder signature: _____

Conditions: Subscription and Supporter rates are valid until 31 July 2008.
Object is committed to handling your personal information in accordance with the Australian Privacy Act.

WELCOME TO OUR WORLD

**Today's Creativity
At Its Best**

Ornament takes you to the artists and their studios as they reveal the innermost workings and details of what their art means, from the technical and the aesthetic to the theory and the practical.

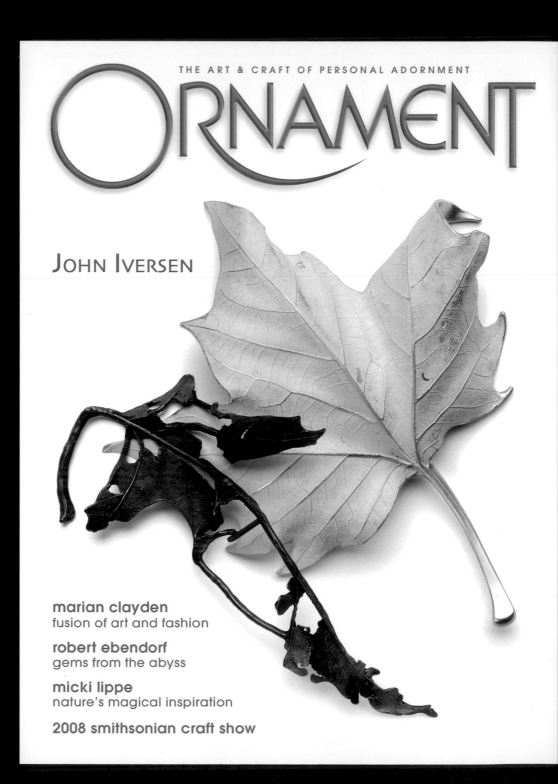

THE ART & CRAFT OF PERSONAL ADORNMENT

ORNAMENT

JOHN IVERSEN

marian clayden
fusion of art and fashion

robert ebendorf
gems from the abyss

micki lippe
nature's magical inspiration

2008 smithsonian craft show

ADD YOUR VISION TO OURS

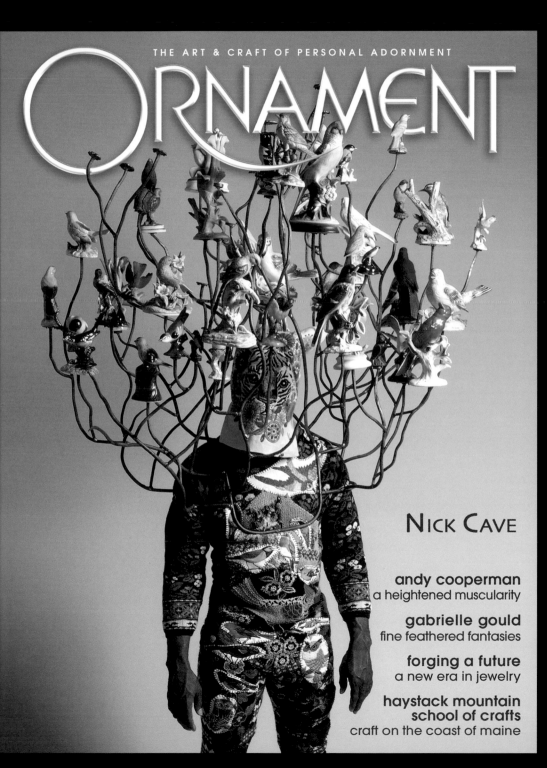

THE ART & CRAFT OF PERSONAL ADORNMENT

ORNAMENT

NICK CAVE

andy cooperman
a heightened muscularity

gabrielle gould
fine feathered fantasies

forging a future
a new era in jewelry

**haystack mountain
school of crafts**
craft on the coast of maine

A Precious Resource

Ornament celebrates the art and craft of personal adornment with stunning displays of creative works in every issue for more than thirty years. Together we will make this world a little more meaningful, a little more beautiful.

800.888.8950 5 Issues / $26

selvedge objects •••

Beautiful products made with integrity and the finest materials, direct from Selvedge magazine... *www.selvedge.org*

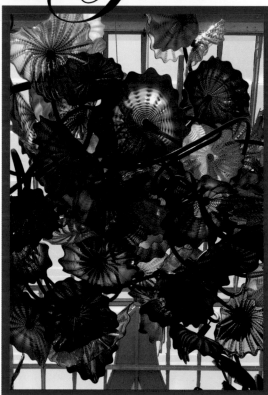
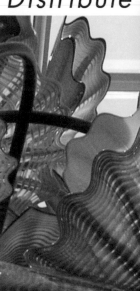

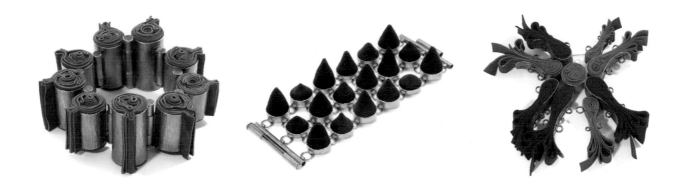

You're invited to join the Art Jewelry Forum

Join us and serve as advocates for this field by promoting education, appreciation, and support for contemporary art jewelry.

As a member, you'll learn more about contemporary art jewelry through monthly e-mail newsletters, the AJF website, and AJF-sponsored lectures and trips. When you travel with AJF, you visit private collections, go behind-the-scenes at art museums, and meet jewelry artists, curators, educators, and students at top universities with metals programs.

Each year, AJF awards grants and presents an Emerging Artist Award at SOFA Chicago. For 2008, AJF has increased the award to $5,000, more than double last year's award.

Work by Andrea Janosik,
winner of the Art Jewelry Forum's
2007 Emerging Artist Award

ART JEWELRY FORUM

ART JEWELRY FORUM • PO BOX 823 • MILL VALLEY, CA 94942 • 415.522.2924 • www.artjewelryforum.org

INTRODUCING ARTNET ONLINE AUCTIONS

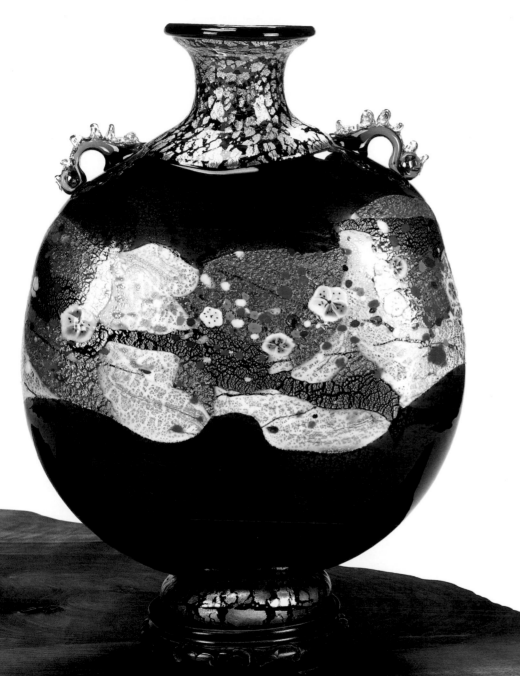

Collectors of Wood Art

Robyn Horn
Photo: Matt Bradley

Join
Collectors of Wood Art
Today!

NETWORK with Artists, Collectors & Curators

VISIT Artist Studios

TOUR Private Collections

ENJOY Lectures and Panel Discussions

RECEIVE the Informative CWA Newsletter

Be Part of the Growing
Studio Wood Movement!

Collectors of Wood Art
P.O. Box 491973
Los Angeles, California 90049
888.393.8332
www.collectorsofwoodart.org

Robyn Horn
2007 Recipient
Lifetime Achievement
Award

CWA honors Robyn Horn as an innovative wood artist and as a founder of CWA. Robyn also is recognized as a national leader in the promotion and support of craft art in all media.

LARSEN

ELLE DECOR

PHOTO: JOSHUA MCHUGH

THE INTERNATIONAL FASHION MAGAZINE FOR THE HOME
A PUBLICATION OF HACHETTE FILIPACCHI MEDIA

FOR ADVERTISING INQUIRIES, CONTACT DAN RAGONE, VP/PUBLISHER AT 212.767.5813

GLASS ART SOCIETY

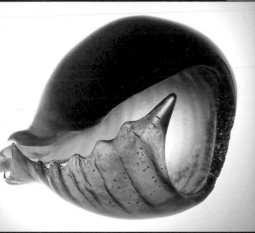

JOIN US!

Membership is open to anyone interested in glass art:
- Artists · Galleries · Students · Collectors
- Educators · Museums · Administrators
- Writers · Manufacturers and Suppliers

You receive:
- *GASnews*: 6 newsletters each year
- *Journal* documenting our Annual Conference
- Web link to your page · Access to our Blog
- *Directory & Resource Guide* · Newsletter Ad Discounts

Take advantage of:
- Hertz Rental Car discounts
- Shipping discounts with FedEx and DHL*
- Traveler's Insurance · GAS Health Insurance Plan*
- Annual Conference · Mailing Lists
- Networking Opportunities
- Members Only Section on the GAS Website

OVER 3000 MEMBERS IN 54 COUNTRIES

For more information or to join, contact the GAS office

*For U.S. based members only

Images *(clockwise from upper left):* Mark Abilgaard, "Ancestor Boat";
Taliaferro Jones, "Embrace"; Laura Donefer, "Afrique"; Scott Benefield, "Cloche Mechanique";
Giles Bettison, "Billett"; Jane Bruce, "Shift; Helen Stokes, "Resonance".

Visit us at SOFA New York, November 7-9, 2008

GLASS ART
SOCIETY

3131 Western Avenue, Suite 414
Seattle, Washington 98121 USA
Tel: 206.382.1305 Fax: 206.382.2630
E-mail: info@glassart.org Web: www.glassart.org

GREENWICH HOUSE POTTERY

A PROGRAM OF GREENWICH HOUSE INC.

SUMMER MASTERS SERIES

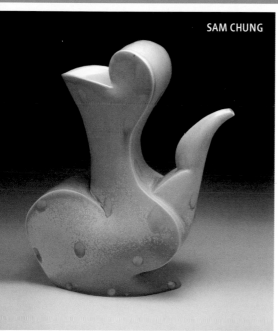

SAM CHUNG

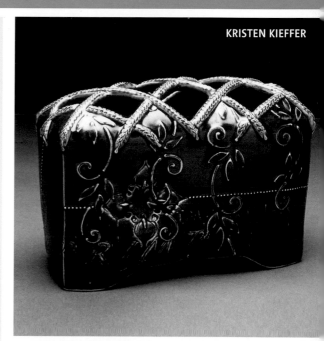

KRISTEN KIEFFER

WORKSHOPS WILL INCLUDE

Pitchers and Ewers with Sam Chung
July 25-27, 10AM- 4PM

Surface and Color: A Focus on Terra Sigillata and Slip with Stephen Robison
July 25-27, 10AM- 4PM

Form and Surface Embellishment with Erin Furimsky
August 1-3, 10AM- 4PM

Ornately Functional: Form and Surface with Kristen Kieffer
August 1-3, 10AM- 4PM

Registration fee is $10
Tuition is $295
Workshops are 10am-4pm
Studio hours are 10am-10pm
Call 212-242-4106 to register
www.greenwichhousepottery.org
Materials and firing included

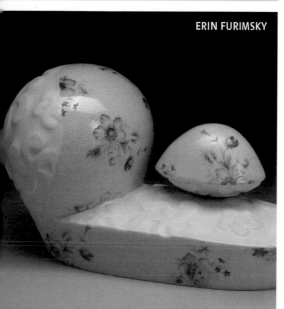

ERIN FURIMSKY

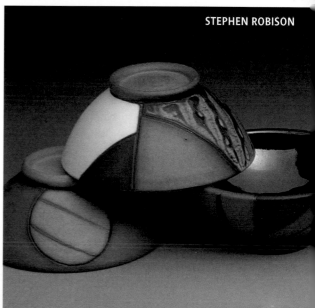

STEPHEN ROBISON

Klimt02 | Community

www.klimt02.net

Online platform for the communication and the development
of the international and emerging art jewellery and jewellery design.
Contemporary creation, selection and quality.

C. Còrsega, 317, Pral. 2ª
08008 Barcelona (Spain)

T. +34 93 368 72 35

mail: klimt@klimt02.net

If it can be hammered, blown, thrown, bent, welded, glued, fired, forged, folded, pierced, melted, cast, cut, sanded, glazed, sculpted, polished, embroidered, stitched, laminated, twisted, incised, molded, embellished, dyed, engraved, stained, riveted, reused, alloyed, or rapid-prototyped, it can be crafted into the art of the now, before your eyes, at the new

Where old boundaries are lost.
And new art is found.

museum of arts and design
www.madmuseum.org

contemporary art fair

palmbeach³
CONTEMPORARY

15-18 JANUARY 2009

PREVIEW EVENING **JAN.14**
Palm Beach County Convention Center
561.209.1308
www.palmbeach3.com

Park Avenue Armory

Park Avenue Armory is a newly launched contemporary arts institution with a vast drill hall and exuberant historic rooms. This non-traditional space catalyzes creative experimentation and interaction between artists and audiences. Park Avenue Armory is also dedicated to the restoration and renovation of its world-class landmark building.

MILLER THEATER at Columbia University in association with Park Avenue Armory will present **STRAVINSKY'S SACRED MASTERPIECES.** Filling the extraordinary vastness of the Armory's drill hall, recently named Wade Thompson Hall, the Vox Vocal Ensemble and Gotham City orchestra, under the direction of George Steel, will offer four ground-breaking masterpieces. **APRIL 19, 2008**

LINCOLN CENTER FESTIVAL 2008 in association with Park Avenue Armory will present an epic production of the opera, **DIE SOLDATEN** in the cavernous Wade Thompson Hall. *"A knuckle-whitening ride through a thrilling tale,"* proclaims the Financial Times (London) about Die Soldaten, German expressionist composer Bernd Alois Zimmermann's post-war powerful and wrenching music drama. A pioneering work at its creation with a 110-piece orchestra, challenging score and vocal writing, Die Soldaten features overlapping and simultaneous scenes that incorporate taped music and amplification. **JULY 5, 7, 9, 11, 12, 2008**

For more information, please call (212) 616-3937 or visit www.armoryonpark.org.

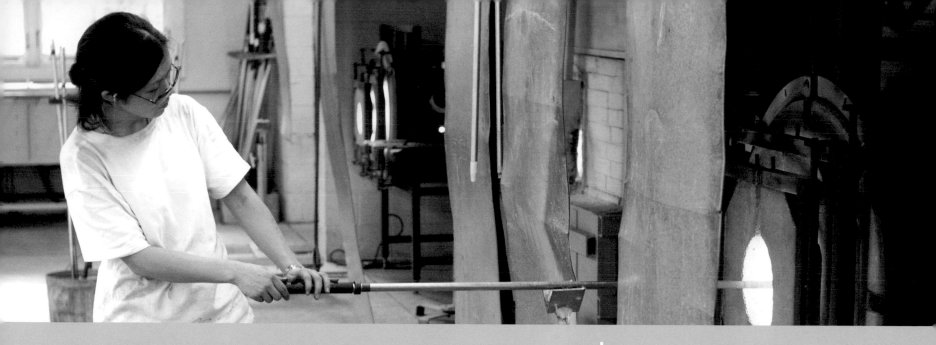

HELPING PEOPLE LIVE CREATIVE LIVES

Workshops • Gallery • Artist Residencies

P.O. Box 37, Penland, NC 28765
828.765.2359 • www.penland.org

Penland
School *of* Crafts

23RD ANNUAL
BENEFIT AUCTION

FRIDAY & SATURDAY
AUGUST 8 & 9, 2008

Save the Date

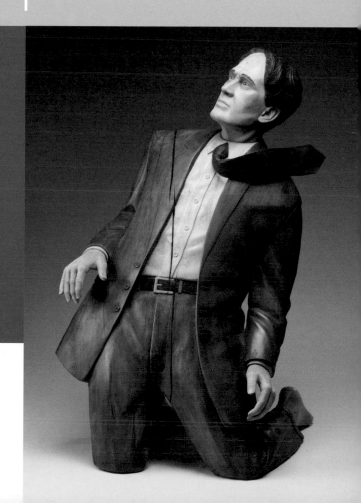

The Penland School of Crafts Annual Benefit Auction is a gala weekend in the North Carolina mountains featuring the sale of more than 200 works in books, clay, drawing, glass, iron, letterpress, metals, painting, photography, printmaking, textiles, and wood. The Penland auction is one of the most important craft collecting events in the Southeast and a perfect opportunity to support Penland's educational programs, which have helped thousands of people to live creative lives.

Photo: Bob Trotman, *Martin*, 2008, poplar, basswood, tempera, wax, 41 x 23 x 23 in.

Wood Turning Center

Visit the Center to discover wood art

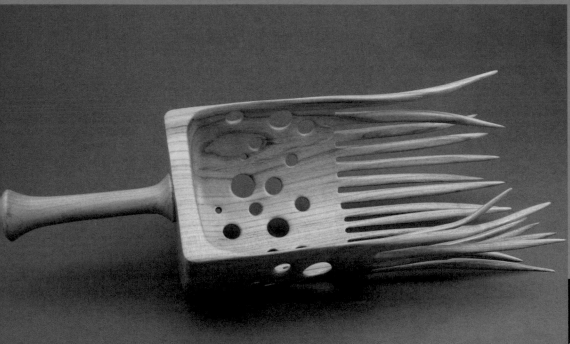

- International not-for-profit art organization
- Contemporary art from wood and other materials
- Gallery exhibitions, publications, Museum Store
- Research library with books, images and artist information
- Permanent collection of wood art

see it, touch it, love it

The Museum Store at the Wood Turning Center

Wood Turning Center
501 Vine Street, Philadelphia, PA 19106
tel: 215.923.8000
fax: 215.923.4403
www.woodturningcenter.org

Hours:
Monday–Friday 10am-5pm
Saturday 12pm-5pm

above:
Pascal Oudet
Peigne Ami'rtilles, 2007
Cherry
3" x 5" x 12"

Pascal Oudet's work is from the upcoming
touring exhibit *Challenge VII: dysFUNKtional*.
For inquiries about the tour please call
(215.923.8000) or email
(info@woodturningcenter.org).

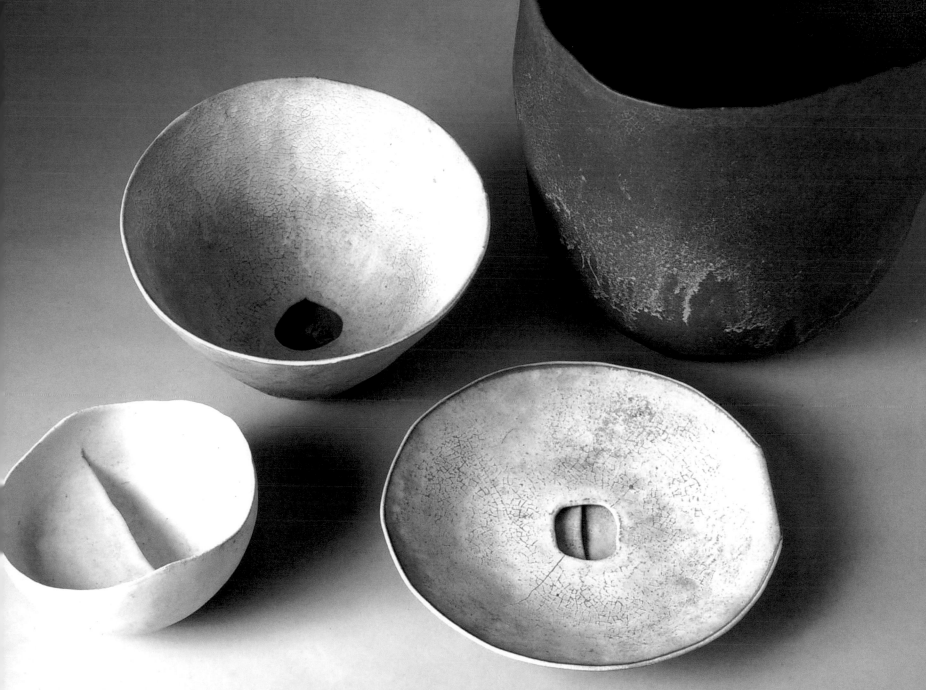

100 VESSELS at LongHouse

2-5pm Wednesdays and Saturdays through October 11, 2008
July & August, Wednesdays through Saturdays 2-5pm

This exhibition is made possible with the generous support by Johnson Family Foundation, Edward R. Roberts Family Foundation, and Barbara Slifka.

LONGHOUSE RESERVE
133 Hands Creek Road | East Hampton, NY 11937 | TEL. 631.329.3568 | www.longhouse.org

Four Vessels by Richard DeVore (American, 1933-2006), collection of LongHouse Reserve, gift of Jack Lenor Larsen.

SOFA savvy
SOFA fairs
SOFA culture
SOFA news
SOFAexpo.com
SOFA galleries
SOFA artists
SOFA salon
SOFA tickets
SOFA now
SOFA next
SOFA CHICAGO
SOFA NEW YORK
SOFA up close
SOFA wow

SOFA

hibitors

Aaron Faber Gallery
666 Fifth Avenue
New York, NY 10103
212.586.8411
fax 212.582.0205
info@aaronfaber.com
aaronfaber.com

Adamar Fine Arts
4141 NE 2nd Avenue
Suite 107
Miami, FL 33137
305.576.1355
fax 305.516.1922
adamargal@aol.com
adamargallery.com

Andora Gallery
77 West Huron Street
Chicago, IL 60610
312.274.3747
fax 312.274.3748
info@andoragallery.com
andoragallery.com

Ann Nathan Gallery
212 West Superior Street
Chicago, IL 60610
312.664.6622
fax 312.664.9392
nathangall@aol.com
annnathangallery.com

Art Miya
2-8-7, 701 Nakameguro
Meguro-ku, Tokyo 153-0061
Japan
81.3.5704.2451
cell 646.596.9085
fax 81.3.5704.3932
sachikotsuchiya@artmiya.com
artmiya.com

**ARTCOURT Gallery -
Yagi Art Management, Inc.**
Tenmabashi 1-8-5
Kita-ku, Osaka 530-0042
Japan
81.6.6354.5444
fax 81.6.6354.5449
info@artcourtgallery.com
artcourtgallery.com

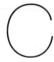

Barry Friedman Ltd.
515 West 26th Street
New York, NY 10001
212.239.8600
fax 212.239.8670
contact@barryfriedmanltd.com
barryfriedmanltd.com

Berengo Studio
Fondamenta Vetrai 109/A
Murano, Venice 30141
Italy
39.041.739.453
cell 646.826.9558
fax 39.041.527.6588
adberen@berengo.com
berengo.com

Berengo Collection
Calle Larga San Marco 412/413
Venice 30124
Italy
39.041.241.0763
fax 39.041.241.9456

Chappell Gallery
526 West 26th Street
Suite 317
New York, NY 10001
212.414.2673
fax 212.414.2678
amchappell@aol.com
chappellgallery.com

Charon Kransen Arts
By Appointment
456 West 25th Street, Suite 2
New York, NY 10001
212.627.5073
fax 212.633.9026
charon@charonkransenarts.com
charonkransenarts.com

**Clare Beck at
Adrian Sassoon**
By Appointment
14 Rutland Gate
London SW7 1BB
United Kingdom
44.20.7581.9888
fax 44.20.7823.8473
email@adriansassoon.com
adriansassoon.com

Blue Rain Gallery
130 Lincoln Avenue
Suite D
Santa Fe, NM 87501
505.954.9902
fax 505.954.9904
info@blueraingallery.com
blueraingallery.com

browngrotta arts
Wilton, CT
203.834.0623
fax 203.762.5981
art@browngrotta.com
browngrotta.com

**Collection Ateliers
d'Art de France**
4 Rue de Thorigny
Paris 75003
France
33.1.4278.6774
fax 33.1.4277.4201
collection@ateliersdart.com
ateliersdart.com

Compendium Gallery
5 Lorne Street
Auckland 1010
New Zealand
649.300.3212
fax 649.300.3212
sales@compendiumgallery.com
compendiumgallery.com

CREA Gallery
350 St. Paul East
Montreal, Quebec H2Y 1H2
Canada
514.878.2787, ext. 2
fax 514.861.9191
crea@metiers-d-art.qc.ca
creagallery.com

The David Collection
44 Black Spring Road
Pound Ridge, NY 10576
914.764.4674
jkdavid@optonline.net
thedavidcollection.com

del Mano Gallery
11981 San Vicente Boulevard
Los Angeles, CA 90049
310.476.8508
fax 310.471.0897
gallery@delmano.com
delmano.com

DF ART INTERNATIONAL
1-7-3 Hozumi
Toyonaka, Osaka 561-0856
Japan
81.6.6866.1405
fax 81.6.6866.2104
art@watouki.com
watouki.com

Donna Schneier Fine Arts
By Appointment
PO Box 3209
Palm Beach, FL 33480
561.202.0137
cell 518.441.2884
dnnaschneier@mhcable.com

Duane Reed Gallery
7513 Forsyth Boulevard
St. Louis, MO 63105
314.862.2333
fax 314.862.8557
duane@duanereedgallery.com
duanereedgallery.com

Ferrin Gallery
437 North Street
Pittsfield, MA 01201
413.442.1622
fax 413.634.8811
info@ferringallery.com
ferringallery.com

Galerie Besson
15 Royal Arcade
28 Old Bond Street
London W1S 4SP
United Kingdom
44.20.7491.1706
fax 44.20.7495.3203
enquiries@galeriebesson.co.uk
galeriebesson.co.uk

Galerie Elca London
224 St. Paul Street West
Montreal, Quebec H2Y 1Z9
Canada
514.282.1173
fax 514.282.1229
info@elcalondon.com
elcalondon.com

Galerie Vivendi
28 Place des Vosges
Paris 75003
France
33.1.4276.9076
fax 33.1.4276.9547
vivendi@vivendi-gallery.com
vivendi-gallery.com

Galleri Udengaard
Vester Alle 9
Åarhus C 8000
Denmark
45.86.259.594
udengaard@c.dk
galleriudengaard.com

Gallery 31
31 KwanHoon Dong
JongRo Koo, Seoul
Korea
82.2.732.1290
gallery31korea@yahoo.com

gallery gen
158 Franklin Street
New York, NY 10013
212.226.7717
fax 212.226.3722
info@gallerygen.com
gallerygen.com

Habatat Galleries Chicago
222 West Superior Street
Chicago, IL 60610
312.440.0288
fax 312.440.0207
info@habatatchicago.com
habatatchicago.com

Heller Gallery
420 West 14th Street
New York, NY 10014
212.414.4014
fax 212.414.2636
info@hellergallery.com
hellergallery.com

Holsten Galleries
3 Elm Street
Stockbridge, MA 01262
413.298.3044
artglass@holstengalleries.com
holstengalleries.com

Jane Sauer Gallery
652 Canyon Road
Santa Fe, NM 87501
505.995.8513
fax 505.995.8507
jsauer@jsauergallery.com
jsauergallery.com

Jewelers' Werk Galerie
3319 Cady's Alley NW
Washington, DC 20007
202.337.3319
fax 202.337.3318
ellen@jewelerswerk.com
jewelerswerk.com

Joan B. Mirviss LTD
39 East 78th Street
4th floor
New York, NY 10075
212.799.4021
fax 212.721.5148
joan@mirviss.com
mirviss.com

Joanna Bird Pottery
By Appointment
19 Grove Park Terrace, Chiswick
London W4 3QE
United Kingdom
44.20.8995.9960
fax 44.20.8742.7752
joanna@joannabirdpottery.com
joannabirdpottery.com

John Natsoulas Gallery
521 First Street
Davis, CA 95616
530.756.3938
art@natsoulas.com
natsoulas.com

KEIKO Gallery
121 Charles Street
Boston, MA 02114
617.725.2888
fax 617.725.2888
keiko.fukai@verizon.net
keikogallery.com

**Køppe Gallery -
contemporary objects**
Bredgade 66
Copenhagen K 1260
Denmark
45.3333.0087
info@koppegallery.com
koppegallery.com

Lacoste Gallery
25 Main Street
Concord, MA 01742
978.369.0278
fax 978.369.3375
info@lacostegallery.com
lacostegallery.com

Leo Kaplan Modern
41 East 57th Street
7th floor
New York, NY 10022
212.872.1616
fax 212.872.1617
lkm@lkmodern.com
lkmodern.com

Loveed Fine Arts
575 Madison Avenue
Suite 1006
New York, NY 10022
212.605.0591
fax 212.605.0592
loveedfinearts@earthlink.net
loveedfinearts.com

Maria Elena Kravetz
San Jerónimo 448
Córdoba X5000AGJ
Argentina
54.351.422.1290
mek@mariaelenakravetzgallery.com
mariaelenakravetzgallery.com

Marx-Saunders Gallery LTD
230 West Superior Street
Chicago, IL 60610
312.573.1400
fax 312.573.0575
marxsaunders@earthlink.net
marxsaunders.com

Mattson's Fine Art
2579 Cove Circle, NE
Atlanta, GA 30319
404.636.0342
fax 404.636.0342
sundew@mindspring.com
mattsonsfineart.com

Mobilia Gallery
358 Huron Avenue
Cambridge, MA 02138
617.876.2109
fax 617.876.2110
mobiliaart@verizon.net
mobilia-gallery.com

Moderne Gallery
111 North 3rd Street
Philadelphia, PA 19106
215.923.8536
fax 215.923.8435
raibel@aol.com
modernegallery.com

Modus Art Gallery
23 Place des Vosges
Paris 75003
France
33.1.4278.1010
cell 917.257.6606
fax 33.1.4278.1400
modus@galerie-modus.com
galerie-modus.com

Mostly Glass Gallery
34 Hidden Ledge Road
Englewood, NJ 07631
201.503.9488
fax 201.503.9522
info@mostlyglass.com
mostlyglass.com

Naun Craft
Hilton Hotel F1
395 Namdaemunro-5ga
Jung-gu, Seoul 100-095
Korea
82.2.779.2259
fax 82.2.318.2846
brian4915@hanmail.net
nauncraft.com

Onishi Gallery
521 West 26th Street
New York, NY 10001
212.695.8035
fax 212.695.8036
info@onishigallery.com
onishigallery.com

Option Art
4216 de Maisonneuve Blvd. West
Suite 302
Montreal, Quebec H3Z 1K4
Canada
514.932.3987
info@option-art.ca
option-art.ca

Orley & Shabahang
241 East 58th Street
New York, NY 10022
646.383.7511
fax 646.383.7954
orleyshabahang@gmail.com
orleyshabahang.com

240 South County Road
Palm Beach, FL 33480
561.655.3371
shabahangorley@gmail.com

223 East Silver Spring Drive
Whitefish Bay, WI 53217
414.332.2486
shabahangcarpets@gmail.com

By Appointment
5841 Wing Lake Road
Bloomfield Hills, MI 48301
586.996.5800

Ornamentum
506.5 Warren Street
Hudson, NY 12534
518.671.6770
fax 518.822.9819
info@ornamentumgallery.com
ornamentumgallery.com

PRISM Contemporary Glass
1048 West Fulton Market
Chicago, IL 60607
312.243.4885
info@prismcontemporary.com
prismcontemporary.com

Ruth Lawrence Fine Art
3450 Winton Place
Rochester, NY 14623
585.292.1430
fax 585.292.1254
nmg3450@frontiernet.net
nanmillergallery.com

Sienna Gallery
80 Main Street
Lenox, MA 01240
413.637.8386
info@siennagallery.com
siennagallery.com

Signature Gallery
2364 Whitesburg Drive
Huntsville, AL 35801
256.536.1960
fax 256.539.8192
siggallery@aol.com
signaturegallery.com

Snyderman-Works Galleries
303 Cherry Street
Philadelphia, PA 19106
215.238.9576
fax 215.238.9351
bruce@snyderman-works.com
snyderman-works.com

TAI Gallery
1601B Paseo de Peralta
Santa Fe, NM 87501
505.984.1387
fax 505.989.7770
gallery@textilearts.com
taigallery.com

ten472 Contemporary Art
10472 Alta Street
Grass Valley, CA 95945
707.484.2685
fax 707.484.2685
info@ten472.com
ten472.com

Turkish Cultural Foundation
Boston, MA
Istanbul, Turkey
Washington, DC
director@turkishculture.org
turkishculturalfoundation.org

21ST Editions
9 New Venture Drive, #1
South Dennis, MA 02660
508.398.3000
fax 508.398.0343
21st@21steditions.com
21steditions.com

UrbanGlass
647 Fulton Street
Brooklyn, NY 11217
718.625.3685
fax 718.625.3889
info@urbanglass.org
urbanglass.org

Valentin Magro New York
42 West 48th Street
New York, NY 10036
212.575.9044
fax 212.575.9045
valentin@valentinmagro.com
valentinmagro.com

William Zimmer Gallery
PO Box 263
Mendocino, CA 95460
707.937.5121
fax 707.937.2405
wzg@mcn.org
williamzimmergallery.com

Y

Yaw Gallery
550 North Old Woodward Avenue
Birmingham, MI 48009
248.647.5470
fax 248.657.3715
yawgallery@msn.com
yawgallery.com

Z

**Zest Contemporary
Glass Gallery**
Roxby Place
London SW6 1RS
United Kingdom
44.20.7610.1900
fax 44.20.7610.3355
nell@zestgallery.com
zestgallery.com

Artists

Aaronson, Adam
Zest Contemporary
 Glass Gallery

Abboud, Rami
Aaron Faber Gallery

Abe, Anjin
Onishi Gallery

Abe, Motoshi
TAI Gallery

Åberg, Barbro
Lacoste Gallery

Abeyta, Tony
Blue Rain Gallery

Abraham, Françoise
Modus Art Gallery

Abright, Oben
Habatat Galleries Chicago

Adams, Renie Breskin
Mobilia Gallery

Adla, Etidloie
Galerie Elca London

Adler, Deborah Faye
UrbanGlass

Aguiar, Hamilton
Ruth Lawrence Fine Art

Ahlgren, Jeanette
Mobilia Gallery

Akers, Adela
browngrotta arts

Akiyama, Yô
Joan B. Mirviss LTD

Alepedis, Efharis
Charon Kransen Arts

Alymeda, Diana
Yaw Gallery

Amano, Shihoko
Sienna Gallery

Amiols, Nati
Yaw Gallery

Amromin, Pavel
Ann Nathan Gallery

Anderegg, Wesley
John Natsoulas Gallery

Anderson, Dona
browngrotta arts

Anderson, Jeanine
browngrotta arts

Anderson, Kate
Snyderman-Works Galleries

Anderson, Marianne
Aaron Faber Gallery

Angelino, Gianfranco
del Mano Gallery

Anilanmert, Beril
Loveed Fine Arts

Antemann, Chris
Ferrin Gallery

Arai, Junichi
gallery gen

Arentzen, Glenda
Aaron Faber Gallery

Arima, Curtis H.
Yaw Gallery

Arneson, Robert
John Natsoulas Gallery

Assakr, Khalid
Mostly Glass Gallery

Autio, Rudy
Donna Schneier Fine Arts
Duane Reed Gallery
Loveed Fine Arts

Avaalaaqiaq, Irene
Galerie Elca London

Babetto, Giampaolo
Sienna Gallery

Babula, Mary Ann
Chappell Gallery

Bach, Carolyn Morris
William Zimmer Gallery

Bacsh, Sara
The David Collection

Baines, Robert
Jewelers' Werk Galerie

Bakker, Ralph
Charon Kransen Arts

Baldridge, Jamie
21ST Editions

Baldwin, Gordon
Loveed Fine Arts

Balsgaard, Jane
browngrotta arts

Barello, Julia
Charon Kransen Arts

Barker, Jo
browngrotta arts

Barnes, Dorothy Gill
browngrotta arts

Barnes, Nick Grant
Yaw Gallery

Barry, Donna
Mobilia Gallery

Bartels, Rike
Charon Kransen Arts

Bartlett, Caroline
browngrotta arts

Bartley, Roseanne
Charon Kransen Arts

Bass, Kim
Mobilia Gallery

Bassler, James
Jane Sauer Gallery

Bastin, Nicholas
Charon Kransen Arts

Batt, Lucy Alexandra
Zest Contemporary
 Glass Gallery

Bauermeister, Michael
del Mano Gallery

Bayless, Heather
Yaw Gallery

Bean, Bennett
William Zimmer Gallery

Beard, Helen
Joanna Bird Pottery

Bearsley, Candace
Yaw Gallery

Beck, Rick
Marx-Saunders Gallery LTD

Becker, Michael
Charon Kransen Arts

Behar, Linda
Mobilia Gallery

Behennah, Dail
browngrotta arts

Behrens, Hanne
Mobilia Gallery

Bellavance, Jeanne
Option Art

Bennett, Garry Knox
Leo Kaplan Modern

Bennett, Jamie
Sienna Gallery

Benzoni, Luigi
Berengo Studio

Berg, Eva
Compendium Gallery

Bergner, Lanny
Mobilia Gallery
Snyderman-Works Galleries

Bergt, Michael
Jane Sauer Gallery

Berman, Nirit
Yaw Gallery

Bernstein, Alex Gabriel
Chappell Gallery

Bess, Nancy Moore
browngrotta arts

Bettison, Giles
Jane Sauer Gallery

Bikakis, Myron
Yaw Gallery

Bilenker, Melanie
Sienna Gallery

Birch, Karin
Snyderman-Works Galleries

Birkkjaer, Birgit
browngrotta arts

Birnbaum, Charles
Loveed Fine Arts

Blank, Alexander
The David Collection

Blavarp, Liv
Charon Kransen Arts

Bloomard, Adrean
The David Collection

Bloomfield, Greg
Leo Kaplan Modern

Blyfield, Julie
Charon Kransen Arts

Bobrowicz, Yvonne Pacanovsky
Snyderman-Works Galleries

Bodemer, Iris
Jewelers' Werk Galerie

Body Politics
Ornamentum

Bohnert, Thom
Loveed Fine Arts

Boieri, Daniela
Charon Kransen Arts

Bona, Luigi
Modus Art Gallery

Bonati, Patrizia
The David Collection

Book, Flora
Mobilia Gallery

Borgegard, Sara
Ornamentum

Borgenicht, Ruth
Lacoste Gallery

Borghesi, Marco
Aaron Faber Gallery

Borgman, Mary
Ann Nathan Gallery

Bottaro, Silvina
Maria Elena Kravetz

Boucard, Yves
Leo Kaplan Modern

Bouduban, Sophie
Charon Kransen Arts

Boyadjiev, Latchezar
Jane Sauer Gallery

Braham, Frederic
Charon Kransen Arts

Brandes, Juliane
Ornamentum

Braun, Stephen
John Natsoulas Gallery

Bravura, Dusciana
Berengo Studio

Bravura, Marco
Berengo Studio

Breadon, Eoin
PRISM Contemporary Glass

Brennan, Sara
browngrotta arts

Bressler, Mark
del Mano Gallery

Brill, Dorothea
Ornamentum

Brodie, Regis
Loveed Fine Arts

Bronstein, Leon
Modus Art Gallery

Brooks, Lola
Sienna Gallery

Brown, Christie
Loveed Fine Arts

Brown, Linda
Yaw Gallery

Brownsword, Neil
Galerie Besson

Brychtová, Jaroslava
Barry Friedman Ltd.

Buckman, Jan
browngrotta arts

Buddeberg, Florian
Charon Kransen Arts

Bump, Raissa
Sienna Gallery

Burchard, Christian
del Mano Gallery

Bussières, Maude
CREA Gallery

Butt, Harlan
Aaron Faber Gallery
Yaw Gallery

Byers, John Eric
Snyderman-Works Galleries

Byun, Veronica Juyoun
Loveed Fine Arts

Cahill, Lisa
PRISM Contemporary Glass

Calderwood, Jessica
The David Collection

Callas, Peter
Loveed Fine Arts

Calmar, Lars
Galleri Udengaard

Camden, Emma
Chappell Gallery

Campbell, Marilyn
del Mano Gallery

Campbell, Pat
browngrotta arts

Cardew, Michael
Joanna Bird Pottery

Carlin, David
del Mano Gallery

Carlson, William
Leo Kaplan Modern
Marx-Saunders Gallery LTD

Carney, Shannon
Charon Kransen Arts

Carnochan, Brigitte
21ST Editions

Carpenter, Arthur Espenet
Moderne Gallery

Carroll, Mary
Loveed Fine Arts

Caruso, Nino
Loveed Fine Arts

Casanovas, Claudi
Galerie Besson

Casasempere, Fernando
Joanna Bird Pottery

Castagna, Pino
Berengo Studio

Castle, Wendell
Barry Friedman Ltd.
Moderne Gallery

Catalano, Bruno
Modus Art Gallery

Celotto, Afro
William Zimmer Gallery

Cepka, Anton
Charon Kransen Arts

Chaleff, Paul
Loveed Fine Arts

Chandler, Gordon
Ann Nathan Gallery

Chang, Yuyen
Aaron Faber Gallery

Chardiet, José
Leo Kaplan Modern

Chaseling, Scott
Leo Kaplan Modern

Chavez, Jane
Snyderman-Works Galleries

Chen, Yu Chun
Charon Kransen Arts

Chesney, Nicole
Heller Gallery

Chiarcos, Giorgio
The David Collection

Chihuly, Dale
Donna Schneier Fine Arts

Chin, Susan
Aaron Faber Gallery

Choi, Daniel
Gallery 31

Christensen, Stopher
Option Art

Christie, Barbara
The David Collection

Chun, DongHwa
Gallery 31

Church, Sharon
Mobilia Gallery

Ciscato, Carina
Joanna Bird Pottery

Clague, Lisa
John Natsoulas Gallery

Clark, Sonya
Snyderman-Works Galleries

Class, Petra
Aaron Faber Gallery

Clausager, Kirsten
Mobilia Gallery

Clegg, Tessa
Clare Beck at Adrian Sassoon

Cnaani-Sherman, Gali
browngrotta arts

Coates, Kevin
Mobilia Gallery

Coffey, Michael
Moderne Gallery

Cohen, Alexia
Mobilia Gallery

Cohen, Mardi Jo
Snyderman-Works Galleries

Coleman, Katharine
Zest Contemporary
 Glass Gallery

Collett, Susan
Andora Gallery

Consentino, Cynthia
Ferrin Gallery

Constantinidis, Joanna
Joanna Bird Pottery

Cook, Lia
browngrotta arts
Mobilia Gallery

Coper, Hans
Galerie Besson
Joanna Bird Pottery

Corbetta, Gloria
Maria Elena Kravetz

Cordova, Cristina
Ann Nathan Gallery

Corte, Annemie de
Charon Kransen Arts

Corvaja, Giovanni
Charon Kransen Arts

Côté, Marie-Andrée
CREA Gallery

Cottrell, Simon
Charon Kransen Arts

Crawford, David
William Zimmer Gallery

Crawford, Hilary
Chappell Gallery

Cribbs, KéKé
Leo Kaplan Modern
Marx-Saunders Gallery LTD

Cross, Susan
Mobilia Gallery

Crow, Nancy
Snyderman-Works Galleries

Crucq, Pascal
Modus Art Gallery

Cruz-Diez, Carlos
Galerie Vivendi

Currier, Anne
Lacoste Gallery
Loveed Fine Arts

Cutler, Robert
del Mano Gallery

da Silva, Jack
Yaw Gallery

da Silva, Marilyn
Mobilia Gallery
Yaw Gallery

Dae, Lee Kui
Galerie Vivendi

Dahm, Johanna
Ornamentum

Dailey, Dan
Leo Kaplan Modern

Daintry, Natasha
Joanna Bird Pottery

Dam, Steffen
Heller Gallery

D'Aquino, Donna
Ornamentum

Darty, Linda
Mobilia Gallery

Darwall, Mary
Mostly Glass Gallery

De Lafontaine, Elyse
CREA Gallery

De Ovies, Lindsey
Modus Art Gallery

de Saint Phalle, Niki
Ruth Lawrence Fine Art

de Santillana, Laura
Barry Friedman Ltd.

De Spoelberch, Elinor
Charon Kransen Arts

Deans, Jenny
Mobilia Gallery

Dejonghe, Bernard
Galerie Besson

Dekel, Nirit
Yaw Gallery

Delsavio, Karina
Maria Elena Kravetz

Dempster, Marina
Option Art

Detering, Saskia
Charon Kransen Arts

DeVore, Richard
Donna Schneier Fine Arts

DiCaprio, Dan
Charon Kransen Arts

Di Cono, Margot
Aaron Faber Gallery
Mobilia Gallery

Di Fiore, Miriam
Mostly Glass Gallery

Dias, Cristina
Mobilia Gallery

Dick, Pearl
Habatat Galleries Chicago

Dittlmann, Bettina
Jewelers' Werk Galerie

Dobler, Georg
The David Collection
Mobilia Gallery

Dodd, John
William Zimmer Gallery

Dohnanyi, Babette von
Charon Kransen Arts

Dolinsky, Lea
Maria Elena Kravetz

Donat, Ingrid
Barry Friedman Ltd.

Doolan, Devta
Aaron Faber Gallery

Draper, Gemma
Ornamentum

Dreyer, Joan
Snyderman-Works Galleries

Drury, Chris
browngrotta arts

Dubuffet, Jean
Ruth Lawrence Fine Art

Dunn, J. Kelly
del Mano Gallery

Duong, Sam Tho
Ornamentum

Dutari, Carolina
Maria Elena Kravetz

Ebner, David
Moderne Gallery

Echeverria, Carolina
Option Art

Edwards, Owen
William Zimmer Gallery

Ehmck, Nina
The David Collection

Eichenberg, Iris
Ornamentum

Eisler, Eva
The David Collection

Eitzenhoefer, Ute
Ornamentum

Ekegren, Björn
Galleri Udengaard

Elfasi, Haya
Yaw Gallery

Elia, Paul
Andora Gallery

Ellsworth, David
del Mano Gallery

Ellsworth, Wendy
Mostly Glass Gallery

Elyashiv, Noam
Sienna Gallery

Emond, Jean Louis
Option Art

Emrich, Sina
Charon Kransen Arts

Endler, Claudia
William Zimmer Gallery

Eng, Peggy
Aaron Faber Gallery

Engholm, Maria
Galleri Udengaard

Erickson, Gary
Loveed Fine Arts

Esherick, Wharton
Moderne Gallery

Eskuche, Matt
Habatat Galleries Chicago

Espersen, Morten Løbner
Lacoste Gallery

Esses, Mary
Yaw Gallery

Falck-Linssen, Jennifer
Mobilia Gallery

Falkenhagen, Diane
Mobilia Gallery

Farey, Lizzie
browngrotta arts

Feibleman, Dorothy
Mobilia Gallery

Fein, Harvey
del Mano Gallery

Fekete, Alex
PRISM Contemporary Glass

Fennell, J. Paul
del Mano Gallery

Ferguson, Ken
Moderne Gallery

Fisch, Arline
Mobilia Gallery

Fleischhut, Jantje
Ornamentum

Fleming, Ron
del Mano Gallery

Flockinger CBE, Gerda
Mobilia Gallery

Fok, Nora
Mobilia Gallery

Folino, Tom
Loveed Fine Arts

Ford, Steven
Snyderman-Works Galleries

Forlano, David
Snyderman-Works Galleries

Foster, Charlene
UrbanGlass

Fox, David
Habatat Galleries Chicago

Frank, Peter
Charon Kransen Arts

Franzin, Maria Rosa
Ornamentum

Frejd, Martina
Charon Kransen Arts

Frève, Carole
CREA Gallery

Fritsch, Elizabeth
Joanna Bird Pottery

Fritsch, Karl
Jewelers' Werk Galerie

Fritts, Debra
Ferrin Gallery

Fujinuma, Noboru
TAI Gallery

Fujita, Emi
Mobilia Gallery

Fujitsuka, Shosei
TAI Gallery

Fukami, Sueharu
Joan B. Mirviss LTD

Fukuchi, Kyoko
The David Collection

Fukumoto, Fuku
Joan B. Mirviss LTD

Futamura, Yoshimi
Joan B. Mirviss LTD

Galazka, Rafal
Mattson's Fine Art

Gall, Ted
William Zimmer Gallery

Ganch, Susie
Sienna Gallery

Garcia, Tammy
Blue Rain Gallery

Gardner, Mark
Andora Gallery

Garduno, Flor
21ST Editions

Garnier, Ariane
Maria Elena Kravetz

Garrett, John
Mobilia Gallery

Gavotti, Elizabeth
Maria Elena Kravetz

Geertsen, Michael
Køppe Gallery -
 contemporary objects

Geese, Claudia
Charon Kransen Arts

Gelbard, Anat
Yaw Gallery

Georgieva, Ceca
browngrotta arts

Gerbig-Fast, Lydia
Mobilia Gallery

Gilbert, Chantal
CREA Gallery

Gilbert, Karen
Snyderman-Works Galleries

Giles, Mary
browngrotta arts

Glancy, Michael
Barry Friedman Ltd.

Goen Amir, Noa
Mobilia Gallery

Goluch, Elizabeth
Mobilia Gallery

Gonzalez, Arthur
John Natsoulas Gallery

Gordin, Misha
21ST Editions

Gorman, Greg
21ST Editions

Gouldson, Rebecca
William Zimmer Gallery

Gralnick, Lisa
Ornamentum

Gray, Myra Mimlitsch
Sienna Gallery

Green, Linda
browngrotta arts

Grenon, Gregory
Habatat Galleries Chicago

Gross, Michael
Ann Nathan Gallery

Grossen, Françoise
browngrotta arts

Gudmann, Elisabett
ten472 Contemporary Art

Guendra, Batho
Ornamentum

Gustin, Chris
Lacoste Gallery

H

Hackenberg, Gesine
Sienna Gallery

Halabi, Sôl
Maria Elena Kravetz

Hall, Laurie
Mobilia Gallery

Hamada, Shôji
Joan B. Mirviss LTD
Joanna Bird Pottery

Hamma, Michael
The David Collection

Hanagarth, Sophie
Charon Kransen Arts

Hansen, Castello
Køppe Gallery -
 contemporary objects

Hansen, Steve
PRISM Contemporary Glass

Harding, Tim
Snyderman-Works Galleries

Hardy, Martine
Collection Ateliers
 d'Art de France

Harrell, Kimberely
Yaw Gallery

Harron, Karl
William Zimmer Gallery

Hart, Noel
Jane Sauer Gallery

Hatakeyama, Seido
TAI Gallery

Hatcher, Stephen
del Mano Gallery

Hatekayama, Norie
browngrotta arts

Hayakawa, Shokosai V
TAI Gallery

Hayes, Peter
Ann Nathan Gallery

Hayman, Jefferson
21ST Editions

Hédé, Armel
Collection Ateliers
 d'Art de France

Hedman, Hanna
Ornamentum

Heinrich, Barbara
William Zimmer Gallery

Henricksen, Ane
browngrotta arts

Henton, Maggie
browngrotta arts

Hentz, Christopher
Yaw Gallery

Heo, KilYang
Gallery 31

Herman, Sam
Zest Contemporary
 Glass Gallery

Hernmarck, Helena
browngrotta arts

Heyerdahl, Marian
Loveed Fine Arts

Hicks, Giselle
Ferrin Gallery

Hicks, Sheila
browngrotta arts

Higashi, April
Aaron Faber Gallery

Higson, Rauni
Yaw Gallery

Hildebrandt, Marion
browngrotta arts

Hill, Chris
Ann Nathan Gallery

Hillel, Meital
Yaw Gallery

Hiller, Mirjam
Charon Kransen Arts

Hindsgavl, Louise
Køppe Gallery -
 contemporary objects

Hinz, Leonore
Charon Kransen Arts

Hiraiwa, Tomoyo
Onishi Gallery

Hiraishi, Yu
The David Collection

Hobin, Agneta
browngrotta arts

Hogg MBE, Dorothy
Mobilia Gallery

Holmes, Kathleen
Chappell Gallery

Honda, Syoryo
TAI Gallery

Honjo, Naoki
TAI Gallery

Honma, Hideaki
TAI Gallery

Honma, Kazue
browngrotta arts

Hood, Barry
Loveed Fine Arts

Hopkins, Jan
Jane Sauer Gallery

Horn, Robyn
del Mano Gallery

Hoshi, Mitsue
KEIKO Gallery

Hoshino, Kayoko
Joan B. Mirviss LTD

Hosking, Marian
Charon Kransen Arts

Hosoe, Eikoh
21ST Editions

Houserova, Ivana
Mostly Glass Gallery

Hu, Mary Lee
Mobilia Gallery

Huang, David
del Mano Gallery

Hübel, Angela
Aaron Faber Gallery

Huber, Ursula
Berengo Studio

Huchthausen, David
Leo Kaplan Modern

Hughes, Linda
Charon Kransen Arts

Hughto, Margie
Loveed Fine Arts

Hull, Lynn
Yaw Gallery

Hunt, Kate
browngrotta arts

Hunter, Lissa
Jane Sauer Gallery

Hunter, William
del Mano Gallery

Hutter, Sidney
Marx-Saunders Gallery LTD

Hwang, Inkyoung
Jewelers' Werk Galerie

I

Iezumi, Toshio
Chappell Gallery

Ikemoto, Kazumi
Chappell Gallery

Ionescu, Ion
Yaw Gallery

Ipsen, Steen
Køppe Gallery -
 contemporary objects

Isaacs, Ron
Snyderman-Works Galleries

Ishida, Meiri
Charon Kransen Arts

Ishino, Koichi
ARTCOURT Gallery -
 Yagi Art Management, Inc.

Ishiyama, Reiko
Charon Kransen Arts

Isohi, Setsuko
TAI Gallery

Isupov, Sergei
Ferrin Gallery

Itchou, Matsuo
Chappell Gallery

Ito, Hirotoshi
KEIKO Gallery

Iwata, Hiroki
Charon Kransen Arts

Iwata, Kiyomi
browngrotta arts

Izawa, Yoko
The David Collection

J

Jacobi, Ritzi
browngrotta arts

Jacquard, Max
Zest Contemporary
 Glass Gallery

Janacek, Vlastislav
Mostly Glass Gallery

Janich, Hilde
Charon Kransen Arts

Jank, Michael
Jewelers' Werk Galerie

Jarman, Angela
Clare Beck at Adrian Sassoon

Jensen, John
Ann Nathan Gallery

Jensen, Mette
Charon Kransen Arts

Jivetin, Sergey
Ornamentum

Jocz, Dan
Mobilia Gallery
Ornamentum

Johanson, Olle
Yaw Gallery

John, Svenja
Jewelers' Werk Galerie

Johns, Mark
Yaw Gallery

Jolley, Richard
Leo Kaplan Modern

Jones, Megghan
Charon Kransen Arts

Jónsdóttir, Kristín
browngrotta arts

Joolingen, Machteld van
Charon Kransen Arts

Jordan, John
del Mano Gallery

Joy, Christine
browngrotta arts

Juenger, Ike
Charon Kransen Arts

Jung, Junwon
Charon Kransen Arts

Jünger, Hermann
Jewelers' Werk Galerie

Kajiwara, Koho
TAI Gallery

Kajiwara, Aya
TAI Gallery

Kakurezaki, Ryûichi
Joan B. Mirviss LTD

Kale, Yucel
Turkish Cultural Foundation

Kalish, Michael
Ruth Lawrence Fine Art

Kalman, Lauren
Sienna Gallery

Kamata, Jiro
Ornamentum

Kamens, Kim
Snyderman-Works Galleries

Kaneta, Masanao
Joan B. Mirviss LTD

Kang, Jong Sook
Loveed Fine Arts

Kang, Karen
Art Miya

Kataoka, Masumi
Charon Kransen Arts

Katsumata, Chieko
Joan B. Mirviss LTD

Katsushiro, Soho
TAI Gallery

Kaube, Susanne
Charon Kransen Arts

Kaufman, Glen
browngrotta arts

Kaufmann, Martin
Charon Kransen Arts

Kaufmann, Ruth
browngrotta arts

Kaufmann, Ulla
Charon Kransen Arts

Kawano, Shoko
TAI Gallery

Kawashima, Shigeo
TAI Gallery

Kawata, Tamiko
browngrotta arts

Keelan, Margaret
Lacoste Gallery

Kenna, Michael
21ST Editions

Kent, Ron
del Mano Gallery

Kerman, Janis
Option Art

Khanna, Charla
Jane Sauer Gallery

Kibe, Seiho
TAI Gallery

Kicinski, Jennifer Howard
Charon Kransen Arts

Kim, Jeong Yoon
Charon Kransen Arts

Kim, Jimin
Charon Kransen Arts

Kimura, Shizuko
Snyderman-Works Galleries

King, Anna
Mobilia Gallery

Kinnaird MBE, Alison
Zest Contemporary
 Glass Gallery

Kirkpatrick, Joey
Donna Schneier Fine Arts

Kishi, Eiko
Joan B. Mirviss LTD

Kitade, Kenjiro
DF ART INTERNATIONAL

Kivarkis, Anya
Sienna Gallery

Klancic, Anda
browngrotta arts

Klein, Christopher A.
Ann Nathan Gallery

Klingebiel, Jutta
Ornamentum

Klockmann, Beate
Ornamentum

Knauss, Lewis
browngrotta arts

Knobel, Esther
Sienna Gallery

Knowles, Sabrina
Duane Reed Gallery

Kobayashi, Masakazu
browngrotta arts

Kobayashi, Naomi
browngrotta arts

Kodré, Helfried
The David Collection

Koenigsberg, Nancy
browngrotta arts

Kohyama, Yasuhisa
Art Miya
browngrotta arts
Galerie Besson

Koike, Shoko
Joan B. Mirviss LTD

Koizumi, Tadashi
Mobilia Gallery

Kolesnikova, Irina
browngrotta arts

Komudo, Miyuki
Art Miya

Kondô, Takahiro
Barry Friedman Ltd.
Joan B. Mirviss LTD

Korowitz-Coutu, Laurie
Chappell Gallery

Kosonen, Markku
browngrotta arts

Krakowski, Yael
Charon Kransen Arts

Kreuder, Loni
Modus Art Gallery

Kroiz, Shana
Mobilia Gallery

Kruger, Daniel
Sienna Gallery

Kuhn, Jon
Marx-Saunders Gallery LTD

Kulka, Lilla
browngrotta arts

Kumai, Kyoko
browngrotta arts

Kuo, Yih-Wen
Loveed Fine Arts

Kurita, Koichi
ARTCOURT Gallery -
 Yagi Art Management, Inc.

Kusumoto, Mariko
Mobilia Gallery

Kwon, Jco-Hye
Mobilia Gallery

Kyriacou, Constantinos
The David Collection

L

Labianca, Lawrence
browngrotta arts

Labonté, Catherine
CREA Gallery

Lahover, Shay
Yaw Gallery

Lake, Pipaluk
Chappell Gallery

Laky, Gyöngy
browngrotta arts

Lamarche, Antoine
CREA Gallery

Landweer, Sonja
Snyderman-Works Galleries

Large, Cynthia
Ann Nathan Gallery

Larochelle, Christine
CREA Gallery

Larssen, Ingrid
The David Collection

Latven, Bud
del Mano Gallery

Lawty, Sue
browngrotta arts

Lay, Pat
Loveed Fine Arts

Layport, Ron
del Mano Gallery

Leach, Bernard
Joanna Bird Pottery

Leader, Emmett
Ferrin Gallery

Leavitt, Gail
Charon Kransen Arts

Lee, Dongchun
Charon Kransen Arts

Lee, Ed Bing
Snyderman-Works Galleries

Lee, Jennifer
Galerie Besson

Lee, Seung-Hea
Sienna Gallery

Leest, Felieke van der
Charon Kransen Arts

Légaré, Lynn
CREA Gallery

Lehtinen, Helena
Ornamentum

Leib, Shayna
Habatat Galleries Chicago

Leiss, Hilde
Charon Kransen Arts

Letts, Philip
Galerie Vivendi

Leuthold, Marc
Loveed Fine Arts

Lewis, John
Leo Kaplan Modern

Libenský, Stanislav
Barry Friedman Ltd.

Lieglein, Wolli
Ornamentum

Lillie, Jacqueline
Sienna Gallery

Linssen, Nel
Charon Kransen Arts

Lislerud, Ole
Loveed Fine Arts

Ljones, Åse
browngrotta arts

Lo, Beth
Duane Reed Gallery

Loeser, Tom
Leo Kaplan Modern

Loew, Susanna
Charon Kransen Arts

Long, J.P.
Habatat Galleries Chicago

Loret, Franck
Collection Ateliers
 d'Art de France

Løvaas, Astrid
browngrotta arts

Lovendahl, Nancy
Loveed Fine Arts

Lucero, Michael
Donna Schneier Fine Arts
Duane Reed Gallery

Lukaszewski, Laurel
Duane Reed Gallery

Lynch, Sydney
Aaron Faber Gallery

M

Macdonald, Marcia
Snyderman-Works Galleries

Macdonell, Jay
Donna Schneier Fine Arts

Mace, Flora
Donna Schneier Fine Arts

MacKenzie, Warren
Lacoste Gallery

MacNeil, Linda
Leo Kaplan Modern

MacNutt, Dawn
browngrotta arts

Maeda, Asagi
Mobilia Gallery

Maestre, Jennifer
Mobilia Gallery

Magro, Valentin
Valentin Magro New York

Mailer, Maggie
Ferrin Gallery

Mailland, Alain
del Mano Gallery

Majoral, Enric
Aaron Faber Gallery

Malinowski, Ruth
browngrotta arts

Malone, Kate
Clare Beck at Adrian Sassoon

Maloof, Sam
Moderne Gallery

Maman, Niso
Adamar Fine Arts

Mann, Sally
21ST Editions

Manz, Bodil
Køppe Gallery -
 contemporary objects

Marcangelo, Rita
The David Collection

Marchetti, Stefano
Charon Kransen Arts

Marder, Donna Rhae
Mobilia Gallery

Marioni, Dante
Marx-Saunders Gallery LTD

Marsh, Bert
del Mano Gallery

Marti, Dani
browngrotta arts

Martin, Chris
PRISM Contemporary Glass

Martinazzi, Bruno
Mobilia Gallery

Maruyama, Tomomi
Mobilia Gallery

Mason, Vicki
Charon Kransen Arts

Massey, Sharon
Charon Kransen Arts

Mathes, Jesse
The David Collection

Matthias, Christine
Charon Kransen Arts

Mazzone, Mary Stacy
Art Miya

Mazzoni, Ana
Maria Elena Kravetz

McClellan, Duncan
Mattson's Fine Art

McCorrison, Ruth
Snyderman-Works Galleries

McDevitt, Elizabeth
Mobilia Gallery

McKnight, Rachel
Charon Kransen Arts

McQueen, John
Mobilia Gallery

Meleski, Leah
Mobilia Gallery

Menconi, Michael Angelo
Mattson's Fine Art

Mendez, Louis
Loveed Fine Arts

Merkel-Hess, Mary
browngrotta arts

Meszaros, Mari
Duane Reed Gallery

Metcalf, Bruce
Charon Kransen Arts

Metoyer, John
21ST Editions

Metzner, Sheila
21ST Editions

Meyer, Sharon
Mattson's Fine Art

Meyers, Ron
Snyderman-Works Galleries

Michel, Nancy
Mobilia Gallery

Michikawa, Shozo
Galerie Besson

Middlebrook, Nancy
Snyderman-Works Galleries

Midgett, Steve
Aaron Faber Gallery

Migdal, Zammy
Adamar Fine Arts

Mihara, Ken
Joan B. Mirviss LTD

Milan, Emil
Moderne Gallery

Milthon
Modus Art Gallery

Mimura, Chikuho
TAI Gallery

Miner, Charles
Holsten Galleries

Minkkinen, Arno Rafael
Barry Friedman Ltd.

Minkowitz, Norma
browngrotta arts
Donna Schneier Fine Arts

Minor, Barbara
Yaw Gallery

Mirabelli, Christy
Snyderman-Works Galleries

Mirabelli, Milo
del Mano Gallery
Snyderman-Works Galleries

Mishima, Kimiyo
Joan B. Mirviss LTD

Miwa, Kazuhiko
Joan B. Mirviss LTD

Miwa, Ryôsaku
Joan B. Mirviss LTD

Miyake, Mae
Art Miya

Miyashita, Zenji
Joan B. Mirviss LTD

Møhl, Tobias
Heller Gallery

Monden, Kogyoku
TAI Gallery

Mongrain, Jeffrey
Loveed Fine Arts

Montgomery, Steven
Loveed Fine Arts

Monzo, Marc
Ornamentum

Moon, Choonsun
Charon Kransen Arts

Moore, William
del Mano Gallery

Morel, Sonia
Charon Kransen Arts

Mori, Junko
Clare Beck at Adrian Sassoon

Morigami, Jin
TAI Gallery

Morino, Taimei
Joan B. Mirviss LTD

Morris, William
Barry Friedman Ltd.
Donna Schneier Fine Arts

Moseholm, Keld
Galleri Udengaard

Moulthrop, Ed
Moderne Gallery

Moulthrop, Matt
del Mano Gallery

Moulthrop, Philip
del Mano Gallery

Mulford, Judy
browngrotta arts

Müllertz, Malene
Lacoste Gallery

Munsen, Mel
Option Art

Munsteiner, Bernd
Aaron Faber Gallery

Munsteiner, Tom
Aaron Faber Gallery

Murray, David
Chappell Gallery

Murray, Shea
Yaw Gallery

Mustonen, Eija
Ornamentum

N

Nagakura, Kenichi
TAI Gallery

Nagano, Kazumi
Mobilia Gallery

Nagy, Sylvia
Loveed Fine Arts

Nakagawa, Mamoru
Onishi Gallery

Nakamoto, Wakae
Art Miya

Nakashima, George
Moderne Gallery

Nakatomi, Hajime
TAI Gallery

Namingha, Les
Blue Rain Gallery

Natzler, Otto
Loveed Fine Arts

Neale, David
Jewelers' Werk Galerie

Negré, Suzanne Otwell
The David Collection

Negri, Martie
UrbanGlass

Newport, Mark
Snyderman-Works Galleries

Nguyen, Trinh
PRISM Contemporary Glass

Nijland, Evert
Charon Kransen Arts

Nio, Keiji
browngrotta arts

Nishi, Etsuko
Chappell Gallery

Nishida, Jun
ARTCOURT Gallery -
 Yagi Art Management, Inc.

Nishino, Kozo
ARTCOURT Gallery -
 Yagi Art Management, Inc.

Nishimura, Yuko
KEIKO Gallery

Nishizaki, Satoshi
DF ART INTERNATIONAL

Nolen, Matt
Snyderman-Works Galleries

Nordman, Efrat
Yaw Gallery

Noten, Ted
Ornamentum

Notkin, Richard
Ferrin Gallery

Noy, Itay
Yaw Gallery

Nuis, Carla
Charon Kransen Arts

Nuna, Taqialuq
Galerie Elca London

O'Connor, Harold
Mobilia Gallery

Ogata, Kamio
Joan B. Mirviss LTD

Ogawa, Machiko
Joan B. Mirviss LTD

Oh, Miwha
Mobilia Gallery

Ohi, Toshio
Onishi Gallery

Ohira, Yoichi
Barry Friedman Ltd.

O'Kelly, Angela
Charon Kransen Arts

Okim, Komelia
Aaron Faber Gallery

Okubo, Kyoko
Mobilia Gallery

Okuno, Yoko
Mobilia Gallery

Oliver, Gilda
Loveed Fine Arts

O'Neill, Brian
Ruth Lawrence Fine Art

Ort, Alena
Loveed Fine Arts

Osolnik, Rude
Moderne Gallery

Osterrieder, Daniela
Charon Kransen Arts

Paganin, Barbara
Charon Kransen Arts

Paley, Albert
Donna Schneier Fine Arts
Ruth Lawrence Fine Art

Palolo
Galerie Vivendi

Pañeda, María Ester
Maria Elena Kravetz

Pappas, Marilyn
Snyderman-Works Galleries

Parcher, Joan
Mobilia Gallery
Ornamentum

Pardes, Miel Marguerita
Yaw Gallery

Pardon, Tod
Aaron Faber Gallery

Park Kwang, Jin
Galerie Vivendi

Park, So Young
Aaron Faber Gallery

ParkeHarrison, Robert
21ST Editions

ParkeHarrison, Shana
21ST Editions

Parr, Nuna
Galerie Elca London

Paxon, Adam
Clare Beck at Adrian Sassoon

Peich, Francesc
CREA Gallery

Pembridge, Gordon
del Mano Gallery

Perdiguero, Juan
Ann Nathan Gallery

Perez, Jesus Curia
Ann Nathan Gallery

Perez-Flores, Dario
Galerie Vivendi

Perkins, Danny
Duane Reed Gallery

Perkins, Sarah
Mobilia Gallery

Persson, Stig
Køppe Gallery -
 contemporary objects

Peters, Hans-Leo
Compendium Gallery

Peters, Ruudt
Ornamentum

Petersen, Huib
Snyderman-Works Galleries

Peterson, George
del Mano Gallery

Peterson, Michael
del Mano Gallery

Petter, Gugger
Jane Sauer Gallery

Pheulpin, Simone
browngrotta arts

Phillips, Maria
The David Collection

Pho, Binh
del Mano Gallery

Picaud, Fabienne
Mostly Glass Gallery

Pierce, Shari
Jewelers' Werk Galerie

Pinchuk, Anya
Charon Kransen Arts

Pinchuk, Natalya
Charon Kransen Arts

Piqtoukun, David Ruben
Galerie Elca London

Pizzini, Alessandra
The David Collection

Podgoretz, Larissa
del Mano Gallery

Pohlman, Jenny
Duane Reed Gallery

Pon, Stephen
CREA Gallery

Pontoppidan, Karen
Jewelers' Werk Galerie

Pootoogook, Kananginak
Galerie Elca London

Potter, Anne
Ann Nathan Gallery

Powell, Stephen
Donna Schneier Fine Arts
Marx-Saunders Gallery LTD

Pragnell, Valerie
browngrotta arts

Prasch, Camilla
Ornamentum

Prestini, James
Moderne Gallery

Preston, Mary
Ornamentum

Price, Beverley
Charon Kransen Arts

Price, Ursula Morley
Andora Gallery

Priddle, Graeme
del Mano Gallery

Priest, Linda Kindler
Aaron Faber Gallery

Primeau, Patrick
CREA Gallery

Prins, Katja
Ornamentum

Quagliata, Orfeo
Snyderman-Works Galleries

Quigley, Robin
Mobilia Gallery

Radda, Tania
del Mano Gallery

Rainey, Clifford
Habatat Galleries Chicago

Ramshaw CBE, Wendy
Mobilia Gallery

Rand, Elizabeth
William Zimmer Gallery

Randal, Seth
Leo Kaplan Modern

Rankin, Susan
Option Art

Rast, Ann Coddington
Mobilia Gallery

Rath, Tina
Sienna Gallery

Rawdin, Kim
Aaron Faber Gallery

Recko, Gateson
Mostly Glass Gallery

Regan, David
Barry Friedman Ltd.

Reitz, Don
Lacoste Gallery

Rezac, Suzan
Mobilia Gallery

Rhoads, Kait
Chappell Gallery

Richmond, Lesley
Jane Sauer Gallery

Ricks, Madelyn
Mostly Glass Gallery

Rie, Lucie
Galerie Besson
Joanna Bird Pottery

Rietmeyer, Rene
Adamar Fine Arts
Berengo Studio

Riis, Jon Eric
Jane Sauer Gallery

Rinneberg, Claudia
The David Collection

Riveria, Edwin
ten472 Contemporary Art

Robertson, Donald
Option Art

Robinson, John Paul
Andora Gallery

Romanelli, Bruno
Clare Beck at Adrian Sassoon

Rose, Jim
Ann Nathan Gallery

Rose, Marlene
Adamar Fine Arts

Rosenfeld, Erica
UrbanGlass

Rosol, Martin
Holsten Galleries

Rossbach, Ed
browngrotta arts

Rothmann, Gerd
Ornamentum

Rothstein, Scott
browngrotta arts

Rousseau-Vermette, Mariette
browngrotta arts

Roussel, Anthony
Charon Kransen Arts

Rowan, Tim
Lacoste Gallery

Royal, Richard
Marx-Saunders Gallery LTD

Rudavska, Maria
Loveed Fine Arts

Ruhwald, Anders
Køppe Gallery -
 contemporary objects

Rush, Katy
Ferrin Gallery

Russmeyer, Axel
browngrotta arts
Jewelers' Werk Galerie

Ruttenberg, Kathy
Habatat Galleries Chicago

Ryan, Jackie
Charon Kransen Arts

Rydmark, Cheryl
William Zimmer Gallery

Saabye, Mette
Køppe Gallery -
 contemporary objects

Saba, Suleyman
Joanna Bird Pottery

Sacabo, Josephine
21ST Editions

Sachs, Debra
browngrotta arts

Safire, Helene
UrbanGlass

Saito, Yuka
Mobilia Gallery

Sajet, Philip
Ornamentum

Sakamoto, Madoka
KEIKO Gallery

Sakamoto, Rie
KEIKO Gallery

Sakiyama, Takayuki
Joan B. Mirviss LTD

Sakurai, Yasuko
Joan B. Mirviss LTD

Saliani, Frank
PRISM Contemporary Glass

Samplonius, David
Option Art

Sang Ho, Shin
Loveed Fine Arts

Sarneel, Lucy
Charon Kransen Arts

Sasaki, Yuki
Charon Kransen Arts

Sato, Naoko
Zest Contemporary
 Glass Gallery

Sawyer, George
Aaron Faber Gallery

Saygi, Erkin
Turkish Cultural Foundation

Saylan, Merryll
del Mano Gallery

Schaupp, Isabell
Charon Kransen Arts

Schick, Marjorie
Charon Kransen Arts

Schimmel, Heidrun
browngrotta arts

Schira, Cynthia
Snyderman-Works Galleries

Schlech, Peter
del Mano Gallery

Schliwinski, Marianne
The David Collection

Schmid, Peter/Michael Zobel
Aaron Faber Gallery

Schmitz, Claude
Charon Kransen Arts

Schreiber, Constanze
Ornamentum

Schuerenkaemper, Frederike
Charon Kransen Arts

Schwarz, David
Marx-Saunders Gallery LTD

Scoon, Thomas
Marx-Saunders Gallery LTD

Scott, Joyce J.
Mobilia Gallery

Seelig, Warren
Snyderman-Works Galleries

Seeman, Bonnie
Duane Reed Gallery

Scido, Paul
Leo Kaplan Modern

Seidenath, Barbara
Sienna Gallery

Sekiji, Toshio
browngrotta arts

Sekijima, Hisako
browngrotta arts

Sekimachi, Kay
browngrotta arts

Seufert, Karin
Charon Kransen Arts

Shaa, Axangayuk
Galerie Elca London

Shabahang, Bahram
Orley & Shabahang

Shapiro, Karen
Snyderman-Works Galleries

Shapiro, Mark
Ferrin Gallery

Sharky, Toonoo
Galerie Elca London

Shaw, Richard
John Natsoulas Gallery
Mobilia Gallery

Sherman, Sondra
Sienna Gallery

Shimaoka, Tatsuzo
Joanna Bird Pottery

Shimazu, Esther
John Natsoulas Gallery

Shimizu, Ushio
Art Miya

Shimizu, Yoko
Mobilia Gallery

Shindo, Hiroyuki
browngrotta arts

Shinohara, Nanae
KEIKO Gallery

Shioya, Naomi
Chappell Gallery

Shirk, Helen
Yaw Gallery

Sicuro, Giovanni
Ornamentum

Siemund, Vera
Jewelers' Werk Galerie

Siesbye, Alev Ebüzziya
Barry Friedman Ltd.
Lacoste Gallery

Silvers, Robert
Galerie Vivendi

Sim, Jae Cheon
Naun Craft

Simpson, Josh
Signature Gallery

Simpson, Tommy
Leo Kaplan Modern

Singletary, Preston
Blue Rain Gallery

Sinner, Steve
del Mano Gallery

Sisson, Karyl
browngrotta arts

Skjøttgaard, Bente
Køppe Gallery -
 contemporary objects

Skubic, Peter
Jewelers' Werk Galerie

Slaughter, Kirk H.
ten472 Contemporary Art

Slemmons, Kiff
Mobilia Gallery

Smelvær, Britt
browngrotta arts

Smith, Barbara Lee
Snyderman-Works Galleries

Smith, Christina
Mobilia Gallery

Smith, Fraser
del Mano Gallery

Smith, Richard Zane
Blue Rain Gallery

So, Jin-Sook
browngrotta arts

Solari, Edmondo
Modus Art Gallery

Soldner, Paul
Moderne Gallery

Sonobe, Etsuko
Mobilia Gallery

Sørenson, Grethe
browngrotta arts

Spano, Elena
Charon Kransen Arts

Speckner, Bettina
Sienna Gallery

Sperkova, Blanka
Mobilia Gallery
Snyderman-Works Galleries

Sperry, Robert
Loveed Fine Arts

Spies, Klaus
Snyderman-Works Galleries

Spinski, Victor
Loveed Fine Arts

Spira, Rupert
Clare Beck at Adrian Sassoon

Spitzer, Silke
Ornamentum

Spring, Barbara
John Natsoulas Gallery

St. Michael, Natasha
CREA Gallery

Stanger, Jay
Leo Kaplan Modern

Stankard, Paul
Marx-Saunders Gallery LTD

Stankiewicz, Miroslaw
Mattson's Fine Art

Stealey, Jo
Snyderman-Works Galleries

Stebler, Claudia
Ornamentum

Steepy, Tracy
Sienna Gallery

Stein, Carol
Andora Gallery

Stein, Ethel
browngrotta arts

Steinberg, Eva
Snyderman-Works Galleries

Stem, Suzanne
Yaw Gallery

Stern, Ethan
Chappell Gallery

Stiansen, Kari
browngrotta arts

Stichter, Beth Cavener
Barry Friedman Ltd.

Stocksdale, Bob
Moderne Gallery

Stoukides, Betty
Charon Kransen Arts

Stoyanov, Aleksandra
browngrotta arts

Striffler, Dorothee
Charon Kransen Arts

Stutman, Barbara
Charon Kransen Arts

Sugawara, Noriko
Aaron Faber Gallery

Suh, Dong Hee
Loveed Fine Arts

Superior, Mara
Ferrin Gallery

Suzuki, Hiroshi
Clare Beck at Adrian Sassoon

Suzuki, Goro
Joan B. Mirviss LTD

Swim, Laurie
del Mano Gallery

Swol, Carol-lynn
The David Collection

Syvanoja, Janna
Charon Kransen Arts

T

Tagliapietra, Lino
Donna Schneier Fine Arts
Heller Gallery

Takaezu, Toshiko
Donna Schneier Fine Arts
Moderne Gallery

Takamiya, Noriko
browngrotta arts

Takamori, Akio
Barry Friedman Ltd.

Takayama, Dai
Art Miya

Takayama, Kazuo
Art Miya

Takayama, Kou
Art Miya

Takeda, Asayo
KEIKO Gallery

Takegoshi, Jun
Joan B. Mirviss LTD

Takiguchi, Kazuo
Art Miya

Tanabe, Takeo
TAI Gallery

Tanaka, Chiyoko
browngrotta arts

Tanaka, Hideho
browngrotta arts

Tanaka, Kazuhiko
KEIKO Gallery

Tanaka, Kyokusho
TAI Gallery

Tanaka, Tadakazu
Aaron Faber Gallery

Tanaka, Yas
Aaron Faber Gallery

Tanikawa, Tsuroko
browngrotta arts

Tataryn, Orest
Option Art

Tate, Blair
browngrotta arts

Tate, Tim
Jane Sauer Gallery

Tawney, Lenore
browngrotta arts

Taylor, Julien
Galerie Vivendi

Taylor, Michael
Leo Kaplan Modern

Taylor, Yoshio
John Natsoulas Gallery

Teratani, Chie
Aaron Faber Gallery

Tetkowski, Neil
Loveed Fine Arts

Thakker, Salima
Charon Kransen Arts

Thayer, Susan
Ferrin Gallery

Thomford, Pamela Morris
Yaw Gallery

Thurman, James
Yaw Gallery

Toda, Seiju
TAI Gallery

Toffolo, Cesare
Mostly Glass Gallery

Tolla
Adamar Fine Arts

Tolvanen, Terhi
Charon Kransen Arts

Tomasi, Henriette
Charon Kransen Arts

Tomasi, Martin
Charon Kransen Arts

Tomita, Jun
browngrotta arts

Toops, Cynthia
Mobilia Gallery

Topaloglu, Ruhcan
Turkish Cultural Foundation

Torii, Ippo
TAI Gallery

Torma, Anna
Snyderman-Works Galleries

Toso, Gianni
Leo Kaplan Modern

Toubes, Xavier
Loveed Fine Arts

Townsend, Kent
William Zimmer Gallery

Toyota, Yoji
Art Miya

Trask, Jennifer
Mobilia Gallery

Trekel, Silke
Charon Kransen Arts

Tridenti, Fabrizio
The David Collection

Truman, Catherine
Charon Kransen Arts

Trusso, Russell
Yaw Gallery

Tuccillo, John
Ann Nathan Gallery

Tunnillie, Ashevak
Galerie Elca London

Tunnillie, Ovilu
Galerie Elca London

Turner, Annie
Joanna Bird Pottery

Turner, Julia
Ornamentum

Turner, Neil
del Mano Gallery

Turner, Robert
Moderne Gallery

Turrin, Daniela
PRISM Contemporary Glass

Tuupanen, Tarja
Ornamentum

Ueda, Kyoko
KEIKO Gallery

Ueno, Masao
TAI Gallery

Ueno, Yumi
Aaron Faber Gallery

Ungvarsky, Melanie
UrbanGlass

Urruty, Joël
Andora Gallery

Usher, Brian
PRISM Contemporary Glass

Vagi, Flora
Charon Kransen Arts

Valkova, Rouska
Loveed Fine Arts

Vallien, Bertil
Marx-Saunders Gallery LTD

Vallila, Marja
Loveed Fine Arts

Valoma, Deborah
browngrotta arts

Van Der Laan, Christel
Charon Kransen Arts

Van Stom, Feyona
Maria Elena Kravetz

Varela, María Inés
Maria Elena Kravetz

Varga, Emma
Compendium Gallery

Vasarely, Victor
Galerie Vivendi

Vatrin, Gérald
Collection Ateliers
d'Art de France

Vaughan, Grant
del Mano Gallery

Veilleux, Luci
CREA Gallery

Velarde, Kukuli
Barry Friedman Ltd.

Velez, Luis Efe
Adamar Fine Arts

Verdier, Anne
Collection Ateliers
d'Art de France

Vermette, Claude
browngrotta arts

Vesery, Jacques
del Mano Gallery

Veverka, Donna
Mobilia Gallery

Vigliaturo, Silvio
Berengo Studio

Vikman, Ulla-Maija
browngrotta arts

Virden, Jerilyn
Ann Nathan Gallery

Visintin, Graziano
The David Collection

Vízner, František
Barry Friedman Ltd.
Donna Schneier Fine Arts

Vogt, Luzia
Ornamentum

Voulkos, Peter
Donna Schneier Fine Arts
Moderne Gallery

Wada, Morihiro
Joan B. Mirviss LTD

Waddington, Anoush
The David Collection

Wagle, Kristen
browngrotta arts

Wahl, Wendy
browngrotta arts

Wahlen, Hervé
Barry Friedman Ltd.

Walentynowicz, Janusz
Donna Schneier Fine Arts

Walker, Jason
Ferrin Gallery

Walter, Barbara
Mobilia Gallery

Walter, Julia
Charon Kransen Arts

Wang, Kiwon
Aaron Faber Gallery

Wapner, Grace Bakst
Loveed Fine Arts

Warashina, Patti
Loveed Fine Arts

Warner, Deborah
Snyderman-Works Galleries

Watkins, Alexandra
Mobilia Gallery

Watkins, David
Clare Beck at Adrian Sassoon

Way, Helen Frost
Snyderman-Works Galleries

Weinberg, Steven
Leo Kaplan Modern

Weir-Quiton, Pamela
Moderne Gallery

Weiser, Kurt
Ferrin Gallery

Weiss, Caro
Charon Kransen Arts

Weissflog, Hans
del Mano Gallery

Weissflog, Jakob
del Mano Gallery

Weldon-Sandlin, Red
Ferrin Gallery

Welker, Lena McGrath
browngrotta arts

Westphal, Katherine
browngrotta arts

White, Heather
Mobilia Gallery

Whitehead, Gill Galloway
Aaron Faber Gallery

Whiteley, Richard
Marx-Saunders Gallery LTD

Whitney, Ginny
Aaron Faber Gallery

Wieske, Ellen
Mobilia Gallery

Willemstijn, Francis
Charon Kransen Arts

Williamson, David
Snyderman-Works Galleries

Williamson, Roberta
Snyderman-Works Galleries

Winqvist, Merja
browngrotta arts

Wirasekara, Sharmini
Mostly Glass Gallery

Wise, Jeff
Aaron Faber Gallery

Wise, Susan
Aaron Faber Gallery

Witkin, Joel-Peter
21ST Editions

Wittrock, Grethe
Køppe Gallery -
contemporary objects

Wolff, Ann
Leo Kaplan Modern

Woo, Jin-Soon
Charon Kransen Arts

Wood, Joe
Mobilia Gallery

Woodman, Betty
Loveed Fine Arts

Woodman, Rachael
Clare Beck at Adrian Sassoon

Yabuuchi, Satoshi
Art Miya

Yagi, Yoko
Snyderman-Works Galleries

Yamamoto, Yoshiko
Mobilia Gallery
Yaw Gallery

Yamamoto, Yusuke
Art Miya

Yamanaka, Kazuko
KEIKO Gallery

Yang, Loretta
Leo Kaplan Modern

Yang, Xiang
Snyderman-Works Galleries

Yeonsoon, Chang
browngrotta arts

Yi, Jung-Gyu
Charon Kransen Arts

Yiannes
Loveed Fine Arts

Yokouchi, Sayumi
Aaron Faber Gallery
Sienna Gallery

Yonezawa, Jiro
browngrotta arts

Yoshida, Kazuya
Art Miya

Yoshida, Masako
browngrotta arts

Youn, Soonran
Snyderman-Works Galleries

Young, Brent Kee
Jane Sauer Gallery

Young-ok, Shin
browngrotta arts

Yuki, Yoshiaki
gallery gen

Yung, Lily
Option Art

Zaborski, Maciej
Mattson's Fine Art

Zanella, Annamaria
Charon Kransen Arts

Zertova, Jirina
Leo Kaplan Modern

Zhitneva, Sasha
Chappell Gallery

Zimmermann, Erich
The David Collection

Zobel, Michael/Peter Schmid
Aaron Faber Gallery

Zonis, Alexandra
Mostly Glass Gallery

Zuber, Czeslaw
Donna Schneier Fine Arts

Zynsky, Toots
Barry Friedman Ltd.